Visions of
Heaven and Hell

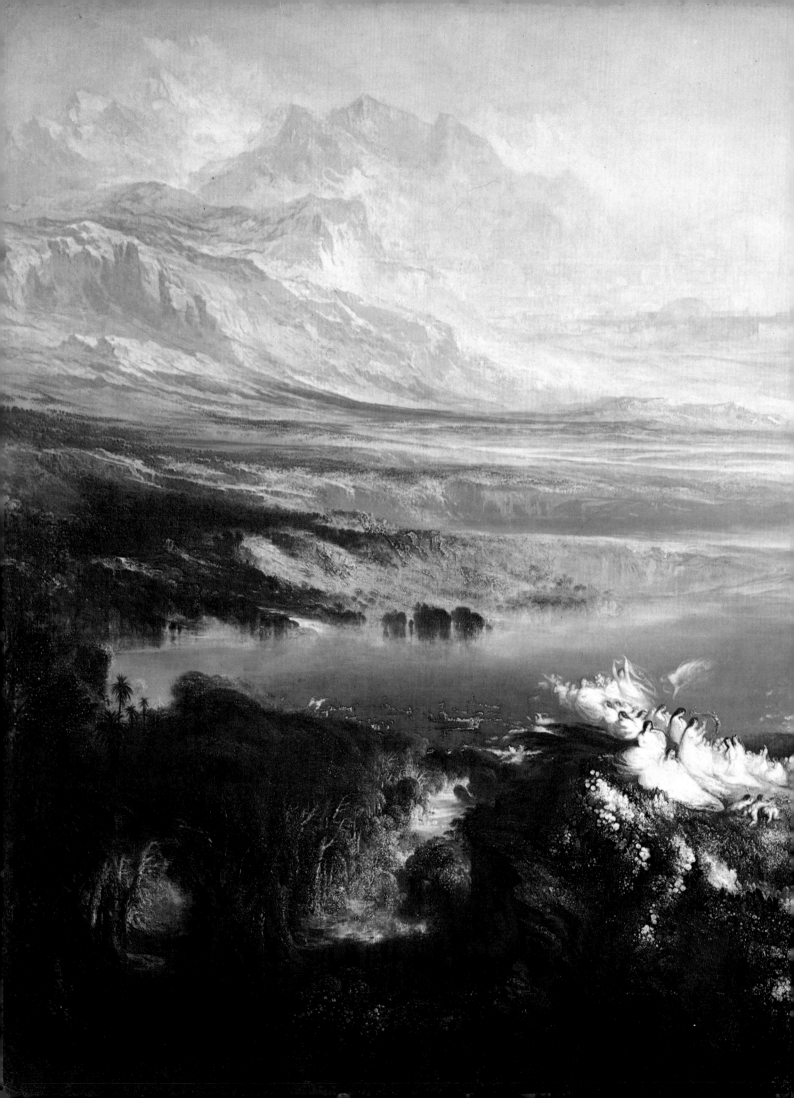

Visions of Heaven and Hell

Richard Cavendish

HARMONY BOOKS · New York

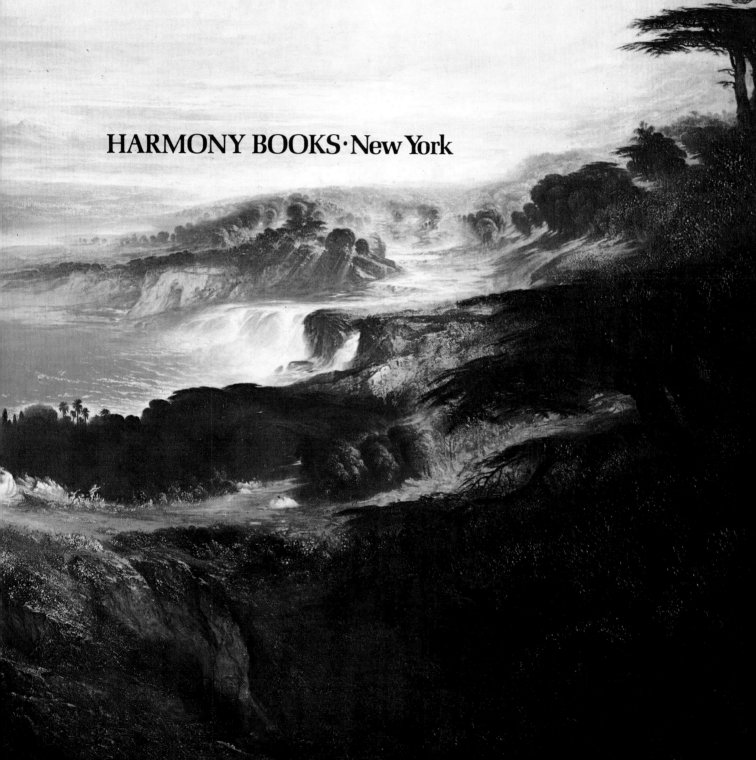

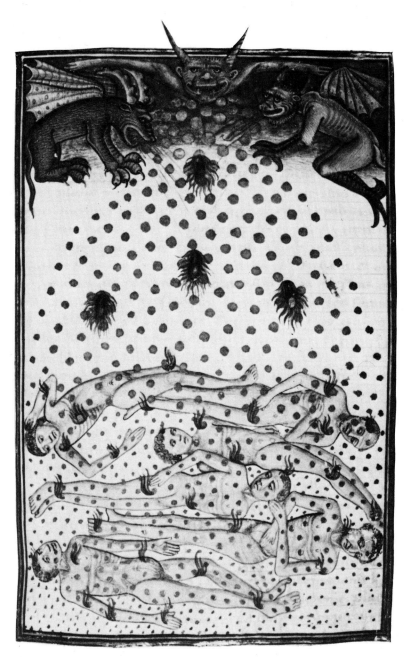

Frontispiece: *The Plains of Heaven*
by John Martin, 1853
(reproduced by kind permission
of the Tate Gallery)

Endpapers: Detail from
Michelangelo's *Last Judgment* in the
Sistine Chapel
(Mansell Collection)

Above: Firestones and hail
rain on the damned (Bodleian
Library, MS douce no. 134 F.
103V)

© Orbis Publishing Ltd, London 1977
First published, 1977, in the
United States by Harmony Books,
a division of Crown Publishers,
Inc. All rights reserved under
the International Copyright
Union. No part of this book may
be utilized or reproduced in any
form or by any means, electronic
or mechanical, including
photocopying, recording, or by any
information storage and
retrieval system, without
permission from the publisher.
Printed in England.

Harmony Books
A division of Crown Publishers, Inc.
One Park Avenue
New York, New York 10016

Published simultaneously in
Canada by General Publishing
Company Limited.

Library of Congress Cataloging in Publication Data
Cavendish, Richard
 Visions of heaven and hell.

 1. Heaven in art. 2. Hell in art. 3. Art –
Themes, motives. I. Title.
N7793.H4C38 1977 704.948 77-5402
ISBN 0-517-53097-X
ISBN 0-517-53098-8 pbk.

Contents

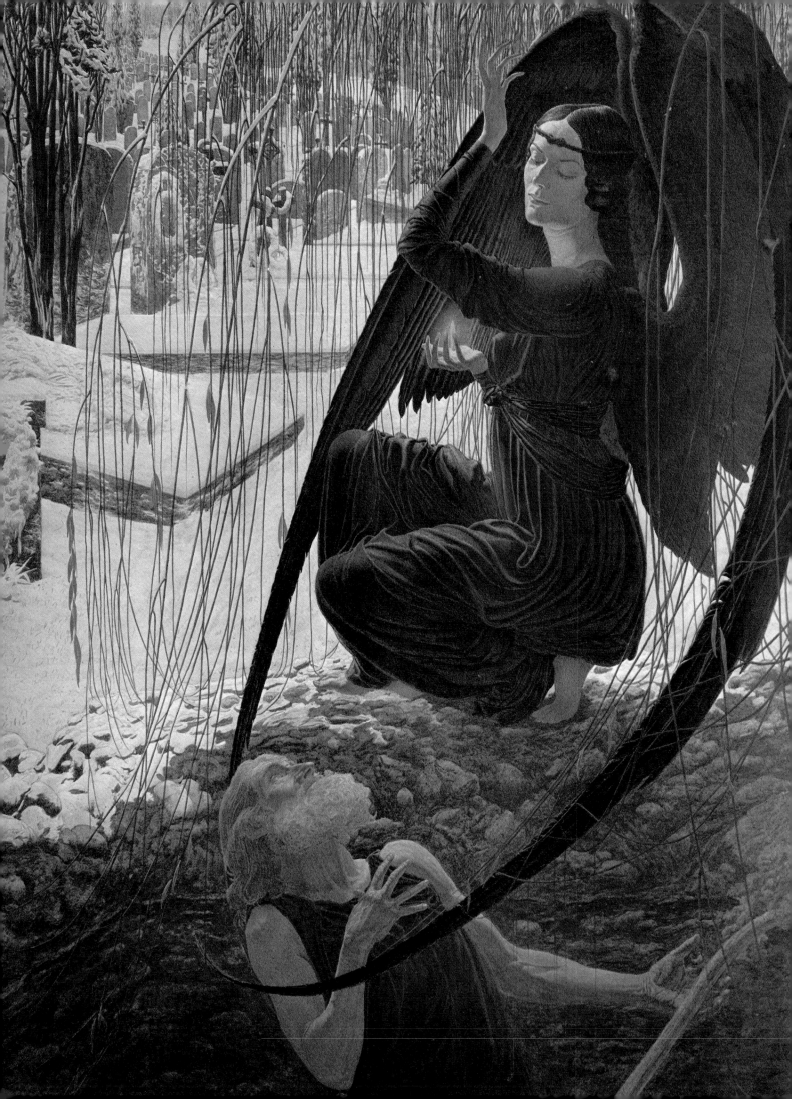

Chapter one
Life After Death

Nor dread, nor hope attend
A dying animal;
A man awaits his end
Dreading and hoping all.

W. B. Yeats, *Death*

Left: Death and the Gravedigger by Carlos Schwabe, a Symbolist painter who died in 1926. Death is feared as the inevitable end of life, but there is always the hope that it may be the gateway to a new life in a different world. In Jewish belief, the angel of death came for every man and woman when their time ran out, but depiction of death as an angel in art is rare. It is even rarer for the angel of death to be imagined as a woman, which suggests the theme of death through which renewed life is achieved. The graveyard in the background is icily dead but, from very early times, belief in an afterlife has been influenced by the cycle of the seasons, in which 'death' in winter is followed by 'rebirth' in the spring.

Human beings know that they will die, but they find it almost impossible to accept that death will put an end to them. Like other animals, men and women have a powerful instinct to survive. Unlike other animals, they realize they will not survive, or not in the world they have known. The human solution to this grim dilemma is a life in some different world after death.

People have always believed in a life after death, with varying degrees of confidence—whether through an inspired grasp of the truth or as a result of wishful thinking. All ideas about heaven and hell and the otherworld necessarily depend on this belief. But what the otherworld is, where it is and what it is like, there is no way of knowing for certain. No one has ever demonstrated, to the satisfaction of everyone else, what happens after death. The result is a mass of different beliefs which reflect different insights, hopes and fears.

Going to heaven can mean the perfecting of the individual personality, or it can mean the extinction of personality which is submerged in something greater. The otherworld can be a place or a state of mind. It can be a paradise of physical pleasure or a heaven filled with the presence of the divine. It can be like this world but much better, or so unlike life on earth that it cannot be described at all. In different systems of belief, heaven can be reached by faith in a god, by leading a good and useful life, through the correct performance of rituals, by way of power and high social status, as a reward for bravery in battle, through visions, trances and ecstasies. And, paradoxically, the feeling that one life is not enough has led not only to beliefs in desirable heavens and paradises but in terrifying hells of punishment.

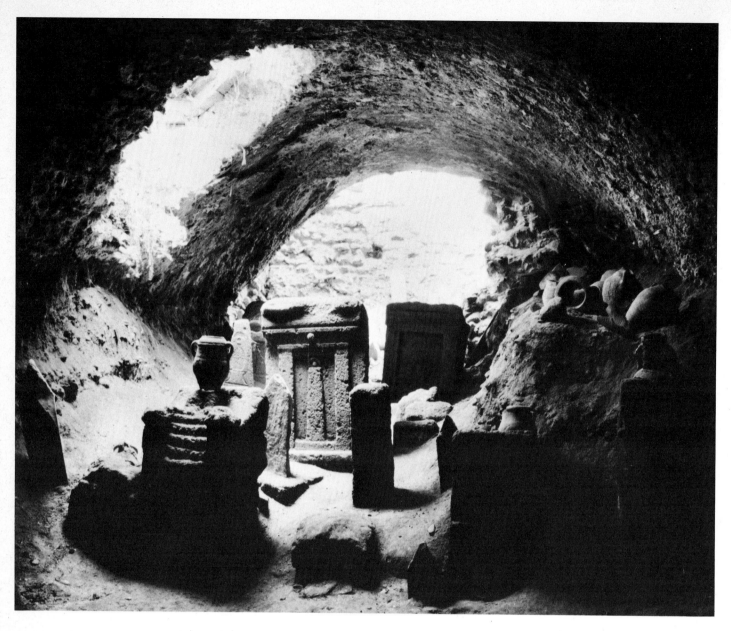

Above: *It is often believed that each person's life-energy is released at death. A sinister discovery at Carthage in North Africa was the sanctuary of the fertility goddess Tanit. Babies were sacrificed to her by burning, apparently so that their vital energy would strengthen her and contribute to the fertility of the land. Their remains were placed in small urns. The custom continued until the destruction of Carthage by the Romans in the second century B.C.*

Primitive peoples have frequently believed that the dead are reborn in their descendants, and theories of reincarnation are also known in more sophisticated circles in both the East and the West. Prehistoric man may have found it difficult to think that death was absolutely final, since he saw death and renewal all around him, in plants and animals. An old and widespread belief is that the dead live on in their graves, either for a short time or indefinitely. The soul or spirit, which is each person's essential self, is often thought to survive the death of the body. It may go on a journey to another world, somewhere on the earth's surface or under the ground or in the sky. The shamans or magicians of tribal societies and the holy men of more complex cultures travel to the otherworld in visions or dreams and bring back descriptions of it. Possibly everyone shares the same fate after death, or perhaps some people experience a better afterlife than others. Alternatively, each person may have several different souls, to which different things may happen.

The theories are all related to experience of life in this world and to the requirements of both the individual and society. But human

beings are not filing cabinets and ideas about the afterlife are not kept tidily in separate folders. Different and sometimes contradictory ideas are muddled together because of the impossibility of being sure of the truth and because different beliefs suit varying needs and moods. People have found it perfectly possible to think that the dead live on in their graves, where affectionate presents are given them, and at the same time that they live in an otherworld far away which frees their families from an uncomfortable sense of their presence. Indeed, flowers are still placed on the graves of the dead who are believed to be either in heaven or no longer in existence at all.

The earliest evidence of belief in an afterlife of some kind comes from burial customs. When an animal dies it is eaten by predators or lies to rot where it has fallen. When a human being dies, his body is almost always disposed of carefully. It is extremely rare for a human corpse to be thrown aside like rubbish and left to moulder away out of sight, out of scent and out of mind. The tradition of special treatment for the dead is immensely old. The manlike creatures which lived near what is now Peking, perhaps 300,000 years ago, seem to have preserved the skulls of their dead. They were cannibals and ate the brains of the dead, possibly because they hoped to absorb their knowledge and skill. Some 50,000 years ago, the Neanderthal men, who were probably also cannibals and headhunters, buried their dead with what seems to have been a combination of respect, affection and fear. Homo sapiens himself later followed the same pattern, and the combination survives to this day in people's attitude to the dead.

In many prehistoric burials between about 30,000 to 10,000 B.C., the corpse was tied up before the onset of rigor mortis in a position like that of a foetus in the womb, with the knees drawn up towards the head and the hands close to the face. This may have been done to save labour by digging as small a grave as possible. It may have been inspired by fear and intended to stop the dead man from getting out of his grave. On the other hand, the dead may have been buried in this prenatal position to help them to be reborn. They were often interred in caves where their families continued to live, suggesting that they were still considered part of the family group and that a religious cult of the family's ancestors may already have existed.

A belief in continuing life or rebirth after death is indicated by the 'grave-goods', the objects buried with the dead: tools, weapons, ornaments, toys for children, and probably clothes and food. These were things which, presumably, the dead would need and would like to have with them in whatever existence was theirs in or beyond the grave. In some cases the bodies were painted red, which was apparently a magical attempt to bring them back to life, red being the colour of blood and therefore associated with vitality. Sometimes cowrie shells, shaped like the female genitals, were buried with the dead, perhaps to assure them of rebirth.

In western Europe, 4,000 years ago or so, large collective tombs were built, holding anything up to 300 bodies. The dead were usually buried in the prenatal position and were provided with axes, daggers, saws, awls and other tools and weapons, beakers and pots, pins, beads and ornaments, figures of animals, and owl-eyed figurines probably representing the Earth-Mother. In some cases designs, including the owlish face of the goddess, were painted on the walls. Archaeologists investigating these tombs have frequently found a few

Below: An old and widespread pattern of ideas connects the dead with the fertility of the ground in which they are buried and with the earth goddess, who gives life to the crops. She may also be believed to give rebirth to the dead, who are laid to rest in her womb.
Thousands of years ago, images of the mother goddess were often placed in graves.

skeletons intact and laid out in an orderly way, while others are broken and strewn about in muddled heaps. It looks as if the tombs were used over long periods of time and the older remains were pushed roughly out of the way to make room for new arrivals. The implication may be that the dead were thought to need respectful treatment for only a limited time after burial; perhaps for as long as it took the flesh to decay and leave the skeleton bare, or perhaps for as long as a person was remembered by the living—after which the dead man may have been believed to have gone to the otherworld or to have been reincarnated in one of his descendants.

Burying daggers, saws and other useful or attractive objects with the dead contradicts the maxim 'you can't take it with you', and implies that the afterlife will resemble this life. There is plenty of evidence of the belief that those who were rich and powerful in this world would retain a privileged position in the world to come. Tombs found at Ur in Mesopotamia, dating from before 2000 B.C., are believed to be those of the city-kings and their consorts. They were far more luxurious than the graves of the ordinary people of Ur, who were buried with a few belongings and simple offerings of food. In the 'royal' tombs the bodies were supplied with enormous quantities of expensive goods, including furniture, musical instruments, games, bowls and pots, statues and ornaments. They were also provided with servants. Soldiers, courtiers and ladies-in-waiting were killed and buried with them, the soldiers with their spears and the court ladies with gold pendants, necklaces, earrings, and head-dresses of lapis lazuli. There were no signs of a struggle and the guards and courtiers seem to have gone voluntarily to their deaths, which suggests a confident belief in an afterlife in which they would continue in their earthly roles.

In Egypt, slightly later, an important official called 'the Chief Headman of the South' was buried with several hundred Nubian slaves, who were evidently put to death in the belief that they would continue to serve him as they had served him on earth. They were probably either strangled or drugged before they were placed in the headman's grave with other useful objects—a sword, pots and pans, and ornaments—and the tomb was then filled in with earth.

In China, similarly, under the Shang dynasty (from the eighteenth to the eleventh centuries B.C.), kings and noblemen went into the afterlife with a substantial escort of slaughtered retainers. The custom changed eventually and dummies made of straw or wooden figures with movable limbs were buried instead of human servants. Confucius, the famous teacher and philosopher, later disapproved of the wooden figures because he feared they might inspire a return to human sacrifice.

The Greek traveller and geographer, Pausanias, visited Mycenae in Greece in the second century A.D. and saw the famous Lion Gate of the old city and the tombs of the kings of the house of Atreus which were rich in treasure. The early rulers of Mycenae and their wives, from the sixteenth century B.C., were buried in shafts, cut into the rock and filled with earth, with hoards of swords and daggers, golden crowns, gold and silver cups, mirrors, jewellery, hairpins, kitchen equipment, amber beads, ostrich eggs from Africa and objects in ivory and lapis lazuli. Some wore magnificent gold masks, and Heinrich Schliemann, the brilliant rediscoverer of Troy and Mycenae in the nineteenth century, believed that in the shaft graves at Mycenae

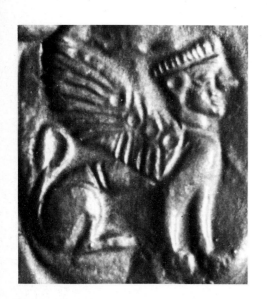

Above: *Burial customs provide the earliest evidence of belief in an afterlife, since the dead are often treated in a way which implies that death is not the end of their existence. An example is the very old custom of burying tools, weapons and ornaments with the dead, because they would need them in the afterworld. The rulers of Mycenae in Greece, from the sixteenth century B.C., were interred with magnificent treasures and equipment. Detail from a gold pectoral, found at Enkomi. (British Museum)*

he had found the death-mask of Agamemnon himself, who led the Greeks in the siege of Troy. These Mycenaean kings were probably thought to live on in great state in their tombs or in the underworld. Their treasure hoards contrast sharply with the description of the afterworld in Homer, where almost all the dead, rich and poor, king and commoner alike, go to a powerless, miserable existence in the halls of Hades down beneath the ground.

The Homeric underworld was not a place of continued earthly power and pomp. On the contrary, when Odysseus visits it, in the

Below: *The 'mask of Agamemnon', from Mycenae, at one time thought to be the death-mask of the leader of the Greeks in the siege of Troy. This is now doubted, but the superb gold mask is evidence of the belief that the rich and powerful in this world would retain a privileged position in the afterworld. (National Museum, Athens)*

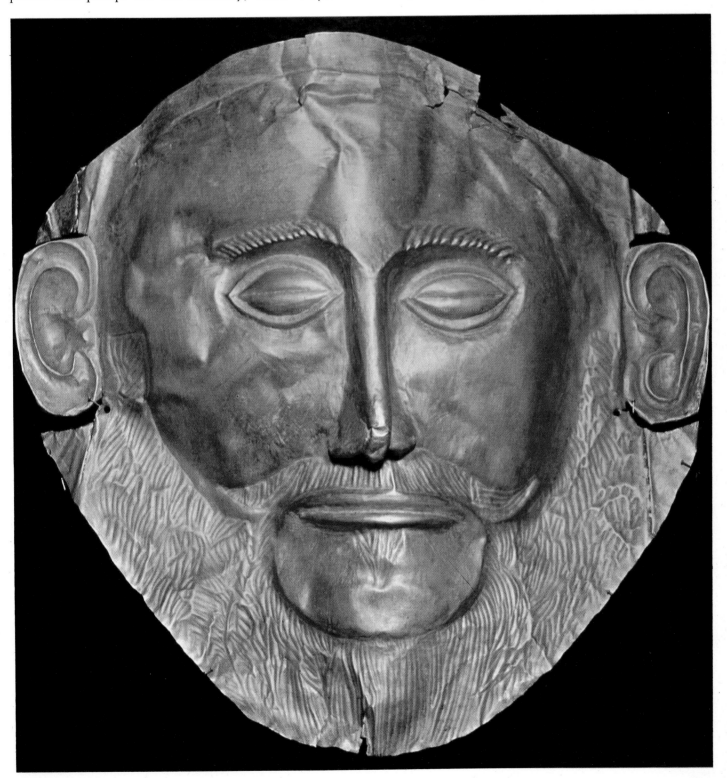

Odyssey, he meets the great hero Achilles, who says he would rather be a poverty-stricken labourer on earth than be king of all the dead. The same belief prevailed in ancient Mesopotamia and Israel, that all mankind shared an identical fate after death in a world of shadowy phantoms in the 'land of no return', the underworld of darkness and dust where rank, wealth and achievement counted for nothing. Not everyone in these societies, however, accepted this pessimistic view of the afterlife.

The more common belief has been that different people are treated differently in the next world. The most enjoyable afterlife is reserved for people of distinction: the high-born, the brave or the good. In pagan northern Europe the dead were believed to live on in their graves, where they watched over their homes and families, and guarded the grave-goods buried with them. But there were thought to be several different otherworlds. The goddess Hel ruled an underground country of the dead, shrouded in mist and darkness. This was in the north and the dead took a long journey to it through dark valleys. Some said that men went to it who died in their beds of old age or disease. There was also an otherworld across the sea and ships were sometimes buried with the dead. According to another belief, recorded in the *Prose Edda*, written by Snorri Sturluson the Icelandic historian in about A.D. 1220, aristocrats and warriors killed in battle gained a glorious afterlife in Valhalla, 'the Hall of the Slain', where they formed the war-band of the god Odin.

Below: When the dead are believed to live on in their tombs after burial, they may be supplied with furniture, food and other comforts and necessities of life by their families. Chairs were provided in this Etruscan tomb.

Valhalla was the paradise of fighting-men of good family, and perhaps of their womenfolk as well. There are traces of a custom of killing a dead warrior's wife to send her with him to the afterworld. As late as the tenth century, it was said, the wife of King Eric of Sweden left him, much to his shame, because she had no intention of being put to death when his time ran out. In Valhalla, the warriors drank mead (the suggestion that these formidable men might drink water is dismissed in the *Prose Edda* as patently ridiculous) and feasted on a never-ending supply of pork from a magic boar. The boar was cooked in a cauldron every day and came back to life again every evening. During the day the warriors amused themselves by fighting each other outside, but to keep the peace in the hall itself weapons had to be handed in at the door. The combats and drinking bouts in Valhalla reflect the warrior's life in this world. Odin was the god of war, ecstasy and intoxication. In drunkenness and battle-frenzy, on earth and in heaven, he freed his followers from the prison of the normal, humdrum, sober self.

The warriors of Valhalla were not to enjoy this heroic existence for eternity, however. The Doom of the Gods lay inexorably in the future and Odin's war-band would die with him in a last, hopeless stand against the powers of chaos. Snorri Sturluson, however, was a Christian and so he says that good men go to live eternally with All-Father in the beautiful hall of Gimle, which is brighter than the sun, while wicked men go down to Hel.

The belief that a god's human fighting men have a passport to a happy afterlife has been important in Christianity itself. Christians who went on a pilgrimage to the Holy Land atoned for their sins and gained spiritual merit which would stand them in good stead in the next world. Christian warriors who went on crusade to wrest Jerusalem from the infidel trod an even more direct path to heaven and the action counted as a full and complete atonement for their sins. The First Crusade, in 1096, has even been called an armed Pilgrim's Progress. Muslim warriors, fighting on the other side and killed in battle for their faith, were equally assured of a place in paradise. Sir Ernest Barker's comments on the Christian knights apply as much to their opponents.

'The knight who joined the crusades might thus still indulge the bellicose side of his genius—under the aegis and at the bidding of the Church; and in so doing he would also attain what the spiritual side of his nature ardently sought—a perfect salvation and remission of sins. He might butcher all day, till he waded ankle-deep in blood, and then at nightfall kneel, sobbing for very joy, at the altar of the Sepulchre—for was he not red from the winepress of the Lord? One can readily understand the popularity of the crusades when one reflects that they permitted men to get to the other world by fighting hard on earth, and allowed them to gain the fruits of asceticism by the way of obedience to natural instincts.'[1]

Roman writers said much the same of the Celts, recognizing that belief in an afterlife is not only a matter of individual hope and solace but has general social functions. According to Julius Caesar, the Druids taught that the soul does not die but is reborn in another body: 'and they regard this as the strongest incentive to valour, since the fear of death is discarded'.[2] According to Pomponius Mela, the Roman geographer, the Celts believed that after death each soul

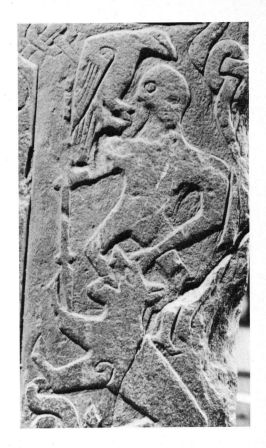

Above: *Carving of Ragnarok, or the Doom of the Gods, from the Isle of Man, showing the god Odin attacked by the great wolf Fenrir. In most religions the gods are immortal and never die, but in Norse belief the gods were destined to be killed when the evil powers of chaos rose against them at the end of the world. Odin recruited a war-band of high-born and brave warriors, who went after death to feast and drink in Valhalla, the Hall of the Slain. They would die fighting in the last battle and the world would be destroyed, but a new and happier world would replace it. (Manx Museum, Isle of Man)*

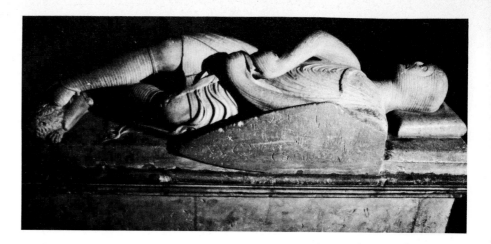

Right: *It is often believed that the most enjoyable afterlife is reserved for people of distinction: the well-born, the brave or the good. Societies dominated by a warrior caste naturally tended to believe in a happy afterworld for brave fighting men. Medieval knights who went on crusade to free the Holy Land from the Saracens were told that if they died fighting for Christ, their sins would be forgiven and they could be sure of heaven. This is the effigy of a knight who was killed on crusade, from a tomb in Dorchester Abbey, England, thirteenth century.*

Far right: *In Christianity heaven has to be earned, by dying for the faith or by good, moral behaviour in life. It was believed that on the Day of Doom at the end of the world Christ would appear in majesty on the clouds, earth and sea would give up their dead, and all the living and the dead would be judged by their actions in life and sent to heaven or to hell. This fourteenth-century Italian picture of the Last Judgment shows heaven in the sky, with God the Father, Christ and the Virgin Mary, surrounded by the angels and the saints, whose merits carried them straight to heaven at death. Below is hell, ruled by the Devil, where the wicked are tortured by demons. (Pinacoteca, Bologna)*

went to a new life in the afterworld: 'and this has been permitted manifestly because it makes the multitude readier for war'.[3] This explained, he said, the Celtic custom of burning or burying equipment with the dead, 'and that in times past they even used to defer the completion of business and the payment of debts until their arrival in another world. Indeed, there were some of them who flung themselves willingly on the funeral piles of their relatives in order to share the new life with them.'[4]

Cicero attempted to inculcate a similarly patriotic and selfless attitude among the Romans themselves by promising that 'all those who have preserved, aided or extended their fatherland have a special place assigned to them in heaven where they may enjoy an eternal life of happiness'.[5] On the other hand, Lucian said scornfully of the early Christians: 'For the poor souls have persuaded themselves that they are immortal and will live for ever. As a result, they think nothing of death, and most of them are perfectly willing to sacrifice themselves.'[6]

Warlike societies which put a premium on valour naturally tend to believe in a happy afterworld for fighting men. In Shinto, the national religion of Japan, paradise was a reward for bravery in battle and loyalty to the Emperor. More recently, the kamikaze pilots who crashed their planes into American and Allied warships in the Pacific during the Second World War were promised that in losing their lives they would become gods.

The Indian custom of suttee, in which a dead man's wife was burned alive with his corpse, was at first restricted to aristocratic and warrior families but later spread lower down the social scale. 'After the husband's death the widow prepared to join him. She was given a ceremonial bath and dressed in her finery and ornaments . . . She accompanied her husband's body to the cremation ground. Since she would soon have access to the spheres of heaven she was entrusted with messages to carry to deceased relations. Arrived at the pyre, she gave away her ornaments which were kept by the recipients as precious mementoes. She then mounted the pyre and sat beside the corpse, placing her husband's head on her lap. The pyre was then lighted.'[7]

Some women went willingly to death, some were mercifully drugged beforehand, but many had to be forcibly prevented from leaping out of the flames. It was believed that a woman sacrificed in this way gained better treatment in the afterworld for herself and her husband, family and friends. A more hard-headed motive for the custom was

that it relieved a dead man's son and relatives from financially supporting his widow. The share of the estate which she would otherwise have enjoyed for life thus went directly to them. Suttee survived into this century, in spite of determined efforts to eradicate it, and a case was reported as recently as 1946.

In Egypt, similarly, a happy afterlife which was at first the preserve of the well-born was later democratized. The burial rites of the pharaohs of Egypt spread to the aristocracy and then to others who could pay for them. The Egyptians spent more time, trouble and money on securing a life after death than perhaps any other people in history, and like many others they could not conceive of a satisfactory afterlife which was not lived in a physical body. The hot, porous sands of Egypt naturally disinfect and preserve corpses buried in them and this may have given the impetus to a belief in an eternal physical hereafter. Texts in the pyramids show that the bodies of pharaohs were being mummified, at least in a rudimentary way, by about 2400 B.C. The procedure later became extremely elaborate and some of the pharaohs remain remarkably well preserved to this day. It was too expensive for most Egyptians, however, who had to hope to survive without it.

Mummification was only part of the arsenal of religio-magical weapons which assured each pharaoh of survival. On the magical principle that saying a thing is so makes it so, texts were inscribed in his tomb which announced that he was divine and his body would

Skulls and bones are symbols of death, but they can also imply survival of death, because the bones outlast the flesh.
Left: *In various cultures all over the world the dead are believed to go to a land ruled by its own grim deities. The Aztec god of death was Mictlantecuhtli, here represented as a grinning skeleton and in the sitting position in which the Aztec dead were often buried. His realm was in the north, the direction of cold and darkness. (University Museum of Anthropology, Jallapa)*
Right: *In very early burials in Europe the dead were frequently tied up before the onset of rigor mortis in a position like that of a foetus in the womb. This may have been done merely to save labour in digging a grave, but it is not unlikely that corpses were buried in this position in the hope that they would be reborn. This skeleton of a six-year-old child dates from about 1000 B.C. and is believed to be Celtic. (Prähistorische Staatsammlung, Munich)*

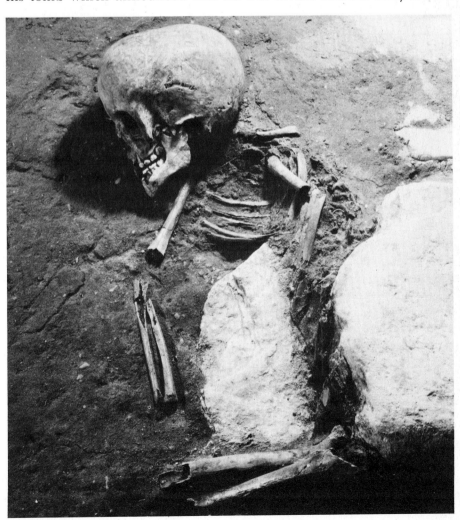

not decay. 'Your bones will not be destroyed, your flesh will not rot, your members will not fall apart, for you are one of the gods.' Other texts instructed the dead king to 'wake up' and 'stand up'. He was identified with the sun god, who rose every day in the morning after his 'death' at sunset, and with the god Osiris, who had died and come back to life again and was now the ruler of the dead. Osiris was, for the majority of ordinary Egyptians, the saviour from death.

There were different, confusing and contradictory beliefs about the afterlife. The dead pharaoh was believed to become Osiris. He might be depicted as Osiris in his tomb, and later every Egyptian hoped to become Osiris after death. It was also believed that he went to join the sun god and sailed with him in his boat across the sky by day and through the underworld at night. The pharaoh might be one of the rowers, or even more humbly set to bail out the boat, or he might be the captain of the boat. To reach the sun god's country, which was in the sky in the east, he had to cross the Lily Lake. He was taken over it by a ferryman, who faced backwards and was called He-who-looks-behind-himself. On the far side were the fields of the rejoicing of the gods. There heralds announced the king's arrival and the gods in robes and white sandals came to welcome him.

Below: *Judgment scene from the Papyrus of Ani. The ancient Egyptians believed that the dead would be judged by their actions in life and treated accordingly. This belief supported the ethical standards of Egyptian society. The dead man's heart, representing his conscience, was weighed against a feather, the symbol of order and truth. If his conscience weighed exactly the same as the feather, he would live happily for ever in the otherworld. If not, he was devoured by a monster, seen at the right of the picture. In the centre is the balance, adjusted by the jackal-headed Anubis, one of the gods of death. (British Museum)*

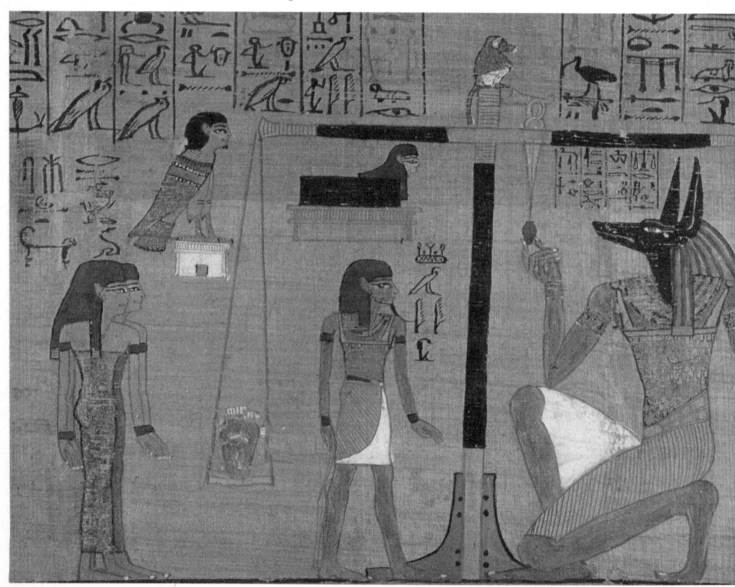

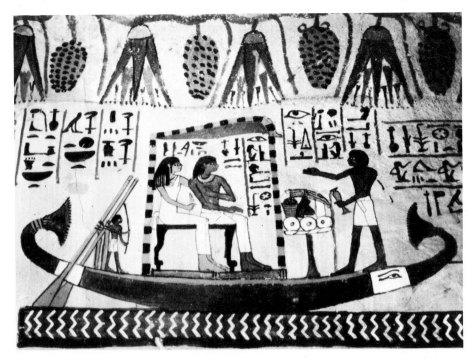

Left: *Life in the Egyptian otherworld was a continuation of life on earth, but with its pleasures enhanced. Pictures of the life after death were painted in tombs as magic to reinvigorate the dead. The dead ride in a boat on an otherworld river in this picture from a tomb at Thebes.*

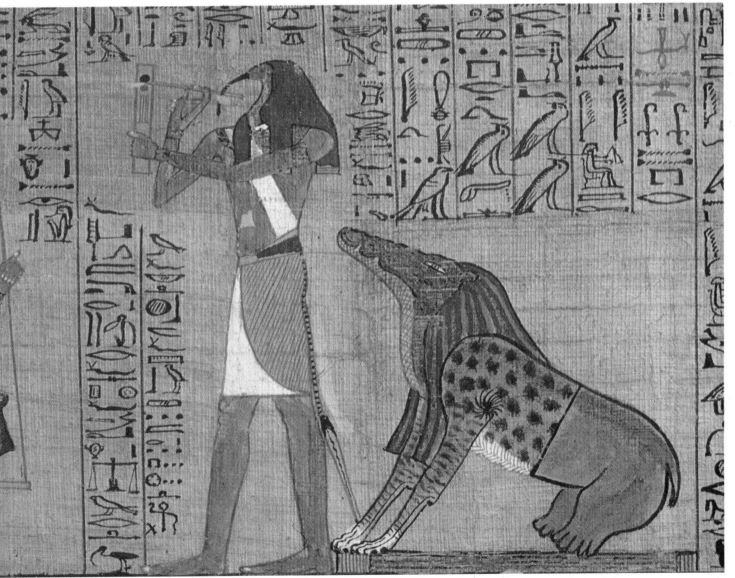

A very old text, the *Cannibal Hymn*, describes the pharaoh chasing and catching the other gods. He cuts their throats, disembowels them, cooks them and eats them—the great ones in the morning, the middling ones in the evening and the little ones at night—thus absorbing their divine qualities and becoming the greatest of gods himself. This 'hymn', like most of the royal funeral ritual, was later taken over by ordinary people. An early text says that the pharaoh becomes the sun god's secretary, but others describe him ruling in paradise with the same splendour which had surrounded him on earth. In still other texts he goes up to join the circumpolar stars, the Indestructible Ones, which know no death because they never set.

Later, it was believed that others, too, could go to join the sun god or reach the stars, if the proper rituals were performed for them. Or they could go to the otherworld of Osiris, of which there were many different accounts. In one version it was a group of islands beyond the western horizon, reached by boat, which enjoyed the beautiful weather of an eternal spring, the crops growing to a great height.

However, the old belief that the dead lived on in their tombs persisted. Offerings of food and drink were brought to them and letters were posted to them. They were provided with furniture, utensils and equipment of all sorts, including lavatories.

In the afterworld, too, life was in many ways an enhanced continuation of life in this one. The dead man is described travelling with the sun god to see pleasant places, exploring valleys with cooling streams, picking flowers and hunting birds; or he is living in a comfortable house with a pool and shade-trees, with his family, concubines and slaves around him. There was work to be done in the afterworld, such as irrigating and tilling the fields. As the dead man might not feel inclined to work, statuettes (called *ushabtis*) of servants and labourers were placed in his tomb to do the work for him. These figures are reminiscent of those found in Chinese tombs of the Shang dynasty and, similarly, superseded the earlier practice of slaughtering living servants. A rich man's *ushabtis* would be made of alabaster or wood and covered with gold-leaf, a poorer man's of cheaper materials such as faience or terracotta. Figures of concubines were sometimes thoughtfully provided. Similarly, paintings inside the tomb showed servants and workmen, who might be given the names of the dead man's own servants. Lively pictures in the tombs showed people farming, harvesting, treading grapes, cooking, feasting, dancing, copulating, playing draughts, hunting, fishing and fighting. In depicting the afterlife which awaited the dead man, they were presumably meant to help revive him.

Ensuring a happy afterlife can be a matter either of ritual or of ethics. One pattern of belief is that all the dead for whom the correct rites are performed will reach safe harbour in the world beyond. The other is that only those who behave well in this world will be rewarded in the next and those who do not will be punished or destroyed. In practice the two attitudes are frequently mixed together, as they were in Egypt. The Egyptians certainly thought that rituals and incantations would ensure survival, but they were also the first people to develop the belief that the dead are judged in the next world and saved or condemned on their merits.

Texts in the pyramids show that, by about 2400 B.C., it was expected that a man might have to defend himself against accusations after

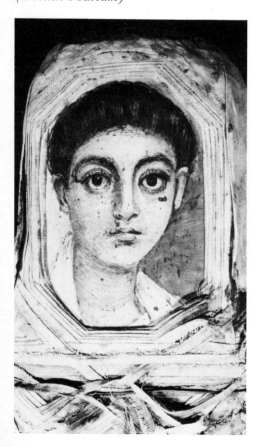

Below: *Like many other peoples, the Egyptians could not conceive of any afterlife worth having without a physical body in which to enjoy it. Mummification, which preserved the body, was one of many religio-magical procedures intended to assure the dead of survival. This mummy of a boy, with a realistic portrait of him, dates from the end of the first century A.D.* (*British Museum*)

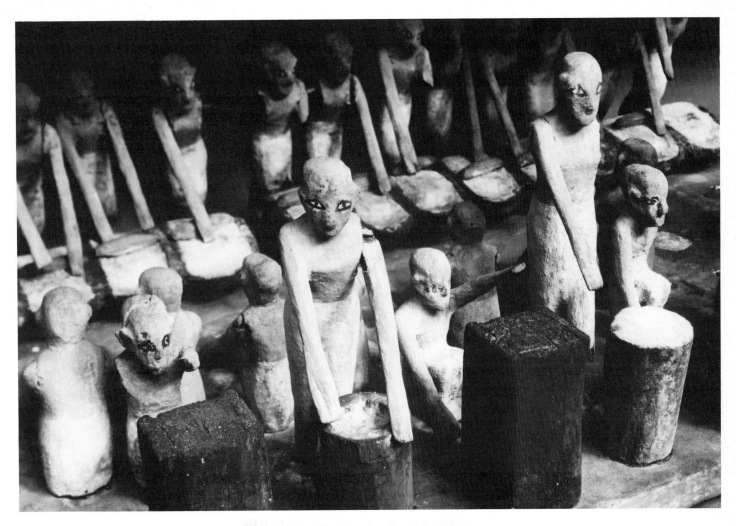

death. One text, attempting to counter this possibility by magic, says that the dead man has no accuser representing a living person, a dead person, a goose or a bull: in other words, no man or beast has reason to complain of him. There are also references to the dead man emerging successfully from an afterworld judgment.

Later, there is evidence of a positive belief that a man's good actions, including helping the poor, would stand to his credit in the judgment. This gave powerful support to Egyptian society's ethical standards. There are also references to weighing the dead man in scales, becoming more elaborate from about 1600 B.C. onwards in the Book of the Dead, a general title for varying collections of texts placed in the tombs to help the dead in the afterworld. The dead man was judged in the Hall of the Two Truths, where his heart, representing his conscience, was weighed against a feather, the symbol of order and truth. To pass the test, his conscience had to weigh the same as the feather, so that he and the correct order of things were in exact equilibrium. If the dead man passed the test he was presented to Osiris and lived happily ever after in the otherworld. What happened to those weighed and found wanting is indicated in pictures showing a monster, part crocodile, part hippo and part lion, called 'the eater of the dead'.

The Book of the Dead also contains long declarations of innocence for the dead man to recite before being judged: he has not caused pain to man or beast, he has not harmed the gods in any way, he has

Above: *The Egyptians thought there would be work to do in the afterworld. Its fields would need irrigating and tilling, like the fields of earth, and trades and crafts would be practised there, as here. To save the dead from having to work in the afterlife, small figures of servants and labourers were placed in tombs, like these wooden models of brewers and bakers from Deir el Bahari. Magic spells were inscribed on the figures, to bring them to life when they were needed. (British Museum)*

not tried to see into the future, he has not committed murder or hired anyone to commit it for him, he has not trampled other people's crops or interfered with their irrigation ditches; he has not tampered with weights and measures or committed sexual offences or caught fish using other fish for bait or put fires out in an incorrect manner or done innumerable other things; 'I am pure', he says emphatically, 'I am pure, I am pure, I am pure'. He then lists all his good actions and repeats that he is pure.

These recitations go on and on in the manner of a lawyer determined to cover every possible eventuality and close every conceivable loophole. They were meant to have an automatic magical effect and in view of their wide scope it is unlikely that the claims they made for the dead were often true. The necessity for making them at all, however, shows that moral values were important in the judgment and the idea of weighing a man in the balance against truth implies that there was a limit to the extent to which magic could help him. An inscription of about 300 B.C. says flatly that genuine innocence is the only passport to the happy afterworld. 'There is no distinction there between the poor and the rich; favour is shown only to him who is found to be without sin, when the balance and the weight are placed in the presence of the Master of Eternity.'[8]

Egyptian beliefs about the afterlife and the judgment were connected with mystery-plays which were acted at centres of the cult of Osiris, believed by ordinary Egyptians to be the saviour from death. Mystery-cults of the Greek and Roman worlds also promised an afterlife of eternal happiness to those initiated into them. The most important ceremonies were kept secret, but initiation was achieved by dramatic rituals. Through them the initiate attained a state of ecstatic excitement in which he felt himself united with a god or a goddess, just as the Egyptians identified themselves with Osiris. After the Emperor Gallienus had been initiated into the mysteries of the goddess Demeter at Eleusis, near Athens, in the third century A.D., he changed his sex on his coinage, naming himself in the feminine as Galliena Augusta.

The mysteries of Eleusis, the most famous in the Ancient World, came under the control of Athens before 600 B.C. and lasted until almost the end of the fourth century A.D. Other important mystery-cults were those of Cybele, Dionysus, Isis and Mithras. There were rituals of purification in all of them, but they do not seem to have put much emphasis on the initiate's morals as a passport to everlasting bliss. At Eleusis the candidates for initiation marched six miles to the sea, each carrying a piglet, and then plunged into the sea and washed themselves and the piglets in the waves, which must have been difficult. In the mysteries of Cybele, and later in those of Mithras as well, there was a ceremony known as the *taurobolium*, in which the

Right: Bacchanal *by Titian,*
sixteenth century. Renaissance painters
were attracted by a theme used
centuries before in pagan Roman tombs.
The orgiastic revel of Bacchus, the god
of sensuous ecstasy and pulsing life, was
depicted to show the paradise which
awaited the soul. (Prado, Madrid)

22

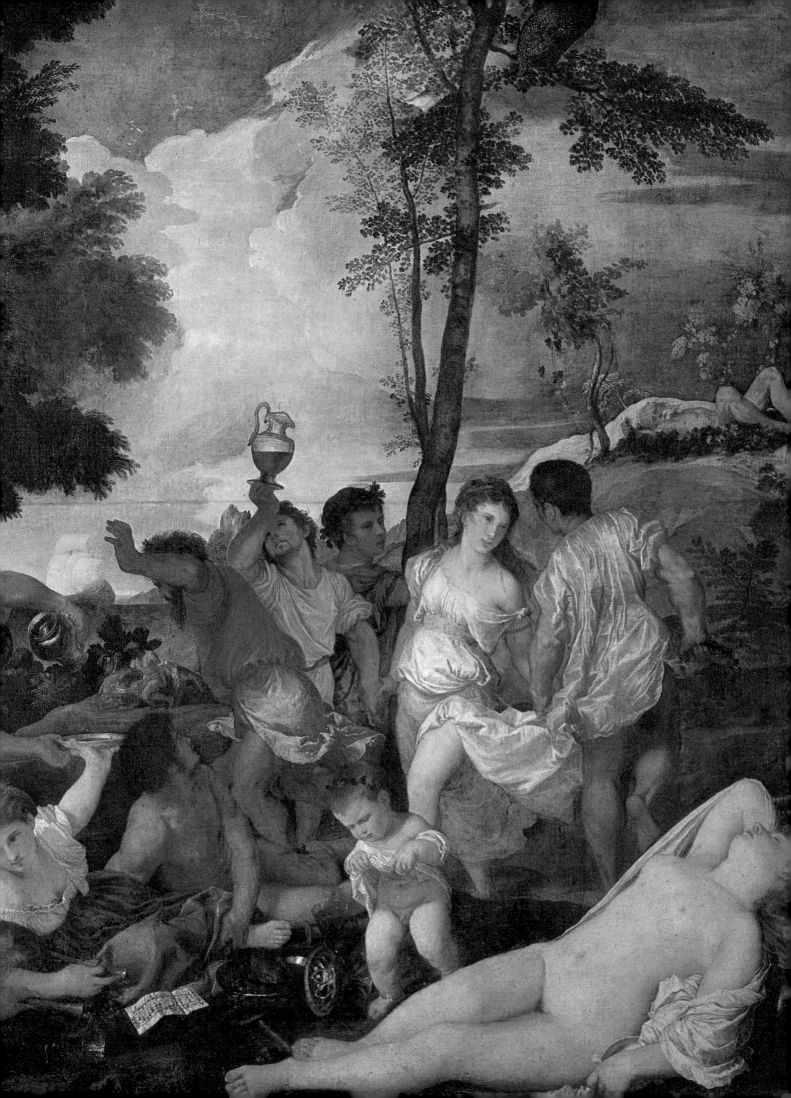

Above: *An angel carries a child safely up to heaven in this nineteenth-century painting. The flowers, like the bouquets and evergreen wreaths which are sent to funerals, represent life renewed after death. The moon, which wanes and dies, but then is reborn and waxes again, has the same symbolic meaning.*

candidate stood in a pit covered by a grill. A bull was led onto the grill, its arteries were cut and its blood poured down over the man underneath. He came out drenched and reeking, his impurities washed away, and proclaimed himself *renatus in aeternum*, 'reborn for eternity'.

Dionysus (known as Bacchus by the Romans), like Odin in Scandinavia, was a god of liberation, and his orgiastic rituals set his followers free from the prison of the normal, conventional self. He was also the god of wine. Drunkenness was an image and a foretaste of the joyful intoxication of freedom which he would grant his initiates after death. Roman sarcophagi of the second and third centuries A.D. show scenes of the triumph of Dionysus. He is portrayed riding in his chariot with an exultant procession of tipsy satyrs, wild animals—panthers, lions, elephants, giraffes—and his women worshippers, the maenads, dancing in ecstasy and playing tambourines and cymbals. This represents the salvation of the soul which joins the god's eternal joyous revelling in the afterlife—a scene which later attracted Renaissance painters.

There is a myth that Bacchus rescued Ariadne, who had been cruelly abandoned by her lover, Theseus, after she had helped him to escape from the Minotaur, the monster of the Cretan labyrinth. The god found her at Naxos, asleep on the shore, and this scene appears on the sarcophagi, where the naked and sleeping Ariadne represents the human soul, rescued by Bacchus from death. One sarcophagus shows Bacchus and Ariadne in chariots, with satyrs, centaurs and maenads. In the centre is a portrait-bust of the dead man, being carried by centaurs to the Bacchic paradise of freedom and delight.

A more restrained account of the blessed afterlife was given by Plutarch, the Greek writer, who described dying and initiation into the mysteries as parallel experiences. 'At first one wanders and wearily hurries to and fro, and journeys with suspicion through the dark as one uninitiated: then come all the terrors before the final initiation, shuddering, trembling, sweating, amazement: then one is struck with a marvellous light, one is received into pure regions and meadows, with voices and dances and the majesty of holy sounds and shapes: among these he who has fulfilled initiation wanders free, and released and bearing his crown joins in the divine communion, and consorts with pure and holy men . . .'[9]

This description sounds not unlike the Christian heaven, but Christian qualifications for entry were quite different. In the early days of Christianity, salvation was gained through an intense emotional experience, the descent of the spirit, in which the believer felt himself united with the divine. There have been sporadic revivals of this 'enthusiastic' type of Christianity ever since. But ecstasy is hard to control and its value difficult to assess. As the early Church found itself dealing with ever increasing numbers of converts, ecstatic experience became suspect and entry into heaven became a matter of correct belief and good morals. In the Christian afterlife each person received what God judged him to deserve.

Christians maintained that God had sent his Son into the world to bring salvation from evil and death, and an afterlife of everlasting happiness to all who believed in him. Christians also thought that those who did not believe in Christ would be consigned to an eternity of torture in hell. The idea of hell was taken directly from the Jewish concept of Gehenna, a place of torment in the afterworld where the

wicked writhed in fire, but the classical underworld also influenced the Christian picture. At first Christ was expected to return at any moment to earth in glory. He would abolish the existing world order and establish the Kingdom of God, in which his faithful followers would receive their reward. 'But our commonwealth is in heaven', St Paul told the Philippians, 'and from it we await a Saviour, the Lord Jesus Christ, who will change our lowly body to be like his glorious body...'[10]

As time went by and the Second Coming did not occur, the question arose of what happened to the faithful who had died before Christ returned in glory. The early Christians had thought that they would not experience death. But when it became clear that many Christians, perhaps generations of them, might have to endure a full span of life on earth and then die, life in this world was seen as a period of preparation for the life in the world to come. The belief that eventually developed was that martyrs and Christians of exceptional goodness went straight to heaven. Unbelievers and Christians of exceptional wickedness went straight to hell. The majority of averagely sinful Christians went to an intermediate state or place called purgatory, where they were painfully cleansed of their sinfulness in order to be fit to enter heaven. (Most Protestants, however, disapproved of purgatory and refused to believe in it.) Babies who died before they had been baptised, but who had not had time to commit any sins, except the 'original sin' of being human, went to limbo, where they were not tortured as they might have been in hell, but neither did they share in the blessings of heaven. There was also a limbo for virtuous pagans who had died before the time of Christ. In folk belief this place tended to be mixed up with fairyland.

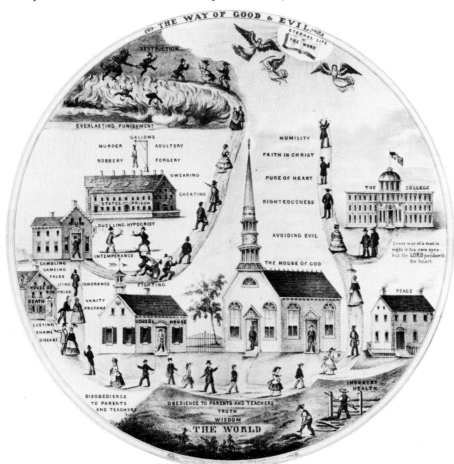

Above: *Two angels sound the last trump at the end of the world in this altarpiece of about 1516, now in Budapest. The dead, their bodies miraculously made new, rise from their graves, ready to be judged and saved or condemned. Paintings of this kind in churches reinforced Christian moral standards by reminding people that they would have to answer for their actions in life. (Museum of Fine Arts, Budapest)*

Left: *Another attempt to encourage good behaviour and discourage sin and crime. This late eighteenth-century American engraving shows how to reach heaven and avoid the path to hell.*

In effect, this meant that each person was judged immediately after death on his merits and sent to the appropriate section of the afterworld. But it was also believed that at the end of time there would be the Last Judgment. The trumpet would sound, Christ would appear in majesty upon the clouds, earth and sea would give up their dead, and all the living and the dead would be judged by their actions in life and sent either to heaven or to hell. The contradictions in these beliefs were never resolved.

The hope of going to heaven was one of the great bastions of the Christian faith until it began to fade away with the rise of scientific explanations of the universe, which seemed to leave little room for God himself, let alone for the traditional picture of a heaven in the sky. Heaven, purgatory and hell, however, also played a social role, or at least they were supposed to, in encouraging good, approved behaviour on earth. Some Christians who doubted whether God in his infinite mercy would condemn any human soul to hell-fire forever, kept their doubts quiet because they believed in hell's effectiveness as a deterrent. So strong was the belief in punishment as a deterrent that the pains of purgatory gradually became almost as agonizing as the torments of hell itself.

Pictures of heaven, the Last Judgment and hell adorned Christian places of worship, both to encourage the faithful and to warn them of what might happen to them if they were not faithful. Mosaics in early Christian churches show Christ triumphant in his glory in heaven, with angels, patriarchs and prophets, the Virgin Mary and the apostles—keeping before the worshippers' eyes the inviting prospect of an afterlife in which they would join the company of the saints and share in the delight of the presence of God. Alternatively, Christ might be shown as the Good Shepherd (which was also a pagan motif) with his faithful flock safely gathered about him in a heaven of trees and flowers. The massive medieval 'dooms', or pictures of the Day of Wrath, show Christ in his double role as saviour of the righteous and implacable judge of the wicked. The theme of weighing in the balance reappears. The Archangel Michael weighs each soul while demons sneak up behind his back to try to tilt the scales the wrong way. The angels and the saved are shown enjoying the peace of heaven above while the damned are racked in savage and ingenious tortures below.

The supreme, indescribable joy of heaven was the presence of God, and the supreme horror of hell was God's absence. In both places, however, more physical pleasures or pains were in store. Christians believed that the afterlife would be lived in a body, a reconstituted version of the one which each person had occupied on earth. *Credo in carnis resurrectionem*, 'I believe in the resurrection of the flesh', is one of the cardinal statements of faith included in the

Left: *The twentieth century has not abandoned the old imagery of death, though it has used a different style. The Four Horsemen of Revelation, with 'Death on a pale horse', bring war and ruin to the earth.* The Riders of the Apocalypse *by Taskovski. (Imperial War Museum, London)*

Apostles' Creed. The belief was sometimes used against Christians by persecutors, as at Lyons in the second century, when the bodies of executed Christians were burned to ashes and thrown into the Rhône in the hope of denying them the resurrection which they preached. Hundreds of years later, advocates of cremation in the nineteenth century had to meet the objection that the cremated would not go to heaven because they would have no bodies for God to raise from the grave at the Last Judgment.

The resurrected body would have all its members and senses, but it would not age and decay. St Thomas Aquinas doubted whether it would possess a sense of smell, but most people believed that the saved would delight in the beautiful scents of heaven, and that an atrocious stench was one of the principal characteristics of hell. It was realized that the bodies of the damned would have to be specially constituted, so as to go on burning forever. It was popularly believed that the saved in heaven would find a never-ending pleasure in radiant light, trees always green and flowers that did not fade, gardens and meadows, streams and fountains, ravishing music, buildings of gold and pavements of jewels. The life of heaven, however, was thought to be far beyond description and accounts of it frequently use a 'negative

Below: *The motif of weighing the soul in the judgment after death presumably came into Christian art from ancient Egypt. In this detail from the medieval Last Judgment at Autun Cathedral angels and demons are weighing souls in the balance. Demons long to get human souls into their clutches and are often shown trying to tip the scales against the dead.*

formula', explaining what does not exist in heaven rather than what does: there is no death in heaven, no sorrow, no hunger or thirst, no ugliness, no quarrels or disagreements, no care and no pain.

In the East extremely complex beliefs about the afterlife developed in Hinduism and Buddhism. In most systems no afterlife worthy of the name is conceivable except in a body of some kind. Hindu philosophers believed, however, that the essential self of each person (the *atman*) is not inextricably bound up with bodily existence and, on the contrary, if the self knew what was good for it, it would abandon bodily existence altogether. But, usually, it insists on clinging to the illusion that life in a body in this world is desirable, and so it can never escape from this world. The self is reincarnated in a succession of bodies, human or animal, higher or lower, depending on its actions in its previous lives. The earliest references to this doctrine of *samsara*, or transmigration of souls, date from about the seventh century B.C. This concept may have influenced Pythagoras and, through him, Western ideas about reincarnation and the soul.

Salvation comes through enlightenment, the knowledge of the truth. On realizing the truth, the self leaves the wheel of rebirth and, in Hinduism, becomes one with Brahman, the only true reality. The

Above left: *Death destroys all Christian values in the* The Disintegration of Faith *by a nineteenth-century Dutch artist. All hope of heaven is lost as bodies are sucked down into the waters of oblivion in a flooded cathedral. The figure on the cross is wounded by bayonets and the waves lap at his legs. (Rijksmuseum, Amsterdam)*

Above right: *This detail from the central panel of the triptych in the Hospital at Beaune by Roger van der Weyden in the fifteenth century shows the Archangel Michael weighing the souls of the dead. Above him is Christ with an olive branch and a sword, symbolizing his dual role as saviour and stern judge.*

parallel state of enlightenment and liberation in Buddhism is called Nirvana, or 'extinguishment'. It is beyond all human ability to describe either of these conditions because they are in no way human. Buddhists have called Nirvana the extinction of personality, the perfect peace, the harbour of refuge, the cool cave, the further shore, the holy city. The negative formula has also been used. There is no earth or water in Nirvana, no fire or wind, no sun or moon, no suffering, no coming or going, no staying or passing away or arising. It is a state of negative bliss. 'There is an unborn, an unbecome, an unmade, an uncomprehended.'[11]

At less rarefied levels, the great majority of Hindus and Buddhists are believed to be tied to the sorrowful weary wheel of successive reincarnations. After death they go to the hall of the ruler of the dead, to be judged according to their good and evil actions in life—the motif of weighing the soul occurs again, from very early on. They are then sent to a heaven or a hell where they are rewarded or punished for a time before being reborn on earth.

In traditional Christian belief there are different layers or divisions of heaven and hell, and, similarly, in the East there are multiple afterworlds. One Buddhist system has eight major hells, each with sixteen lesser hells attached, so that there are 128 lesser hells altogether. There are hells of fire, fumes and smoke, a hell of dung, a hell of hot ashes, a hell of trees with swords for leaves, a hell of dismemberment, a hell of crushing. There are seven principal Hindu hells, the lowest

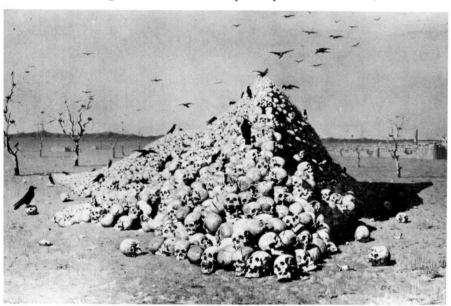

Above: Apotheosis of War *by the Russian painter V. V. Vereschagin, nineteenth century. The artist protests at the futility of war by playing on the very ancient fear of one's body being devoured by carrion birds.*

Right: *A serene and beautiful landscape in the paradise of Shinto, the ancient religion of Japan. (Museum of Oriental Art, Venice)*

and worst of which is a place of darkness and fire, where the wicked are roasted, fried, boiled in oil, pierced with spikes, impaled on thorny trees, flayed and shredded. Their bodies are made specially sensitive to pain, to sharpen their agonies. Some believed that people evil enough to be sent to this hell would be tortured there forever.

There are also many heavens. The Hindu gods have their homes in the paradise of Svarloka, the bright country. It is a land of jewelled palaces, beautiful music, paths of gold, flowers and perfumes, delicious food and enchanting nymphs, the *apsaras*, who are skilled in all sexual arts. The Hindu heavens are grouped round a colossal legendary mountain, Mount Meru, which stands at the centre of the universe, somewhere to the north of the Himalayas.

There are some obvious resemblances between oriental and Christian beliefs. This is especially true of oriental hells, which have been influenced by Christian teaching and art. The differences are more striking than the similarities, however. The Christian goal of achieving the sublime, being in the presence of God in heaven, does not necessitate the loss of personal identity, as the ideal of Nirvana does. Most Christians have not believed in reincarnation and the Christian heaven and hell are not places of temporary occupancy between spells of life on earth. Although it is widely believed that good actions in this world bring better treatment in the next, which encourages civilized behaviour, morality has no bearing on some of the eastern paradises. Hinduism includes among its vast and complex ramifications the practice of *bhakti*, or loving devotion to a personal god. In Vaishnavism, one of the major Hindu sects, the worshippers' goal is eternal life in Vishnu's paradise of Vaikuntha, the place of no hindrance, through which a heavenly Ganges flows past a magnificent city of jewels and gold. Good actions are irrelevant to *bhakti*, however, and may even hinder it, if doing good interferes with the believer's ardent concentration upon the god.

On the whole, however, oriental paradises and hells are of less importance and interest than their counterparts in the West. Their pleasures and tortures are generally similar, but they are usually regarded as merely temporary halts between successive earthly lives. As a result, they are of far less consequence than the Western heaven and hell, which are ultimate and permanent spiritual states, and have not received the same attention from religious teachers, theologians and seekers for salvation. This created a problem for Christian missionaries in the East whose audiences had been brought up in a different tradition, and could easily mistake Christian teaching about the kingdom of heaven as an invitation to a second-class destination.

The more original and significant oriental concepts of the afterlife, if it can properly be called that in this connection, are the life-escaping ideals of Hinduism and Buddhism. Both religions have a long history, during which they have changed and developed, and both contain numerous different sects and doctrines. Broadly speaking, the characteristic Indian approach to the afterlife starts from the conviction that life in this world is not something which is to be prolonged and enhanced in the next, but is sorrowful, painful, impermanent and unsatisfying. Death brings no release from life. On the contrary, after a period in a heaven or a hell, it is followed by rebirth, and this in turn by another death, and so on forever. Salvation means release from this world, from the heavens and hells and from the wheel

Below: *The paradises and hells of Buddhism and Hinduism are of less importance than their counterparts in the West because they are usually not the ultimate and permanent destinations of the dead. They are merely stopping-points in a long journey. In them the soul is rewarded or punished for its actions in its past life, but from them it returns to another life on earth—unless it can free itself altogether from 'the sorrowful weary wheel' of successive reincarnations. Buddha taught that the only worthwhile goal is to achieve total extinction of personality in Nirvana, or 'extinguishment'. This bronze statue of Buddha comes from Nepal and dates from the fourteenth or fifteenth century.*

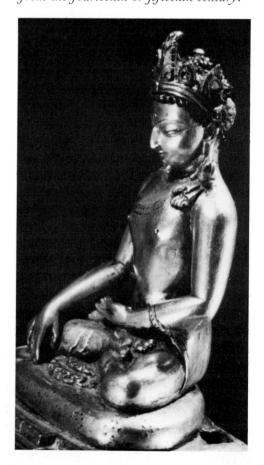

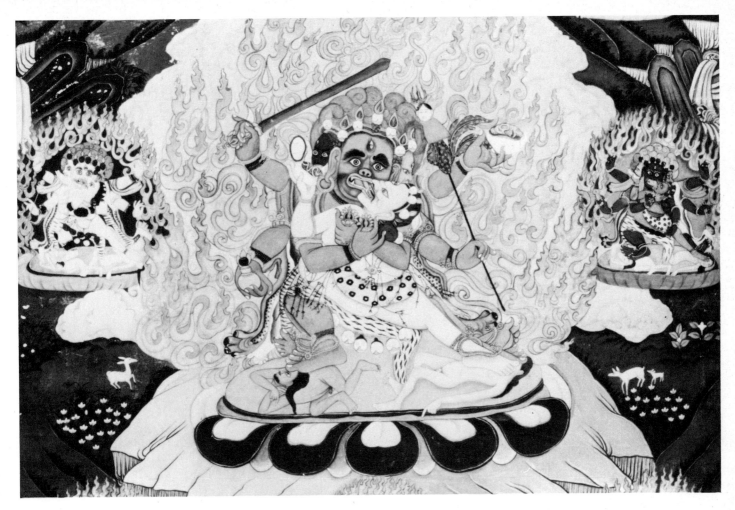

of death and rebirth altogether. The ideal is not the joyful activity and delight in sensuous beauty of the typical western paradise, but the passive serene peace of a state in which one cannot be said either to exist or not to exist.

In the Hindu tradition, which has attracted most attention in the West, there is no such thing as personal immortality. The *atman* or self is of the same nature as Brahman, the impersonal Absolute, and that is its immortality. The *Chandogya Upanishad*, a Sanskrit religious text, says that the whole universe is Brahman, which is also the 'self within the heart' of man, smaller than a grain of rice yet greater than the earth and sky, and into Brahman the self will merge.

Buddhism teaches that the belief in an individual self or soul is merely an illusion, and the longing for personal immortality an obstacle to the highest spiritual attainment. The notion that one exists must finally be abandoned to attain Nirvana. Buddha described the state of Nirvana as tranquil, subtle, beyond the grasp of logic and attainable only by the wise. When he was asked whether a man who enters Nirvana survives or does not survive, he declined to decide. 'The Buddha declared that it was neither right to say he does, nor that he does not, nor that he both does and does not, nor that he neither does nor does not. He compared the case to asking where a fire goes when it goes out. Does the flame go north? The question, being intrinsically absurd, cannot be properly answered.' The *Visuddhimagga* says: 'There is Nirvana: but no person who enters it. The path exists: but one can see no traveller on it.'[12]

Above: *Detail of Tibetan Buddhist painting showing gods of the dead. There are numerous places of torment in Buddhist and Hindu belief. One Buddhist system has eight major hells, each with sixteen minor hells attached to it, where different types of wickedness are punished. The tortures resemble those of the Christian hell and have been influenced by the teaching of Christian missionaries in the East.*

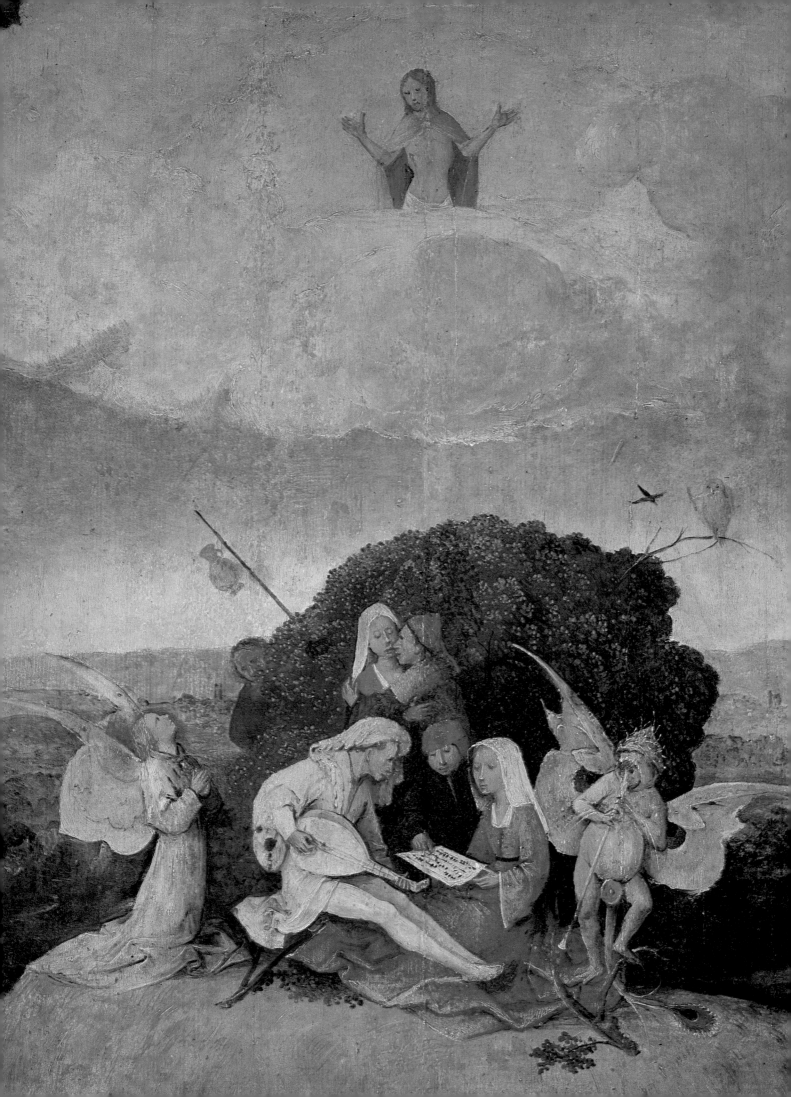

Chapter two
Paradise and Heaven

We know that God is everywhere; but certainly we feel
His presence most when His works are on the grandest
scale spread before us: and it is in the unclouded night-
sky, where His worlds wheel their silent course, that we
read clearest His infinitude, His omnipotence, His
omnipresence . . . Looking up, I, with fear-dimmed eyes,
saw the mighty Milky Way. Remembering what it was—
what countless systems swept space like a soft trace of light
—I felt the might and strength of God. Sure was I of His
efficiency to save what He had made: convinced I grew
that neither earth should perish nor one of the souls it
treasured.

Charlotte Brontë, *Jane Eyre*

Left: Detail from The Haywain *by
Hieronymus Bosch, who lived at the
turn of the fifteenth century. On one side
of the human figures stands an angel and
on the other a demon. They represent
good and evil, and the choice which
human beings must make between them.
On the bush, similarly, the jug of life-
giving water hangs on one side and the
ill-omened owl, a graveyard bird,
perches on the other. Above, Christ
displays the wounds of the Crucifixion,
in which he sacrificed himself to bring
to all men through his death the
possibility of eternal life in heaven.
(Prado, Madrid)*

In popular Christian tradition, God lives in the sky, and heaven is
therefore in the sky. The best-loved of all Christian prayers begins
'Our Father, which art in heaven'. Not that God is confined to the
sky, far from it, but there he is most at home. The same is true in
Judaism and Islam, and many other religions have found their
supreme gods in the sky. In Ancient Greece, Zeus and the Olympians
lived in the heavens on the summit of the highest mountain in Greece.
Before Christianity the cult of the Unconquered Sun was the state
religion of the Roman Empire. The Hindu gods live above the
clouds on Mount Meru, around which the stars revolve.

The powers above are thought to look down from the sky and see
everything that happens in the world. From the sky comes light,
warmth and rain which nourishes all life on earth, and also the
lightning and thunder of divine power and fury. The God of the Old
Testament, Zeus and Jupiter, Thor and Indra were all wielders of
thunder. In the temple of Jupiter Feretrius in Rome the supreme god
was embodied not in a statue but in a stone (presumably a meteorite),
believed to have fallen from the sky. Things on earth are chaotic,
temporary and unpredictable, but in the sky where the stars wheel in
their courses there is order and permanence. There is no death in the
heavens, or rather there is a triumphant conquest of death in every
reappearance of the sun, moon and stars. So it has been natural to
think that in the sky, if it could be reached, man would find immor-
tality, order, harmony, beauty and the presence of the divine.

'Heaven' is one of the titles of God in the Old Testament and the
star-spangled sky is his mantle. He holds his court in heaven with the

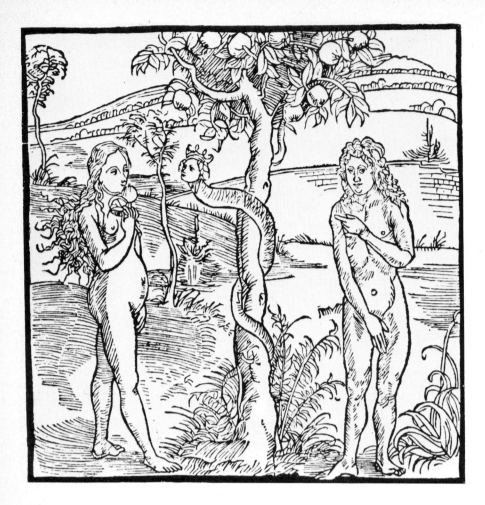

Christianity inherited the Jewish myth of Adam and Eve, the first human beings, for whom God made the garden of Eden, a paradise on earth where there was no evil and no death. Adam and Eve lived in the garden in an innocent happiness, close to God. Tempted by the serpent, they disobeyed God and were punished by being expelled from Eden. The beautiful garden with its fruitful trees and river or fountain of life became part of the popular picture of the happy afterworld.

Left: The temptation in Eden, by Albrecht Dürer, sixteenth century.

Below: Adam and Eve are expelled from Eden by an angel with a sword; fourteenth-century German stained glass panel in St Etienne, Mulhouse, France.

stars and the angels gathered about him. The sky is his throne and the earth is his footstool. The heavens declare his glory and he rides through them in splendour.

> When I look at thy heavens, the work of thy fingers,
> the moon and the stars which thou hast established;
> what is man that thou art mindful of him.[1]

When Solomon built the Temple at Jerusalem as the home of God and came to dedicate it, he said: 'But will God indeed dwell on the earth? Behold, heaven and the highest heaven cannot contain thee; how much less this house which I have built!'[2]

By the time of Jesus, many Jews believed that there were seven heavens or seven divisions of heaven (some said there were three), and that God had his throne in the highest of them. There was also a belief by this time, though not everyone shared it, that after death faithful servants of God would achieve everlasting happiness in heaven or in one of its divisions. The Christian Church made this hope its central promise and also adopted the classical picture of the universe, derived from Greek philosophers, as a set of concentric spheres, rising higher and higher in purity and light. In the medieval conception there were nine spheres or heavens: one for the sun, one for the moon, one for each of the five planets then known, one for the fixed stars, and one on the outer perimeter for God himself as Prime Mover and First Cause. Some added a tenth sphere for the earth, or some thought that beyond the sphere of God as Prime Mover was the

Empyrean, the highest heaven of all, composed of pure light or fire and the ultimate dwelling-place of the divine. But despite its divisions or layers, heaven was also thought of as essentially one place or state and the final goal was to live there in eternal blessedness with God.

Western concepts of heaven, however, were influenced by the old and persistent tradition of an ideal place or condition not in the sky but somewhere on earth, to which the fortunate, the initiated or the good would go after death. The most important single source of this tradition was the story of Adam and Eve in Genesis. 'And the Lord God planted a garden in Eden in the east; and there he put the man whom he had formed. And out of the ground the Lord God made to grow every tree that is pleasant to the sight and good for food, the tree of life also in the midst of the garden, and the tree of the knowledge of good and evil. A river flowed out of Eden to water the garden, and there it divided and became four rivers . . . The Lord God took the man and put him in the garden of Eden to till it and keep it. And the Lord God commanded the man, saying, "You may freely eat of every tree of the garden; but of the tree of the knowledge of good and evil you shall not eat, for in the day that you eat of it you shall die."'[3]

The tale of Adam and Eve and the forbidden fruit was probably written down about 950 B.C. The concept of a perfect place of beauty and happiness on earth has Mesopotamian parallels, and in Genesis two of the rivers that flow from the garden are the Tigris and the Euphrates. This suggests that it was believed to be somewhere to the north of Babylonia, probably in the mountains of Armenia, where Noah's Ark came to rest after the Flood.

Eden combines the theme of the ideal place with that of a golden age long ago, when the first human beings knew a happiness and innocence that the world has lost. Adam and Eve lived in the garden close to God and in a simplicity that seems to be a nostalgic reminiscence of a primitive gathering economy, before the development of agriculture. Although Adam is put in Eden 'to till it and keep it', the story implies that his work was easy and pleasant, for when God expels Adam and Eve from the garden for eating the forbidden fruit, Adam is condemned to hard agricultural labour, to which he had evidently been a stranger before. The subordination of woman to man, the pain of childbirth, the wearing of clothes and the association of shame with sex were also unknown before Adam and Eve disobeyed God. Death was also unknown and there was no killing before the Fall, or so the story was later taken to imply. Adam and Eve were vegetarians and all the animals lived peaceably with them in the garden and did not prey on each other.

There are several references in the Old Testament to Eden as God's garden, its fertility contrasted with the barrenness of the desert.[4] Ezekiel refers to the cedars, fir-trees and plane-trees in the garden of God. In Genesis God walks in his garden in the cool of the evening and Jewish folk belief pictured him resting in the shade of the tree of life. The beautiful trees, fruitful and shady, the tree of life and the river or fountain of life became part of the popular picture of the happy afterworld.

When the Old Testament was translated into Greek in the third century B.C., 'the garden of Eden' was translated as *paradeisos tes truphes*, 'paradise of delight'. *Paradeisos* comes from Old Persian

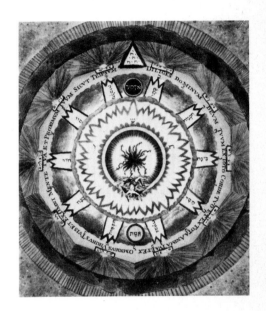

The earthly paradise, from which Adam and Eve were expelled, combines the theme of a golden age of perfection in the past with the longing for an ideal place, free of death and all the sorrows and troubles of life, where human beings could live in idyllic harmony with each other and with the whole world of nature.

Above: *The Anima Mundi, or Soul of the World, from* Key to Physick *by Ebenezer Sibley, an English occultist of the late eighteenth century. Nature is shown ruling, loving and fashioning all things in perfect harmony.*

Overleaf: The Earthly Paradise *by Jan Brueghel, seventeenth century, is an inspiring vision of the ideal harmony of nature, teeming with life in all its richness, but in the background, ominously, Eve is offering Adam the forbidden fruit. (Galleria Doria, Rome)*

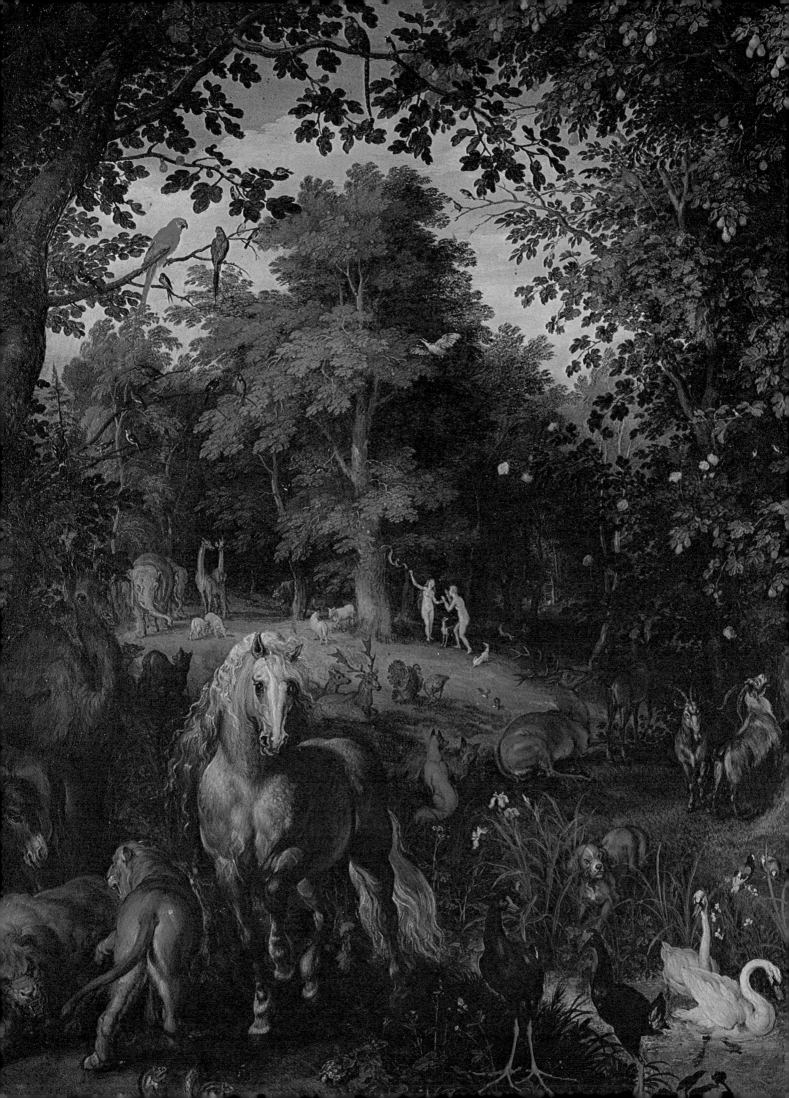

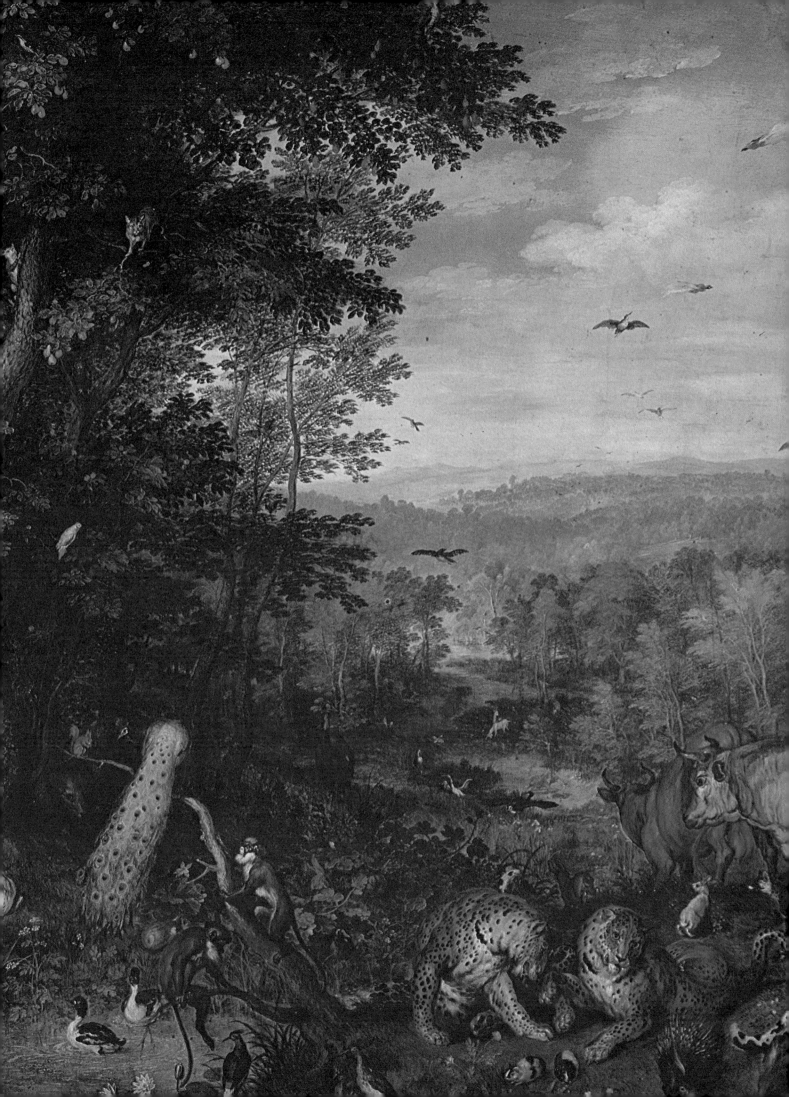

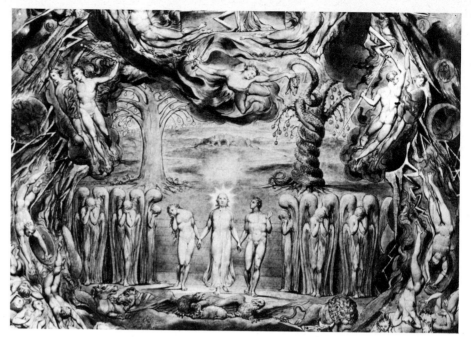

In Eden grew the tree of life, which conferred immortality, and the tree of the knowledge of good and evil, on which hung the forbidden fruit, which was traditionally represented as an apple.

Right: The two trees are shown in this detail from William Blake's Fall of Man, *with the serpent coiled round the tree of knowledge. (Victoria & Albert Museum, London)*

Below: The tree of life was symbolically connected with Christ's family tree, the tree of Jesse, seen here in a detail from a sixteenth-century stained glass window in Autun Cathedral. Christ was 'the second Adam', who brought back to man the hope of immortality which Adam had forfeited.

pairidaeza, 'enclosure', which passed into Hebrew, Aramaic and Greek as a term for a luxurious enclosed park or hunting ground of the type which Persian kings laid out on their estates. A paradise or a garden is an enclave of contented leisure, beauty, freedom and security, separated from the surrounding countryside. It is a place in which wild nature has been tamed and so it can be seen as a symbol of the soul's conquest of its environment and an image of the refuge which awaits it after death, remote from the clamour and ugliness of life in this world.

The old religion of Israel consigned the dead (with rare exceptions) to a gloomy underworld like the Mesopotamian land of no return or the Greek Hades, but in the later centuries before Christ a belief in a better future for the faithful emerged. They would be resurrected, either immediately after death or on the Day of God in the future, when the Almighty would establish his Kingdom. There was no one dominant doctrine about the afterlife. Different ideas flourished side by side, as they still do in Judaism. One was that when God brought the existing world-order to an end, he would restore the golden age of the first days of creation and Gan Eden, 'the garden of Eden', would be the eternal home of his faithful worshippers. Alternatively, paradise was the place where the righteous dead lived happily while waiting for the Day of God. Gan Eden was frequently located in the sky, in one of the seven heavens, and the Eden of Adam and Eve was said to have been an earthly copy of the true celestial paradise.

Conservative Jews did not accept these ideas, but they influenced Jesus and his followers. Jesus told the penitent thief, 'Truly, I say to you, today you will be with me in Paradise.'[5] St Paul had a visionary experience in which—'whether in the body or out of the body I do not know, God knows'—he was 'caught up into Paradise' in the third heaven and 'heard things that cannot be told, which man may not utter'.[6] The book of Revelation promises that Christian martyrs will 'eat of the tree of life, which is in the paradise of God'.[7]

In subsequent Christian belief paradise was frequently a synonym for heaven. Alternatively it was a separate place where the souls of

good Christians and the righteous men of the Old Testament spent the time between death and the Last Judgment. In the Apocalypse of Peter, an apocryphal Christian work of the early second century, St Peter is shown the place where the faithful departed wait for the Second Coming. It is a region outside this world, radiant with light and rich in fruit and spices, and flowers that never fade. The dead wear shining clothes, there are shining angels with them, they are all equal in glory and they all rejoice and praise God. This description is strongly influenced by the scene of the Transfiguration in the New Testament, in which the disciples saw Jesus shining with light on the mountain with Moses and Elijah—both of whom were believed to have been spared death and caught up bodily to heaven.

Although St Paul had firmly informed the Corinthians that what he had learned in his vision of paradise could not and should not be told, the belief developed that he had written an account of it which had been found, after his death, in a marble chest buried in the foundations of his house in Tarsus. Varying versions of this supposed Vision of Paul influenced Christian beliefs for centuries afterwards. According to an early one, an angel showed Paul paradise, which was

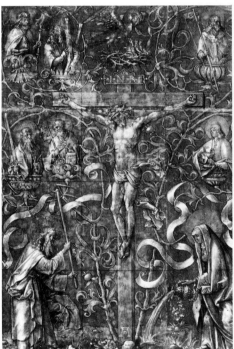

Below: *Christ crucified on the tree of life, by Dürer. The tree is blossoming and bearing fruit, to show that through Christ's death man could attain eternal life in heaven, that his sacrifice had cancelled out the sentence of death passed on all nature because of the crime in Eden. The tree is nourished by the Virgin Mary, who is seen watering it. At the top is 'the pelican in her piety', feeding her brood on her own blood, another symbol of Christ's life-bringing sacrifice. (Museum of Fine Arts, Rennes)*

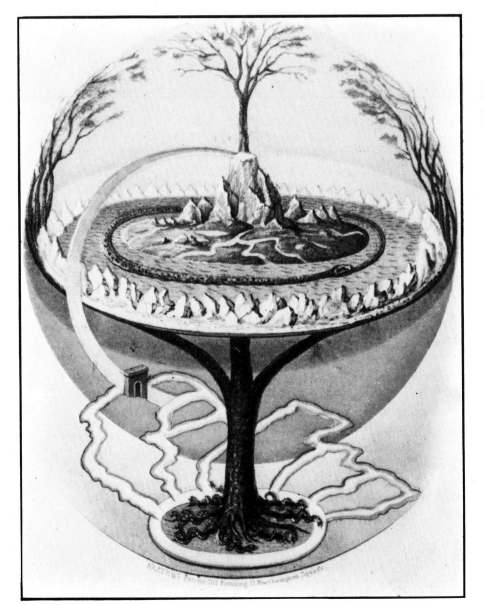

Left: *The symbol of nature as a great tree, whose spreading branches support and sustain all life in the world, is not confined to the Judaeo-Christian tradition: Yggdrasil, the world-tree of Norse mythology.*

the garden of Eden with the tree of life and the four rivers. There he saw the Virgin Mary, escorted by 200 angels, and the patriarchs and prophets of the Old Testament with their angels. Paul was then shown a different section of the afterworld, 'the land of promise of the saints' where, as predicted in Revelation, Christ will reign with the saints for a thousand years before the final establishment of the Kingdom. This land of promise was the future equivalent of the promised land of Canaan in the past—the land flowing with milk and honey to which God had led the Israelites after their escape from slavery in Egypt. In the Vision of Paul there is a river of milk and honey, with fruit-trees along its banks which bear a different fruit every month. There are colossal palm-trees, each of which has ten thousand branches and on each branch are ten thousand clusters and in each cluster are ten thousand dates; and there are equally superabundant vines, bearing myriads of grapes. This idea goes back to a remark attributed to Jesus, quoted by St Irenaeus in the second century, which also says that the wheat in the land of promise will grow with ten thousand ears per stalk and the bunches of grapes will speak to the saints and beg to be eaten.

Although paradise was translated into the sky or 'a region outside this world', many people in the Middle Ages thought that the original garden of Eden was still in existence on earth, somewhere just beyond the bounds of known geography. Some writers placed it near the domains of Prester John, the legendary ruler of an empire of vast wealth and extraordinary marvels in the East or Africa, a utopian country where poverty, crime, lies and differences of opinion were unknown. When Columbus sailed across the Atlantic to reach the East and discovered the Americas, he thought he must be close to Eden. Sir Walter Raleigh, travelling up the Orinoco River in 1595 through beautiful country, with birds singing sweetly in the trees, believed for a moment that he had found the earthly paradise.

In the East itself, paradises are depicted in many of the mandalas. Mandala means 'circle', though they are not always circular. It is a symbol of the universe and is used by Buddhists and Hindus in meditation. The Buddha may be shown at the centre of the mandala, surrounded by other great spiritual beings to whom are allotted the appropriate paradises, directions and colours. In one system, for instance, the eastern paradise is white, the southern is yellow, the western is red and the northern is green. The mandala is a diagram of spiritual progress. Begining at the circumference and passing through three outer circles which signify purification, initiation and spiritual rebirth, one of the paradises is gained, and finally Nirvana at the centre.

The western paradise became the spiritual goal of certain sects within Mahayana Buddhism (the dominant form of Buddhism in

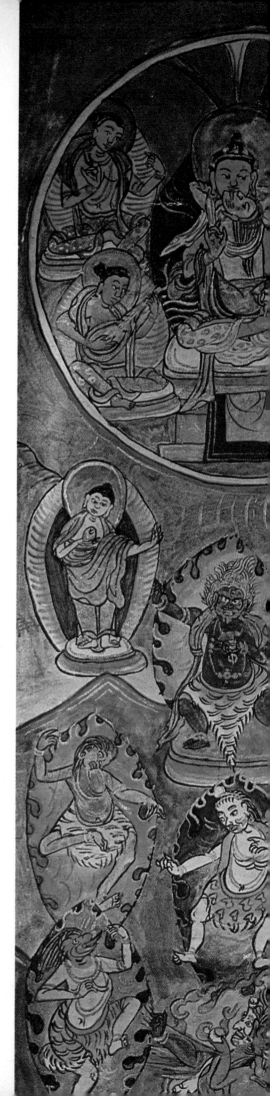

Right: *Some Buddhist sects in Tibet, China and Japan thought that the true believer could attain a paradise from which he need never be reborn on earth. Buddhist divine beings in paradise, Tibetan, seventeenth or eighteenth century. (Victoria & Albert Museum, London)*

42

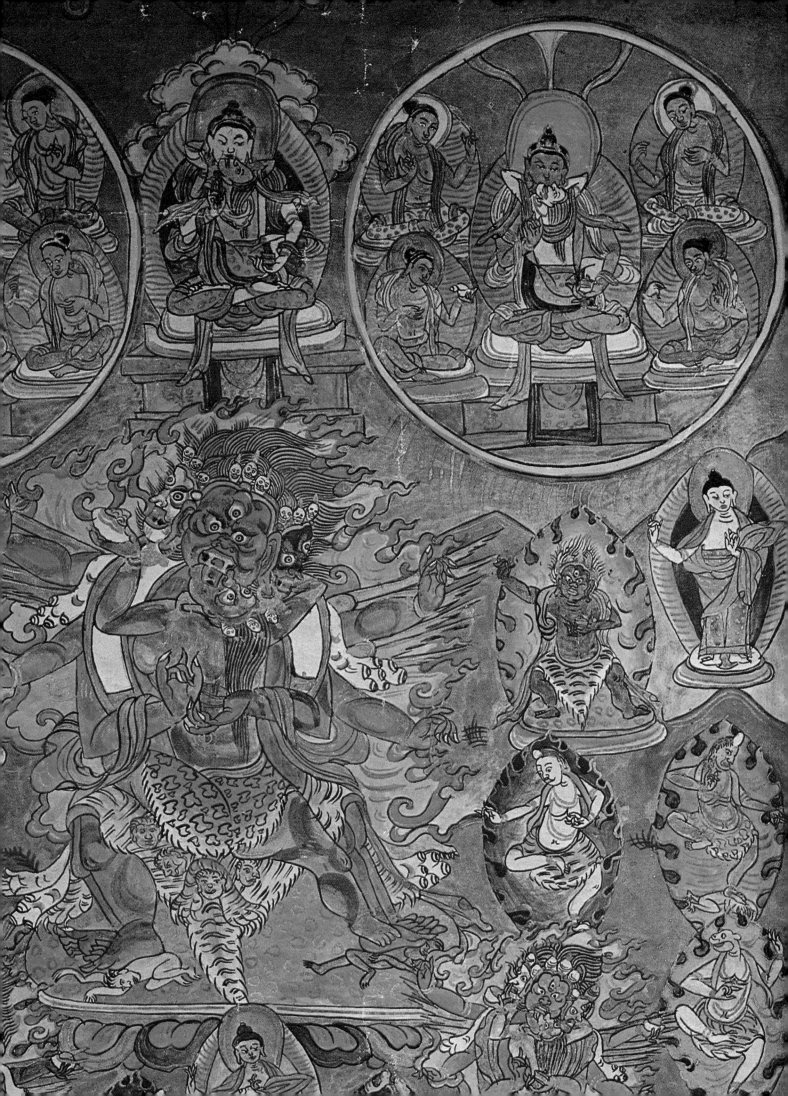

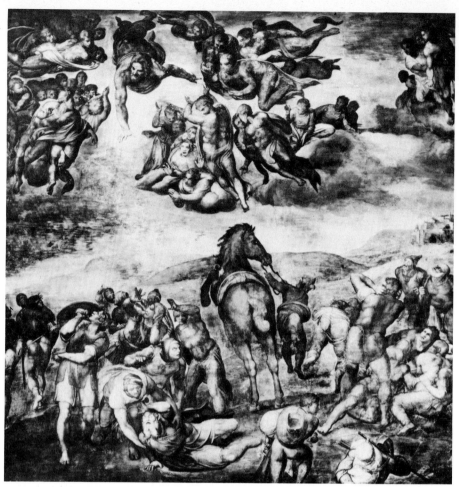

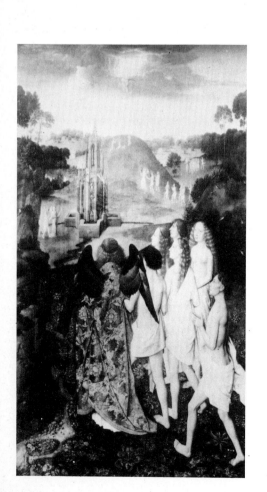

Tibet, China and Japan). It is called Sukhavati, the blessed land or pure land, and belongs to the Buddha Amitabha, whose name means 'boundless light'. The worshipper who gains Sukhavati escapes from life on earth and is never reborn. Entry to Sukhavati is not a matter of good actions but of confident faith in Amitabha's saving power and surrender to him. A Pure Land sect emerged in Chinese Buddhism around A.D. 500, and in Japan the sect of the Jodo-shu was founded in the twelfth century to seek salvation through prayer to the Buddha Amida, or Amitabha. According to the *Sukhavativyuha* (the fundamental scripture of the Pure Land faith), the Pure Land is fertile, prosperous and crowded with gods and men. It has flowers, fruits, fragrant scents and flocks of birds with sweet voices. There are no mountains there but a great plain, through which streams and rivers run, some as much as fifty miles wide, flowing over golden sands and emitting delicious odours and beautiful music. 'And the sound which issues from these great rivers is as pleasant as that of a musical instrument . . . which, skilfully played, emits a heavenly music. It is deep, commanding, distinct, clear, pleasant to the ear, touching the heart, delightful, sweet, pleasant, and one never tires of hearing it, it always agrees with one and one likes to hear it . . .'[8]

The temperature of the water in the rivers varies to suit each inhabitant's preference at any particular moment. Their banks are lined with scented jewel-trees in hundreds of thousands of shades of colour, made of gold, silver, beryl, crystal, coral, red pearls and emeralds. There are banana-trees, palm-trees and multitudes of

lotus-flowers made of precious stones. There are no jewels on earth to match the gems of Sukhavati. This paradise is not necessarily the final home of the soul. It can be a stepping-stone to higher things. Everyone in it hears the sounds he wishes to hear, and these sounds can include teachings of detachment, dispassion, calm and cessation, which lead to the final enlightenment and the ultimate negation of self in Nirvana.

The Apocalypse of Peter identifies the Christian home of the righteous with the Elysian Fields, a Greek paradise which is mentioned in Homer's *Odyssey*. It is a place far away on the edge of the world, where life is easy, where there are no storms, no rain and no snow, and the west wind blows gently every day. Elysion or Elysium seems to be a pre-Greek notion, taken over by the Greeks from the earlier Aegean civilization dominated by Crete. In Homer the normal fate of human beings, robbed of their bodies by death, is to flit sadly about as phantoms in the underworld. But, in the *Odyssey*, Menelaus, King of Sparta, is to escape this fate because he is the son-in-law of Zeus, the king of the gods. Instead of dying, he will be bodily translated to the Elysian Plain. The Eleusinian mysteries, however, restored the Elysian Fields to what had probably been their original function as the paradise to which the initiated went at death.

The Elysian Fields were also called the Isles of the Blessed or the Fortunate Isles, far across the sea. Blended into this tradition, as into Eden, was the idea of a golden age in the past, free of the troubles to which flesh is now heir and, in particular, free of the evil of work. Hesiod, the Greek poet, says in his *Works and Days*, written in about 700 B.C., that it is the Olympian gods who have sentenced man to a life of hard labour. Otherwise anyone could easily do enough work in a day to supply himself for a year. But the first race of men to live on the earth long ago, the golden race, did not have to work; nature provided everything they needed and they lived in peace and ease. They spent their time cheerfully feasting, and when death came to them it was no more frightening than sleep. This was before the rise to power of Zeus and the Olympians, in the days of the old gods, Cronus and the Titans, who were overthrown by Zeus. Cronus was traditionally associated with pleasurable idleness, and with social equality. His festivals were held in the slack season of the agricultural year, between harvest and ploughing, and masters and men sat down to feast together as equals. The life of Hesiod's golden race seems to be another rose-coloured reminiscence of a prehistoric gathering economy.

The golden race, Hesiod says, was succeeded by a silver race and a bronze race, and then by a fourth race of men, the godlike heroes who lived at the time of the Trojan War. Many of the heroes died, but Zeus spared some of them from death and sent them to the Isles of the Blessed at the ends of the earth. There they live happily, ruled by Cronus, with the ground bearing plentiful harvests for them three times a year.

In the fifth century B.C. Pindar described the Isles of the Blessed, governed by Cronus, as swept by ocean breezes, filled with beautiful trees and golden flowers, cornfields and meadows studded with roses and shaded by trees exuding fragrant balsam. It is a paradise of the Greek aristocratic ideal, where there is no work and the fortunate inhabitants, garlanded with flowers, spend their time playing strenuous

Below: In both Jewish and Christian belief the garden of Eden was translated into the sky and became the paradise where the souls of the righteous awaited the end of the world and the coming of the kingdom of God. The classical myth of the Elysian Fields, where life is easy and the sun always shines, also influenced Christian beliefs about paradise. This medieval illustration shows the green trees and animals of paradise, where nature is benign and harmonious.

Above: It was long believed that Eden still existed, somewhere on earth. The description of Eden in the Bible suggests that it was thought to be to the north of Babylonia. This late seventeenth-century map, however, places it much nearer to the Persian Gulf, south of Babylon.

45

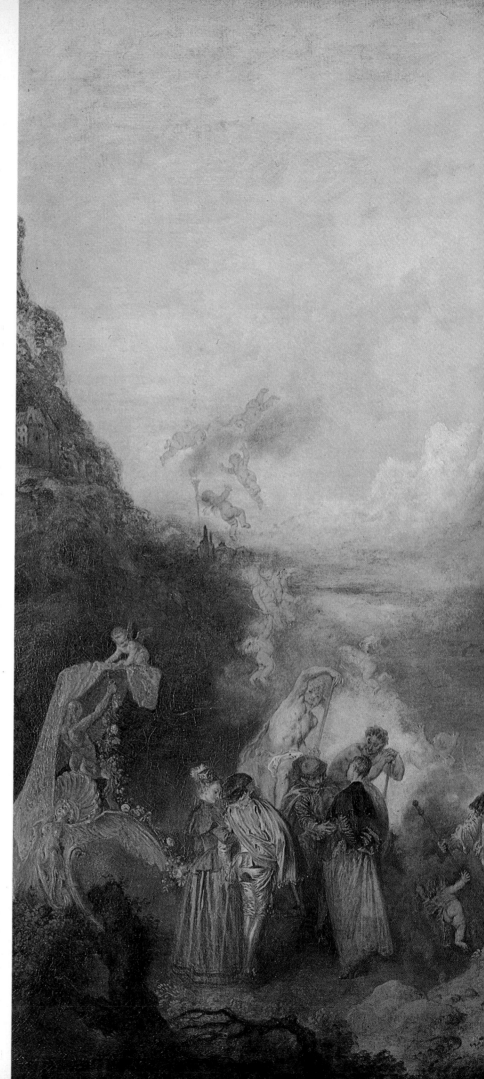

Right: L'Embarquement pour Cythère *by Watteau, early eighteenth century. Cythera was the island of Venus, and this is another vision of an erotic paradise, a place of perfect natural harmony and love. (Louvre, Paris)*

Above: *The paradise of the Hindu god Shiva, believed to lie on Mount Kailasa in Tibet, where the god and his consort, the beautiful Parvati, experience eternal sexual union—detail of Rajput painting of the eighteenth century. (Victoria & Albert Museum, London)*

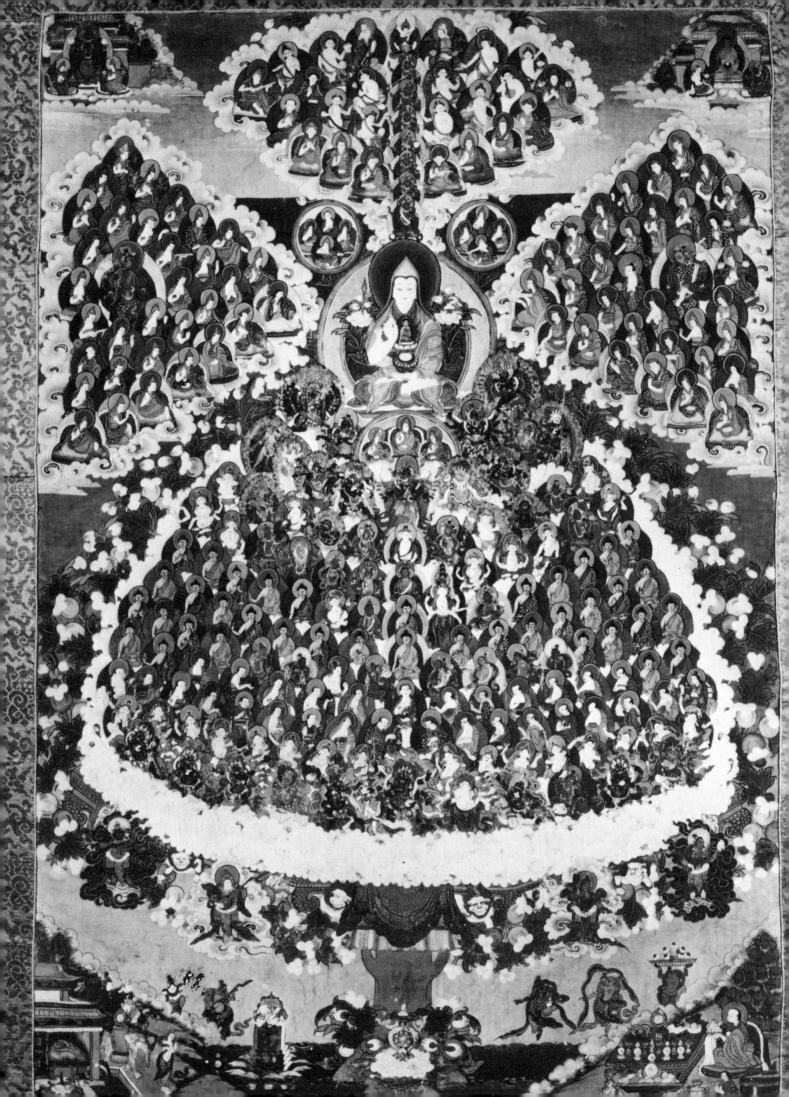

games, riding, playing draughts or making music on the lyre, while a sweet smell wafts over them from the incense burned on the altars of the gods. Entry to it, according to Pindar, who believed in reincarnation, is reserved for those who have led three successive lives of purity on earth. In the first century B.C., Horace lamented the civil wars in Rome and an approaching age of barbarism, and wistfully suggested sailing away to the west, to the Fortunate Isles set aside by Jupiter for the pious. The corn grows by itself there, the fig needs no grafting, vines are always in flower and olives in shoot, honey drips from the oaks and water splashes down the mountain-sides. The cows and goats do not need tending, the climate is perfect, and the place is totally untouched by the ungentlemanly fingers of trade and commerce.

The Elysian Fields or Isles of the Blessed were sometimes located on the earth's surface, sometimes in the sky and sometimes underground as a separate division of the land of the dead in the underworld. The appearance on some Roman sarcophagi of dolphins, sea-monsters, sea-nymphs and Tritons, and of curving lines possibly representing waves, suggest a belief in the journey to an afterworld across the sea.

Lucian of Samosata, a travelling lecturer and humorist of the second century A.D., wrote a satire on the more fanciful speculations of his time under the sardonic title of *The True History*. (It influenced both Sir Thomas More's *Utopia* and Swift's *Gulliver's Travels*.) It is the story of a voyage far out into the Atlantic and up into the sky, with visits to fantastic islands, the moon and the planet Venus. The travellers are swallowed up, ship and all, by a whale; they see giants three hundred feet high using islands as boats; they come to a sea of milk and an island of cheese, and eventually reach the Isle of the Blessed itself.

The sharp edge of Lucian's sarcasm softens noticeably when he comes to describe this idyllic island, though medieval Christian authors were enraged by what they considered to be a blasphemous parody of their own ideas. The idyllic island is shown as a place of clear streams, flowery meadows and beautiful woods, with birds singing in the trees and a westerly breeze rustling the branches. The grapes ripen every month and the trees yield crops of pomegranates, apples and other fruit thirteen times a year. A city of gold and jewels, paved with ivory, is encircled by a river of perfume. Nobody grows older on the island, it is always spring and there is no day or night but only a soft perpetual twilight: there is no time there. In the middle of a wood is the meadow of the Elysian Fields, where there is a delightful permanent party in progress. The guests drink from two springs, one of laughter and one of pleasure. Then they loll on beds of flowers while nightingales rain petals down on them, scent falls from the sky like dew, and the surrounding trees magically supply glasses of wine. Free love, heterosexual and homosexual, is also in ample supply on the island, and love-making is conducted in public.

There are many resemblances between Greek and Roman notions, of the kind caricatured by Lucian, and the enchanted and enchanting otherworlds of the Celts. Both sets of ideas may come from the same source in eastern Mediterranean tradition and both influenced Christian pictures of the afterlife. Both involve voyages to mysterious islands in the west, where there is no death, no time, no ageing, no

Left: *Tibetan painting showing Tsongkapa, the great sage and spiritual teacher who founded the Gelugpa sect in the early fifteenth century. He is surrounded by divine beings and, interestingly, the painting resembles Christian depictions of the saints in heaven. (Victoria & Albert Museum, London)*

Above: *In the enchanted otherworlds of the Celts magic cauldrons and other vessels supplied the food and drink which kept the inhabitants eternally young. The scene on the Gundestrup cauldron, found in Denmark and dated to the sixth century B.C., may be related to this belief. It shows a god plunging a human figure into a cauldron or vat, and there are traces in Celtic legends of magic vessels in which the dead were brought back to life in this way. (Danish National Museum)*

disease, no work, no private property, no buying and selling, and which have a perfect climate, fertility on a grand scale and great natural beauty.

There were old Celtic traditions of sacred islands off the coasts of Britain, Ireland and Brittany. People of mysterious sanctity lived on these islands and were regarded with awed respect. In the first century B.C., the philosopher Posidonius reported that a religious community of women lived on an island off the mouth of the Loire. No men were allowed on the island. Once a year the women put a new roof on the temple of their god. The work had to be completed in one day and if one of the women accidentally dropped any of the roofing material, the others promptly tore her to pieces.

According to Pomponius Mela in the first century A.D., nine virgin priestesses, who lived on the Île de Sein, off the Breton coast, were believed to have magical powers. Plutarch reported a story that the god Cronus and his court slept on an island which was five days' sail from Britain. Enchanted islands with uncanny occupants are the central feature of later Celtic otherworld stories and they often include an island of women.

The Celtic otherworld was not always supposed to be the home of the dead. It was frequently inhabited by a fairy people, happy and beautiful and eternally young, though the dead and the fairies tended to be mingled together. It was often over the sea to the west, but it could also be at the bottom of the sea, or inside a hill or a burial mound, or just round the next corner. Most people would never see it in this life, but occasionally through heroism or luck or a powerful longing a living person might visit it, and some even came back to tell the tale of it, though it was not an easy place to escape from. In Irish stories it is called the Delightful Plain (Mag Mell), the Great Plain, the Shining Land or the Land of the Young (Tir na nOc); or it is the Land of the Living, because its inhabitants are really alive while we in our world are really dead; sometimes it is called the Land of Promise (Tir Tairngiri), adopted from the Christian land of promise of the saints. It is ruled by Manannan, or Manawydan in Welsh, god of the sea, of magic and rebirth. 'It is a land where there is naught but truth; without death or decay, or sadness, or envy, or jealousy, or hate, or gloom, or pride, a land of plenty, of flocks and herds, of the ever-young, of flowers and fruit.'[9]

When the Celtic paradise is the home of the dead, there is no suggestion of judgment and punishment. The dead do not carry their crimes and guilt with them into the afterworld. Their amusements are those of the Celtic aristocracy (with the notable exception of fighting), feasting, love-making, music and song, games and sports, chariot races and boat races. Enjoyment never grows stale there and to wish for a thing is to have it, but the desires of its inhabitants never conflict. Delicious food and satisfyingly intoxicating drink are supplied from magic cauldrons, the trees are always in fruit and the flowers in blossom. There are wells and springs, streams, rivers and lakes in this paradise as well as beautiful birds of magnificent plumage, whose singing lulls one to sleep. There are otherworld cows, white with red ears, and superb otherworld horses, some of which are sky-blue. In one Irish story a golden otherworld horse is seen, galloping over the sea: 'two fierce flashing eyes he had, an exquisite pure crimson mane, with four green legs and a long tail that floated in wavy curls'.[10]

Right: *Angels in Jewish, Christian and Muslim belief are spiritual beings who live in heaven with God. They form God's court and are sent on missions to the earth. They are closely linked with the stars, hence their radiant beauty, and in art they almost invariably have wings. The angel in Gustave Moreau's* Angel Traveller *is perched on a cathedral high above a city, of which he seems to be the benevolent guardian. This is a typically romantic recreation of medieval symbolism by Moreau, a French painter who died in 1898. (Gustave Moreau Museum, Paris)*

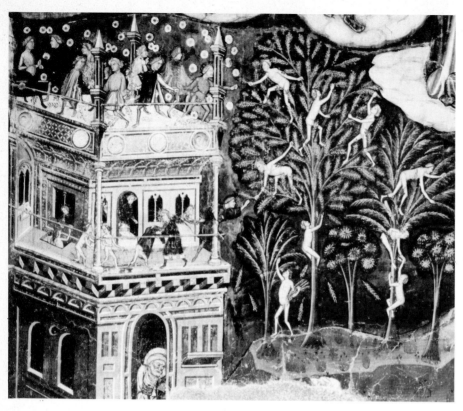

When Christianity reached western Europe, the old tradition of uncanny island-dwellers continued. Saintly hermits lived alone or in small communities on islands and in isolated places. Holy men sailed out to sea in coracles or currachs in search of remote islands where in solitude they could come close to God. There is a parallel here with Eden, the garden or enclave shut away from the bustle and evil of the world—indeed some of the Celtic saints were believed to have found the earthly paradise. The *immrama* or tales of these voyages Christianized the pagan adventure stories of visits to the otherworld. Similarly, accounts of Christians seeing the afterworld in visions developed a genre already established in pagan story-telling.

The most famous of the *immrama* is the story of St Brendan's voyage to the land of promise of the saints. St Brendan was an Irishman who founded the monastery of Clonfert in Galway and died in A.D. 565. The Latin version of his adventure, the *Navigatio Brendani*, was written in Ireland in the ninth or early tenth century. Though it sparkles with imaginative fantasy, it is based on real voyages and it brings pagan motifs—classical as well as Celtic—into a Christian setting. Medieval maps marked St Brendan's Island in the Atlantic, sometimes identifying it with the Fortunate Isles. The belief that St Brendan had discovered an unknown country by sailing west influenced Columbus.

In the *Navigatio* Brendan and seventeen companions sail westward in a large currach and have numerous adventures. They come to many islands, including one with sheep the size of bulls, one with birds singing praises to God, an island of huge grapes and an island on which they camp and which turns out to be a friendly whale. At one point Brendan sings Mass at the top of his voice in the boat and crowds of fish gather to listen respectfully. They see a giant column of crystal (perhaps an iceberg), an island of evil smiths who pelt

them with slag, and the volcano of hell. They encounter Judas Iscariot who is crouched uncomfortably on a sea-beaten rock, where on certain Sundays of the year he is allowed a respite from his torments in hell. Eventually they enter a region of thick darkness, reminiscent of the magic mist which sometimes shrouds the Celtic otherworld from mortal view, and emerge from it to find the land of promise itself. It is a large island, bathed in perpetual brilliant light, rich in springs and precious stones and covered with apple-trees whose fruit is always ripe. There is no night there and no sun, for Christ himself is the light. They come to a great river, far too wide for them to cross, and are told that they can go no further and must now return home. The island will not be revealed again until a time in the future when Christians are suffering persecution.[11]

The theme of a long and difficult journey occurs frequently in beliefs about what happens after death. Plutarch talked of wandering in the dark and of experiences of terror. It used to be the custom in various parts of Europe to bury the dead with their shoes on, so that they would not have to stumble along the rough tracks of the after-world in their bare feet. In the north of England it was believed that the dead would have to cross a wild area of land covered in gorse, thorns, brambles and flinty stones, called the Whinnymuir. In some places candles were placed in graves to provide light for the dead on their journey. In Ireland hammers were sometimes buried with the

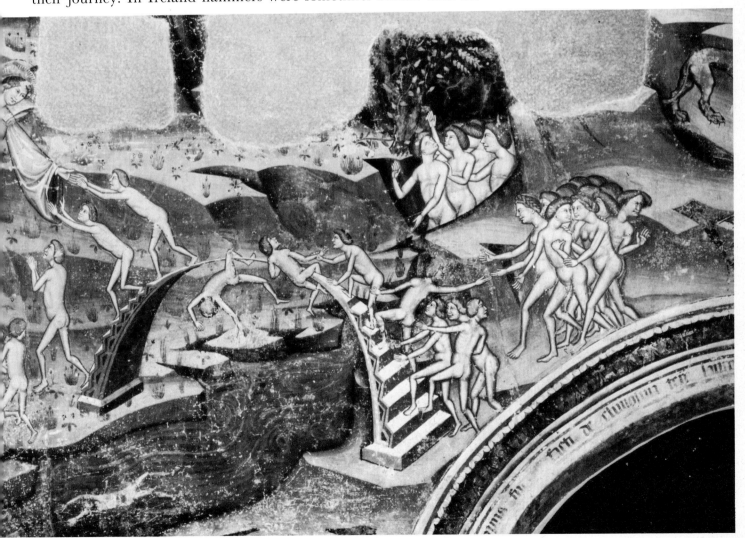

dead, so that when they reached purgatory they could bang on the door to announce their arrival.

Very often the journey after death involves crossing water, either in the form of a river like the one St Brendan saw in the land of promise, or a lake or the sea. The water may have to be crossed by boat, as in the case of the Egyptian pharaohs who were ferried over the Lily Lake in the sky. In the Arthurian legend, when Arthur is mortally wounded in his last battle, three fairy women come to take him away in a boat to Avalon, the paradise of apple-trees. The predominant belief in Greece and Rome was that the dead would have to cross the Styx, the principal river of the underworld, in order to reach the halls of Hades. They were ferried over by an old and evil-tempered boatman named Charon. Since he charged a fee, it was the custom to put a coin in the dead man's mouth before burial. This custom was taken up by the Germanic peoples in Europe. In England coins have frequently been found in graves, and in Oxfordshire in the nineteenth century a penny was still placed in a dead man's mouth before the coffin was nailed down.

Another obstacle in the journey after death is an ominous bridge, which crosses the river of death or the valley of hell. After the north-country dead had negotiated the Whinnymuir, they came to the Brig o' Dread.

> From Whinnymuir when thou may pass,
> Every night and all;
> To Brig o' Dread thou comes at last,
> And Christ receive thy soul.
> From Brig o' Death when thou art passed,
> Every night and all;
> To Purgatory fire thou comes at last,
> And Christ receive thy soul.

This verse is from the Lyke-Wake Dirge, known to have been sung at funerals in Yorkshire as late as the seventeenth century. The bridge was said to be 'no broader than a thread'. So was al-Sirat, the bridge of popular Muslim belief, which was one of several ordeals in which the dead were tested and judged. The bridge was thinner than a hair and sharper than the edge of a sword. It spanned the valley of hell, from which great flames roared up, and all the dead had to cross it. True believers who had led good lives crossed rapidly, supported by angels holding them up by the hair. The wicked fell off into the maelstrom of fire beneath. Those who were not good enough to cross quickly but not bad enough for hell endured a kind of purgatory in making the crossing, licked by the flames. The worse they were, the longer it would take them, and some might spend 25,000 years in pain on the bridge.

This Muslim bridge is probably descended from the Bridge of the Separator, or Bridge of the Avenger, in the old Persian religion of Zoroastrianism, which survives as the religion of the Parsees in India. Zoroaster, in the sixth century B.C., promised to lead his followers safely across the bridge of judgment in the afterlife, and presumably he took the motif of the bridge from beliefs already current in his time. Later it was believed that the dead were judged by a tribunal of gods who weighed each man's good actions in life against his bad actions.

Another variation on the difficult journey to heaven is the belief that it is reached by a ladder. In some ancient Egyptian texts the dead ascend to the sky up a ladder or stairway made of the slanting beams of the sun.
Left: This Russian icon of the sixteenth century shows the dead struggling up the ladder to heaven in the sky, encouraged by angels. Those who fail the test and fall off are seized by demons. Near the foot of the ladder is the mouth of hell.

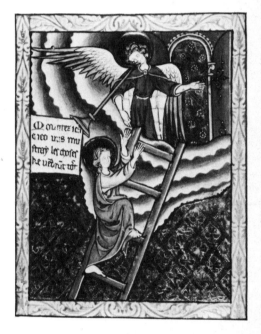

Above: *'And after this I looked, and lo, in heaven an open door. And the first voice, which I had heard speaking to me like a trumpet, said, "Come up hither . . ."' (Revelation 4.1). St John, the author of Revelation, climbs the ladder to heaven; from a manuscript in the Bodleian Library, Oxford.*

Then he had to cross the bridge, which soared over the abyss of hell. The good crossed easily and came to the heaven of Endless Light on the far side; but the wicked found the bridge growing narrower and narrower as they struggled across, until they could no longer keep their footing and tumbled into hell.

The afterworld bridge also appears frequently in medieval Christian literature. An example is the legend of St Patrick's Purgatory, an island in Lough Derg, County Donegal, where there was an Augustinian monastery and an uncanny cave which was believed to be an entrance to the otherworld. Visitors spent several days in fasting and

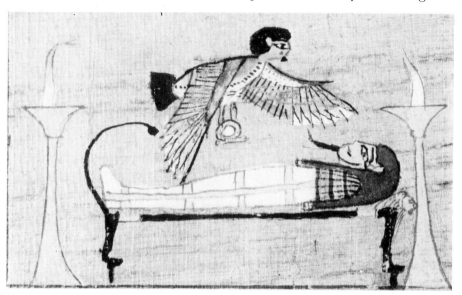

Right: One of the various Egyptian beliefs about life after death was that the dead lived on in their tombs, where they were provided with food, utensils and equipment, sometimes including lavatories. The Egyptians also thought that each human being had several different souls. One of them was the ba, *imagined as a human-headed bird, which came back to visit the mummy in the tomb. (British Museum)*

Below: The prophet Elijah was believed to have been spared death and carried up to heaven in a fiery chariot, as shown on the stem of an initial letter from the Winchester Bible, twelfth century. The animals drawing the chariot are red to indicate that it was a chariot of fire.

prayer under the supervision of the monks before entering the cave alone. Some came out raving mad and some described extraordinary visionary experiences. In 1153 a knight named Owen went into the cave, so the story goes, and came to a plain where he was met by demons. They led him through a wilderness of black earth and freezing winds, where he saw sinners being tormented. Some were sunk in pits filled with sulphur and molten metal; others were hurled from the top of a mountain into a foetid and icy river. Owen saw a bridge over a pit of fire and a river of flame. It was dizzyingly high and so narrow that it was impossible to stand on it. Owen called on God and the bridge became broader as he crossed it. Reaching the other side, he came to paradise which was surrounded by a high wall, with a gate covered with gold and silver, and studded with jewels. Within the walls the air was sweetly perfumed and there were flowery meadows and fruit-trees and crowds of people.

There are other conceptions of the way to a heaven or paradise in the sky. In Egyptian texts the dead pharaoh is described soaring up into the sky as a falcon or a goose; or he is carried up on the back of a grasshopper or on a cloud or on fumes of incense; or he mounts a stairway or a ladder made of the slanting beams of the sun. It is likely that one purpose of building giant step-pyramids, and later true pyramids, over the tombs of kings was to provide a solid representation of the staircase or ramp of the sun's rays, up which the dead man would climb to the sky.

The many different concepts of the afterlife in the Graeco-Roman world included various ideas about the dead reaching the sky. They

might fly up as birds or be carried up by birds or winged spirits, or they might climb a ladder or float up like specks of dust in the rays of the sun. Some thought that they became stars, and multitudes of them could be seen in the Milky Way. Others thought that the Milky Way, as its name implies, was the road in the sky which souls took to the higher heavens. This belief was also known in northern Europe.

Another common belief was that the souls of the pious rose up into the air where they were purified by wind, water and fire, and that this was the real crossing of the Styx. Once purified, they rose to the moon, where they found the Elysian Fields or Isles of the Blessed. Some rose higher, to the sphere of the sun, and some higher still to the sphere of the stars, where they lived with the gods. A roughly similar belief in 'rising on the planes' after death, usually given a Christian moral tinge, has been held by many modern occultists and spiritualists.

The spirit of the Emperor Augustus, who died in A.D. 14, soared up into the sky with the smoke of his funeral pyre, or so one of the spectators claimed to have observed. The Emperor Trajan was shown on a relief at Ephesus being taken up into the heavens in the chariot of the sun. The author Herodian, in the third century A.D., described the imperial funeral ceremonies of his time. A wax image of the dead emperor was carried in procession to the Campus Martius, where it was placed on an elaborate wooden tower. The tower was set on fire, and as it burned an eagle was released from the summit to soar into the sky, carrying the emperor's soul with it.

In the Old Testament the patriarch Enoch was believed to have been translated directly into heaven: 'Enoch walked with God; and he was not, for God took him.'[12] Elijah was also spared death and was taken bodily into the sky in a fiery chariot. In medieval art the ascension of Elijah was a symbol or prefiguration of the ascension of Christ, who was carried up to heaven on a cloud: 'he was lifted up, and a cloud took him out of their sight'.[13] The Virgin Mary is also shown in Christian art ascending into the sky on a cloud. She is attended by angels, and sometimes angels are raising the cloud as if they were lifting a carpet. Martyrs and saints were also borne up to heaven by clouds and angels. Wealthy patrons had their portraits painted with saints and heavenly beings in the hope of ensuring their own successful ascent when their time came. In the Wilton Diptych, for instance, Richard II of England is shown with his patron saints; they are illustrated recommending him to the Virgin Mary and her attendant angels, all wearing the king's badge of the white hart.

Most ordinary mortals, however, continued to expect a more arduous ascent. In the seventh century St John Climacus, a monk of Mount Sinai, wrote *The Ladder of Paradise*, which helped to bring into Christian art the picture of the dead climbing the rungs of a ladder towards heaven, with some of them being dragged off the rungs by ugly black demons. The celestial ladder was identified with the one which Jacob saw in his dream at Bethel. It stretched from the earth to the sky and the angels of God were going up and down on it. Jacob's ladder was understood as a sign that the good will achieve salvation (and Bethel eventually became a common term for a Non-conformist meeting-house). The old Egyptian concept recurs in Dante's *Paradiso*, where Jacob's ladder is seen, golden like the sun's rays, leading up to the highest heaven, where all desires are granted and every wish comes true.

Above: *In Christian art the ladder to heaven was identified with the one which Jacob saw in his dream at Bethel, as described in the book of Genesis. It stretched from the earth to the sky and the angels were going up and down on it. The dream was understood as a sign that the dead will achieve salvation in heaven. Swiss stained glass panel, seventeenth century. (Wragby Church)*

Chapter three
The Perfect Existence

Allah has promised the men and women who believe in Him gardens watered by running streams, in which they shall abide for ever. He has promised them goodly mansions in the gardens of Eden. And what is more, they shall have grace in His sight. That is the supreme triumph.

The Koran, sura 9

Left: The Madonna of the Rose-Garden *by Stefano da Zevio, fifteenth century, conveys beautifully the feeling of the enclosed garden as an enclave of peace and love which is the refuge of the soul after death. 'The enclosed garden' is one of the titles of the Virgin Mary, who is also 'the rose without a thorn', the rose of love, and 'the second Eve', who repaired the mischief which the first Eve had done. Her garden, the second Eden, is a paradise of roses. The white roses stand for purity and the red for consummation. In the background is 'the sealed fountain', which is another title of the Virgin and which corresponds to the spring or fountain of life in Eden. It was believed that the peacock's flesh did not decay, and so the peacocks are symbols of life after death. The figure in the foreground is St Catherine of Alexandria, who was martyred by being broken on the wheel. She is present in the garden as the mystic bride of the infant Christ. (Castelvecchio, Verona)*

Heaven has been pictured in glowingly beautiful terms, but descriptions of it tend to be less vivid and less circumstantial than accounts of hell. Experience of life has made it easier for human beings to envisage an eternity of suffering than an eternity of pleasure which would not become tedious. But, according to Christian theology, this is because human nature is stunted. If we cannot imagine a happiness which goes on forever without growing stale, it is not because such happiness is impossible but because our imagination is limited. Some faint, inadequate impression of heaven can be deduced from earthly life, but its true reality is supernatural and indescribable:

> 'What no eye has seen, nor ear heard,
> nor the heart of man conceived,
> what God has prepared for those who love him'.[1]

Heaven is ultimately beyond the reach of imagination because it is a state of good without any admixture of evil, which is a condition foreign to human experience. As a result, it is frequently described in negatives. In heaven there is no death, sorrow or time, no faith or hope, because they are no longer needed. There is no danger, violence, pain, disagreement or anxiety. Heaven contains only one pole of each of the pairs of opposites which make up life on earth. In the words of a medieval writer, it is 'the palace of the everlasting King, where is life without death, day without night, truth without falseness, joy without sorrow, sureness without dread, rest without travail, everlastingness without end'.[2]

59

The difficulty of conceiving a state of never-cloying bliss is one of the supporting arguments for the doctrine that the happiness of heaven is spiritual, not physical, and consists essentially in the joy of being with Christ. Cardinal Newman wrote in the nineteenth century: 'Did this world last for ever, would it be able ever to supply my soul with food? Is there any earthly thing which I do not weary of at length even now? . . . Thou alone, my dear Lord, art the food for eternity, and Thou alone. Thou only canst satisfy the soul of man. Eternity would be misery without Thee, even though Thou didst not inflict punishment. To see Thee, to gaze on Thee, to contemplate Thee, this alone is inexhaustible. Thou indeed art unchangeable, yet in Thee there are always more glorious depths and more varied attributes to search into; we shall ever be beginning as if we had never gazed upon Thee. In Thy Presence are torrents of delight, which whoso tastes will never let go.'[3]

Theologians and preachers have constantly attempted to correct the popular picture of heaven as an improved edition of life on earth. 'Carnal, fleshly, or beastly in knowledge be they', said a preacher in the sixteenth century, 'that of almighty God and heavenly things, imagine and judge by corporal fantasies, as of God that he is a fair old man with a white beard, as the painters make him, and that the joys of heaven stand in eating and drinking, piping and dancing.'[4] Long before, St Paul had found it necessary to tell Christians that 'the

Left: *The Resurrection of the Dead by Giorgio Ghisi, sixteenth century. Skeletons are clothed with flesh as the dead rise from their graves in a cemetery, to be judged at the end of the world. 'I believe in the resurrection of the flesh' is one of the cardinal statements of the Christian faith in the Apostles' Creed.*

Right: *Illustration from a fifteenth-century French manuscript, showing the judgment scene prophesied in St Matthew's gospel, when Christ separates the good sheep from the wicked goats. The Virgin Mary is to Christ's right, the apostles to his left, the angels carry the instruments of his sacrificial death. In the centre two angels sound the last trump. Below them is St Paul, holding a text from his epistles, 'so that all may be condemned who did not believe the truth' (II Thessalonians 2.12). The saved are at the left of the picture and the damned at the right, with demons below.*

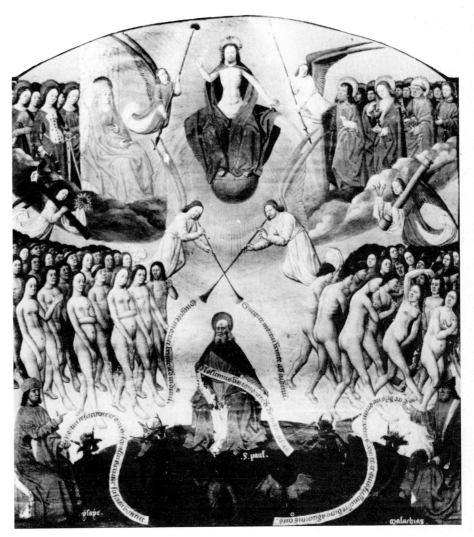

Above: *Christ poised between heaven and hell, from an Ethiopian manuscript. There is a contrast in Christianity between the Christ who is loving and merciful, and the Christ who divides the sheep from the goats and condemns the wicked to eternal torment. (British Museum)*

kingdom of God does not mean food and drink but righteousness and peace and the Holy Spirit'.[5] Similarly in Judaism, Rabbi Rav, who taught in Babylonia in the third century A.D., said of the world to come: 'There is there neither eating, nor drinking, nor any begetting of children, no bargaining or jealousy or hatred or strife. All that the righteous do is to sit with their crowns on their heads and enjoy the effulgence of the Presence.'[6]

The 'effulgence of the Presence' is called in Christian theology the Beatific Vision, the experience of seeing God as he is. 'For now we see in a mirror dimly,' said St Paul, 'but then face to face. Now I know in part; then I shall understand fully, even as I have been fully understood.'[7] In 1336 Pope Benedict XII issued the definitive Roman Catholic statement of the doctrine in the bull *Benedictus Deus*. The souls in heaven 'behold the divine essence with intuitive and face-to-face vision, with no creature mediating in the manner of object seen, but the divine essence immediately showing itself to them without covering, clearly and openly . . . From this vision and enjoyment the souls of those who have already departed are truly blessed and have eternal life and rest; and the souls of those who will depart hereafter will also see that same divine essence . . .'[8]

Strictly speaking, heaven is not a place but a condition—the state of being with God. And despite the words 'face-to-face', the experience of seeing the divine essence is spiritual and intuitive, not physical.

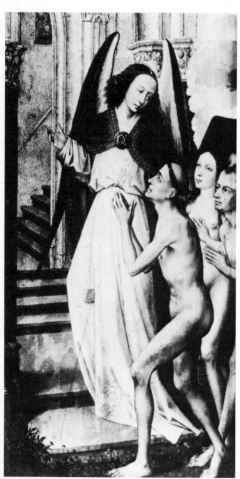

Above: *Detail from an altar-piece by Roger van der Weyden. An angel leads the saved to heaven's gate. Their nakedness is a sign that they have been freed from the limitations of earthly life.*

The souls which go to heaven are not yet reunited with their resurrected bodies, and will not be until the end of the world and the Last Judgment. Most Christians have found it impossible, however, to think of a satisfactory afterlife without a location or without a body which resembles a human one, however transfigured and glorified. For the great majority, going to heaven has meant going to a place, an area in the sky where God, Christ, the angels and the blessed are to be seen in bodily form, wearing shining white robes.

The souls in heaven do not share equally in the Beatific Vision, though all of them experience its joy. The saying of Jesus, 'In my Father's house are many mansions',[9] lent itself to a belief in distinctions in heaven. The Council of Florence in 1439 laid it down that some souls will enjoy the divine presence more perfectly than others, depending on their merits. The old idea of the soul ascending towards God through the planetary spheres suggested a journey of spiritual progress after death, and in Dante's *Paradiso* the nine spheres of heaven are occupied by spirits which have attained different levels of goodness. In the nineteenth century, Victorian believers in progress and hard work criticized the traditional picture of heaven as being an 'elysium for indolence' instead of 'the sphere of highest action'. Some modern theologians believe that progress towards perfection continues in heaven.[10]

It does not seem easy to reconcile this view with the belief that there is no time in heaven. God is beyond time—'with the Lord one day is as a thousand years, and a thousand years as one day'[11]—and there is no day or night in heaven, no succession of seasons, years or centuries. Everything which happens in heaven happens now, everything experienced there is experienced all at once. The soul sees all things as God sees them, *sub specie eternitatis*, whole and complete, past, present and future. This characteristic is not peculiar to the Christian heaven. In the Egyptian Book of the Dead the dead man, who has been identified with Osiris, says that he is yesterday, today and tomorrow: in other words, he has passed beyond time. Generally, time does not exist in pagan paradises and the season is always spring. So it is

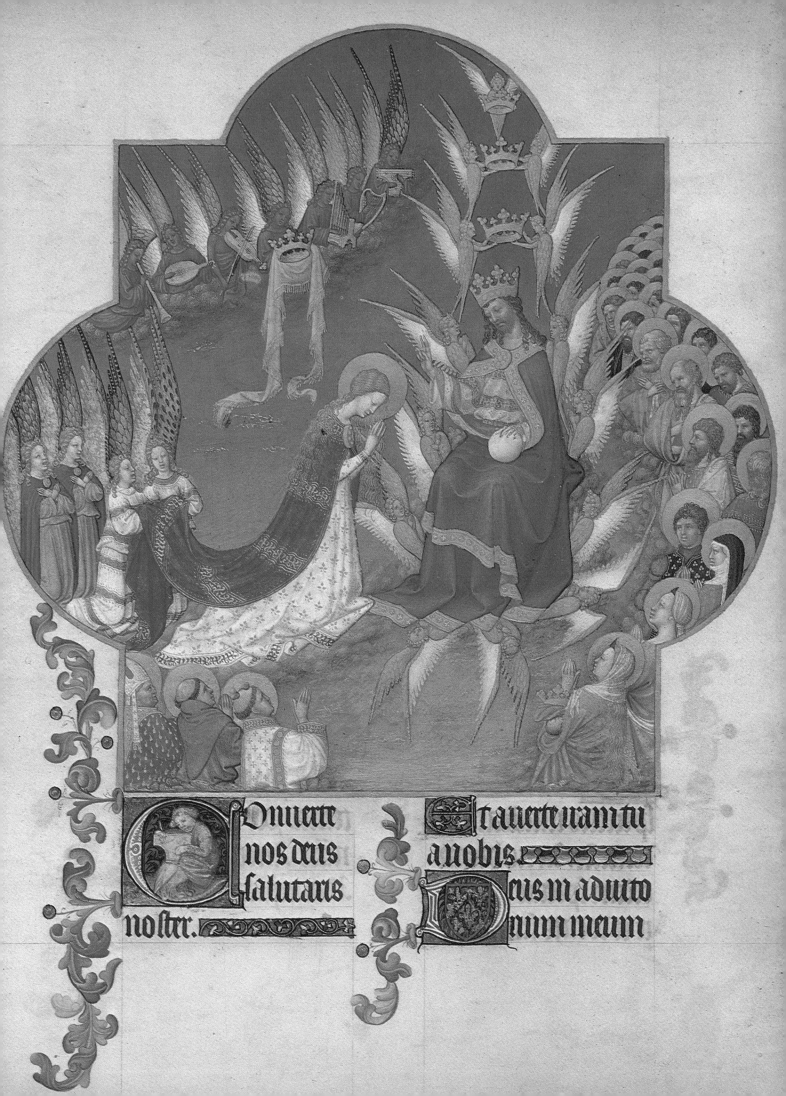

in heaven, according to Lancelot Andrewes, the great seventeenth-century Anglican preacher, who contrasted the transience of spring in this world with the eternal spring of heaven: 'Now, nothing *fades*; but all springs fresh and green. At this time, here; but, at all times there: a perpetual spring; no other season there, but that.'[12]

High above the clouds, heaven is filled with an unchanging glory of light, the radiance of the godhead. God's brightness and the light of his face, it was said, are such that sunlight is like shadow by comparison. In paintings heaven is shown brilliant with beautiful light. In the twelfth century a monk of Eynsham, near Oxford, fell into a trance in which he visited purgatory and paradise. The paradise he saw was not 'the high heaven of heavens' itself, but a stopping-point in the ascent to it, where souls gave thanks to Christ on his throne. It lay behind a glorious wall of crystal, so high and stretching so far that the monk could not see where it ended. Its entrance was through a shining gateway, barred by a cross which rose to let the faithful in. The brightness and clearness of the light inside was beyond description. 'That brightness, though it were inestimable, nevertheless it dulled not a man's sight; it rather sharpened it. Soothly it shined full marvellously, but more inestimably it delighted a man that beheld it, and wonderfully compelled a man's sight to see it.'[13]

The white robes of the inhabitants of heaven shine with light and they also have radiant haloes of various kinds. Saved souls and angels have a nimbus, known as a halo, surrounding the head. It is usually circular as a symbol of eternal life. If living people are ever shown with a nimbus in art, it is square, representing limited earthly life. God, Christ, the Holy Spirit and the Virgin Mary may have a nimbus or the greater glory of an aureole, a white or golden radiance of light or flames which surrounds the whole body. God the Father sometimes has a triangular nimbus, symbolizing the Three-in-One, and Christ may have a cruciform nimbus. In pictures of the Last Judgment, Christ is often given an elliptical aureole, called a mandorla or almond—the almond being a symbol of the Saviour in his role as High Priest. The Virgin Mary sometimes has a mandorla as a mark of divine favour, especially in scenes of her assumption into heaven.

The belief that gods and persons of great spiritual achievement emanate light is found not only in Christianity but in Hinduism and Buddhism. In Islamic art Muhammad is often represented as a flame. Flying saucers can be interpreted as modern heavenly visitors to the earth and are said to be surrounded by haloes of light. It is occasionally suggested that the cloud on which Christ ascended into heaven was really a flying saucer.

The company of the other inhabitants is traditionally one of the supreme delights of heaven. The saved are reunited there with many of those they knew and loved on earth (according to some theologians, this included animals as well as people). Some may unfortunately have failed to gain entry, but the Christian doctrine is that the saved will not feel sad at their absence since there is no sadness in heaven and so no attachment can be felt to anyone unworthy of admittance.

Beyond the pleasure of the presence of family and friends, there is the wider fellowship of the whole population of heaven—the angels and archangels, the Old Testament patriarchs and prophets, the apostles, the martyrs and other holy Christians. In paintings they are all shown in their due rank and order and harmony, against a back-

Top: *Detail from* The Ascension, *Greek, fifteenth century. 'As they were looking on, he was lifted up, and a cloud took him out of their sight' (Acts 1.9). The cloud is shown here as a disc of light, raised by two angels, and Jesus has a halo round his head, in which is the sign of the cross.*

Above: *Since heaven was popularly placed in the sky, it was natural to think of it as filled with radiant light, the glory of the godhead. The inhabitants of heaven wear shining white robes and have haloes of light round their heads, like these angels in a detail from* The Crucifixion *by Giotto, fourteenth century.*

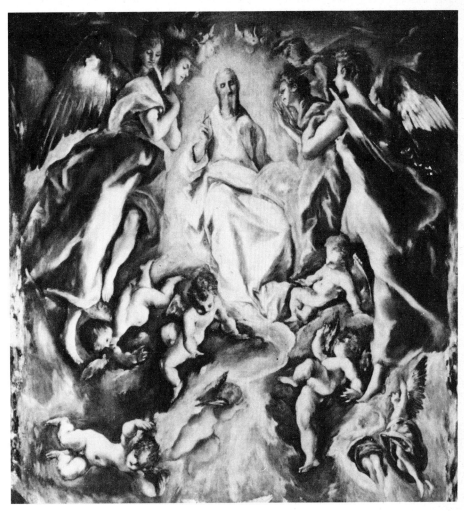

Right: *Detail from* The Baptism of Christ *by El Greco, sixteenth century. God the Father is seen in heaven in an aureole of light, with angels and cherubs. The cherubim of Jewish belief were awe-inspiring and formidable angels, but in Christian art they degenerated into chubby little boys with wings. (Prado, Madrid)*

Below: *The belief that gods and persons of great spiritual achievement radiate light is not confined to Christianity. This detail from a twentieth-century Tibetan painting shows Buddha and Buddhist saints with haloes.*

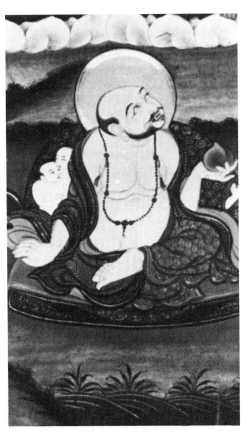

ground of golden light or supported on rolling clouds. Heaven is the perfect society, the divine kingdom of peace, where there is no war, violence, competition, jealousy or resentment. Everyone is delighted with his place, everyone's purposes are identical, felicity is unmarred by friction and the joy of each is multiplied by the joy of all.

In 1078 St Anselm wrote: 'Question within yourself, could you hold the joy of so great a bliss? But surely if another whom you loved in every way as yourself, had that same bliss, your joy would be double, for you would rejoice no less for him than for yourself. And if two or three or many more had the same blessedness, you would rejoice for each of them as much as you do for yourself, if you loved each one as yourself. So in that perfection of charity of countless blessed angels and men, where no one loves another any less than he loves himself, they will all rejoice for each other as they do for themselves.'[14]

The perfect harmony of heaven is expressed in its sublime music. The monk of Eynsham, in his trance, heard the music of paradise, a sound as if all the bells in the world were pealing. The adoption of the planetary spheres into the Christian scheme of things brought with it the Pythagorean notion of the music of the spheres, the beautiful sound which they make as they revolve. In 1480 Caxton published *The Mirror of the World*, a translation of a French book some two hundred years older, which says of the revolutions of the starry sky: 'Of such moving is so great joy, so great melody and so sweet, that there is no man that, if he might hear it, he never after should have

talent nor will to do things that were contrary unto Our Lord in
anything that might be, so much should he desire to come thither
where he might always hear so sweet melodies and be alway with
them. Whereof some were sometime that said that little young
children heard this melody when they laughed in their sleep; for it
is said that then they hear the angels of Our Lord in heaven sing,
whereof they have such joy in their sleep . . .'[15]

Traditionally, there are nine 'choirs' of angels who sing praises to
God in heaven—the 'nine bright shiners' of the old rhyme. The
choirs correspond to the nine spheres and, like the blessed, are ar-
ranged in heaven in order of rank. In Dante's *Paradiso*, in the Empy-
rean, God is seen as a point of piercing light, surrounded by nine
concentric circles of flame which are the angelic choirs. According
to the generally accepted classification of angels, worked out by
Pseudo-Dionysius in Syria in A.D. 500, there are three hierarchies,
each of three choirs, so that three, the number of the Trinity, is
repeated three times in the system. The first and highest hierarchy
consists of the Seraphim, Cherubim and Thrones, the second of the
Dominations, Virtues and Powers, the third of the Principalities,
Archangels and Angels. Estimates of the numbers of angels varied
considerably, but some said that there were originally 399,920,004 of
them. However, one-third of them joined Satan, the highest of the
seraphim, in his rebellion against God. They were defeated in the
war in heaven and hurled into hell, leaving 266,613,336 angels in
heaven.

Angels are mentioned frequently in the Old Testament, where they
form God's court and are sent on missions to people on earth (the word
angel means 'messenger'). They are closely linked with the stars,
hence their enormous numbers and their beauty and radiance. The
seraphim had six wings and were seen by Isaiah in a vision, worship-
ping God in heaven. Two great winged cherubim, carved of olive
wood and covered in gold, stood in the Holy of Holies in the Temple
at Jerusalem, and God posted one of the cherubim with a flaming
sword to guard the gate of Eden after Adam and Eve were expelled
from paradise. They were awe-inspiring and formidable beings, but
much later on, in Christian art, cherubs were mixed up with cupids
and degenerated into winged small boys, frequently of fat and
repellent aspect. Other types of angels in the Old Testament were
not winged, but they were all given wings in Christian belief, appa-
rently through a connection with birds, which in folklore often act
as messengers of the gods. They were sometimes said to be of immense
size and one was reported to have been 96 miles high.

There were seven great archangels in Jewish belief at the time of
Christ, corresponding to the seven heavens. Christianity inherited
them, but only Michael, Gabriel and Raphael have been given
distinct personalities in Christian tradition. The archangel Michael,
whose name means 'like God', led God's army against the Devil in
the war in heaven, and is often shown as a mailed warrior. He is the
angel who will sound the last trump at the end of the world and who
will weigh souls in the balance. Gabriel, which means 'God is my
strength', is the Almighty's chief messenger, who came to tell Mary
that she was to be the mother of Christ. In Muslim tradition he
revealed the Koran to Muhammad. By a papal decree of 1951, he
is the heavenly patron of postmen and telephonists. Raphael, whose

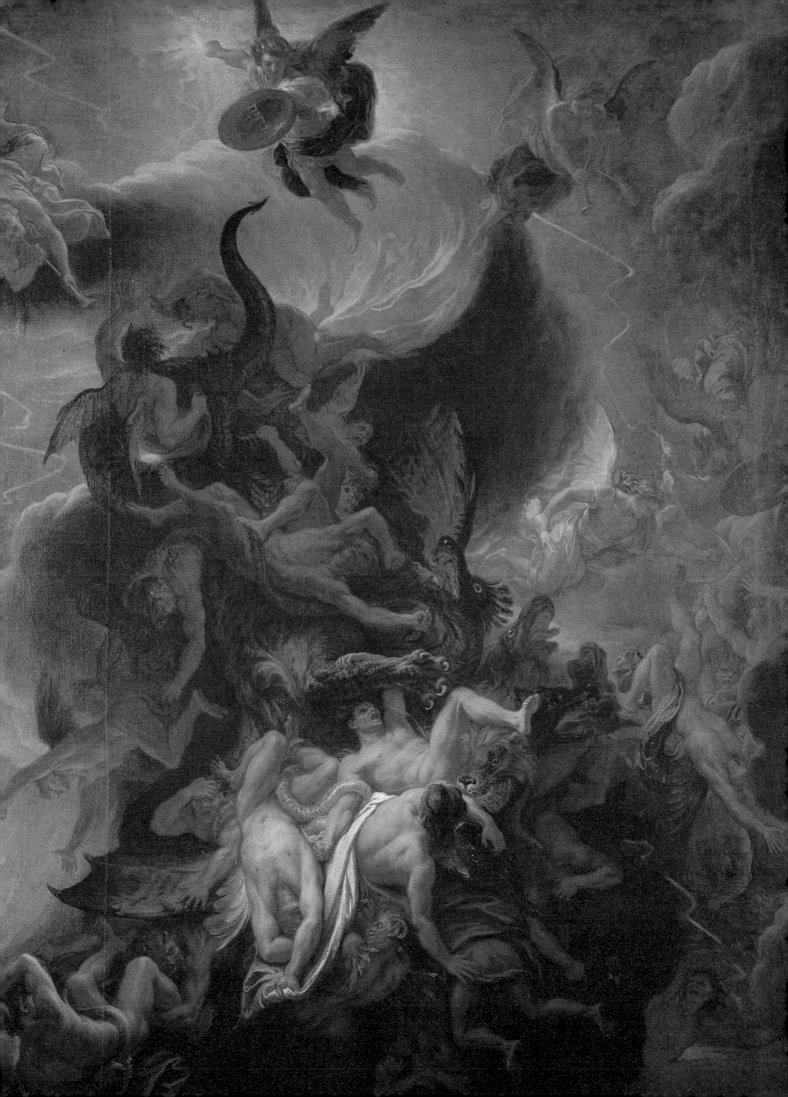

There were seven great archangels in Jewish belief at the time of Jesus. Christianity inherited them, but only Michael, Gabriel and Raphael have distinct personalities in Christian tradition.

Above: *Michael, from a Russian icon. His name means 'like God' and he is often depicted as a warrior, because he led the army of God in the war in heaven. He is the protector of Christians, especially Christian soldiers. He is also the angel who will weigh souls in the Last Judgment and the Negro spiritual, 'Michael, row the boat ashore', implies that he ferries souls across the river of death.*

Left: The Annunciation *by Dante Gabriel Rossetti, nineteenth century. The Archangel Gabriel tells Mary that she is to be the mother of Christ. Gabriel, whose name means 'God is my strength', is the chief messenger of God and, in Muslim tradition, he revealed the Koran to Muhammad. The lily is a symbol of chastity and the dove represents the Holy Spirit. (Tate Gallery, London)*

Left: *Islam, like Christianity, inherited the angels of Jewish belief. They are seen on the clouds in this detail from a sixteenth-century Persian illustration, which shows the ascent of Muhammad to heaven. The Prophet radiates light in the form of a nimbus of flames. (Victoria & Albert Museum, London)*

Below: *The popular Christian picture of heaven was strongly influenced by the superb visions of the book of Revelation. Christ as the Lamb of God, in a mandorla, or almond-shaped aureole of light, holds the book with seven seals. Panel from a German altar-piece, fourteenth or fifteenth century. (Victoria & Albert Museum, London)*

name means 'God heals', is the chief guardian angel of mankind, and is the angel who announced the birth of Jesus to the shepherds.

The angels are seen singing in heaven in the magnificent visions of the book of Revelation, which with its many echoes of the Old Testament was the leading influence on the popular Christian picture of heaven. God is seen on his royal throne, surrounded by his celestial court, as he was seen by Isaiah, Ezekiel and Daniel. Round the throne is the rainbow, the symbol of God's mercy, and from the throne issue manifestations of his power—flashes of lightning, voices and claps of thunder. Near the throne are the four mysterious 'living creatures', which come from the vision in the first chapter of Ezekiel and in Christian art became symbols of the four evangelists. These creatures have six wings and are 'full of eyes all round and within'. The first is like a lion, the second like an ox, the third has the face of a man, and the fourth is like an eagle. They sing unceasingly, 'Holy, holy, holy, is the Lord God Almighty, who was and is and is to come.'

There are also the 24 elders or senior angels. They may represent the books of the Old Testament, of which there were 24 by Jewish reckoning. They sit on thrones, robed in white and wearing golden crowns, and also sing praises to God. Hosts of angels, 'numbering myriads of myriads and thousands of thousands', worship Christ as the Lamb and so do the living creatures and the elders, holding harps and golden bowls of incense. And then the faithful human servants of God are seen, 'a great multitude which no man could number, from every nation, from all tribes and peoples and tongues'. Clothed in white and holding the palm branches of victory, they stand before the throne and worship God and the Lamb. 'They shall hunger no more, neither thirst any more; the sun shall not strike them, nor any

scorching heat. For the Lamb in the midst of the throne will be their shepherd, and he will guide them to springs of living water; and God will wipe away every tear from their eyes.'[16]

This noble, inspiring picture in Revelation contrasts vividly with the blood-streaked visions of divine fury, slaughter and havoc elsewhere in the book, which contributed to its popularity. The principal activity of heaven is worship, the active counterpart of passive contemplation of the divine presence. As in pagan paradises, there is no work in heaven. The blessed enjoy an eternal sabbath-day: 'for whoever enters God's rest also ceases from his labours as God did from his'.[17]

It was Revelation which fastened the image of heaven as a city into Christian patterns of thought. The celestial city is the heavenly analogue of Jerusalem, which was believed in the Middle Ages to stand at the centre of the world and was venerated by Jews, Christians and Muslims. Pilgrimage to the earthly Jerusalem gained spiritual merit, but it was only a copy or reflection of the true Jerusalem above, the capital city of the promised land of heaven which is the goal of the Christian's pilgrimage through life in many hymns: 'Jerusalem the golden, with milk and honey blest'; 'City of God, how broad and far outspread thy walls sublime'; 'Glorious things of thee are spoken, Zion, city of our God'. In *Pilgrim's Progress* the celestial city stands on a towering hill beyond Jordan, the river of death. Built of pearls and jewels, its streets are paved with gold and it glitters in the sun. Crossing the river, the pilgrims are greeted by angels, pipers and singers, horses and chariots. The trumpets sound, the city's bells peal a welcome and the pilgrims are led in through the golden gates. 'Then I heard in my dream that all the bells in the city rang again for joy, and that it was said unto them, "Enter ye into the joy of your Lord."'

The Christian concept of the heavenly Jerusalem was based on earlier Jewish hopes and the chequered history of the earthly Jerusalem. Originally a Canaanite stronghold, Jerusalem was captured by David, who made it the capital of the united Israelite kingdom which he established in the tenth century B.C. His son, Solomon, built the Temple there as the dwelling-place of God. It was believed that God had promised David a future of peace and security for his people, but no such future materialized. After Solomon's death the kingdom split into two antagonistic halves, both of which were overwhelmed by foreign aggressors. The Assyrians destroyed the northern kingdom late in the eighth century B.C. The Babylonians invaded the southern kingdom of Judah in 598 B.C., and again, ten years later, when they besieged Jerusalem. They entered the city in 587, sacked it, razed the Temple to the ground and took many of the inhabitants away into exile. When the Persians conquered Babylon, they allowed the exiles to return, from the year 538, and the Temple and the city walls were rebuilt. But Israel remained an oppressed nation, harassed and dominated by foreigners. In the first century B.C. Palestine came under Roman rule and, after a revolt against Rome, Jerusalem was stormed and sacked again in A.D. 70 and the Temple was destroyed.

Through all these calamities, generations of Jews hoped for the fulfilment of God's promise to David. They expected, not far in the future, the great and terrible Day of the Lord. On that day God would arise in wrath, destroy the foreign oppressors and establish a new order of holiness, peace and prosperity, a restored and perfected

Right: The Virgin of the Lilies by Carlos Schwabe. The Virgin's paradise here is not a rose-garden but an avenue of exquisite lilies among the clouds. White traditionally represents purity. The lily is Mary's flower as a symbol of the immaculate conception of Christ. The whiteness of the river in the landscape below again suggests the purifying and life-bringing influence of the Virgin. (Robert Walker Collection, Paris)

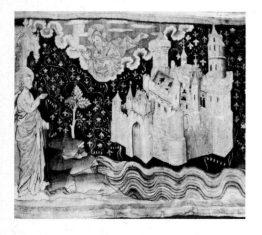

Above: *The New Jerusalem, which in Revelation comes down out of heaven to earth. The city is the celestial counterpart of the earthly Jerusalem, which was believed in the Middle Ages to stand at the centre of the world and was venerated by Jews, Christians and Muslims.*

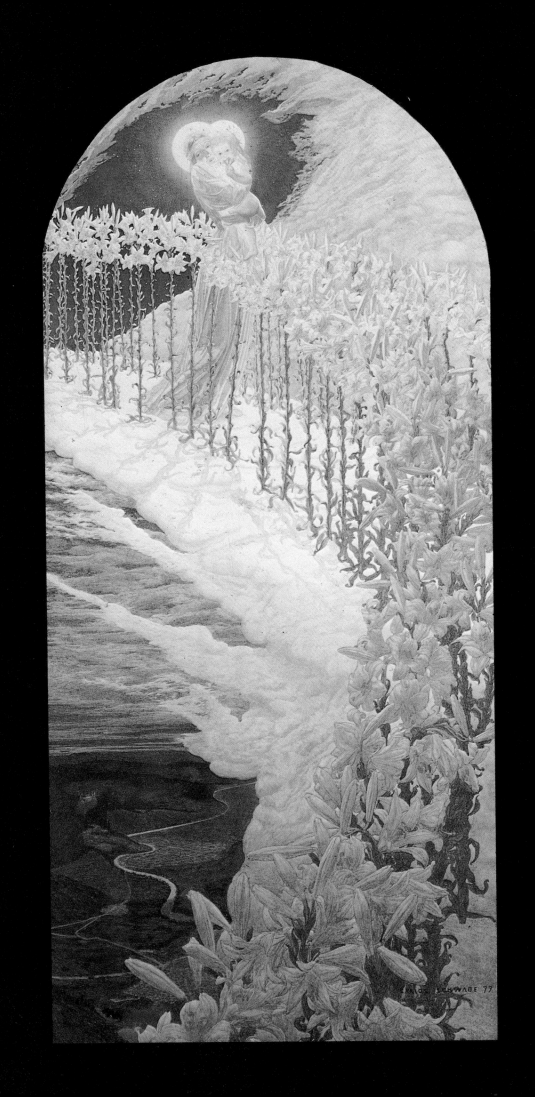

Above: A Village in Heaven by
Stanley Spencer, twentieth century. Near
the centre, God is leaning against the
war memorial. A village, like a garden
or a city, suggests a refuge, a safe haven
for the soul after the turmoil and
trouble of life on earth. The picture also
conveys the old theme of heaven as the
ideal community, where there is no
violence, competition, jealousy or
resentment, where everyone's purposes
are the same. Work is unknown in
heaven, and the company of the other
inhabitants is traditionally one of its
supreme delights. (City Art Museum &
Galleries, Manchester)

kingdom of David with its capital at Jerusalem on Mount Zion, the
hill on which the Temple stood. 'For out of Zion shall go forth the
law, and the word of the Lord from Jerusalem. He shall judge between
the nations, and decide for many peoples; and they shall beat their
swords into ploughshares, and their spears into pruning hooks; nation
shall not lift up sword against nation, neither shall they learn war
any more.'[18]

'Walk about Zion, go round about her, number her towers, con-
sider well her ramparts, go through her citadels.'[19] The Old Testa-
ment hope of the great city, towered and battlemented, high on its
hill, inspired the Christian picture of the celestial city, and every
reference to Zion in the Bible was interpreted as an allusion to
heaven. It is the home of God, where he manifests himself in glory,
the safe refuge of his people and a magnet to all nations, which flock
there to honour him. It is a focus of beauty and riches which gleams
with jewels; it has sapphires for its foundations, its pinnacles are of
agate, its gates of carbuncles and its walls of precious stones. Multi-
tudes of camels bring gold and frankincense to adorn it, ships bear
gold and silver from afar. 'The glory of Lebanon shall come to you,
the cypress, the plane and the pine, to beautify the place of my sanc-
tuary.'[20] It is a haven of peace and joy, of song, music and dancing
in praise to the Lord.

As foreign oppression made the prospect of a happy future for
Israel seem unlikely in the normal course of events, the future Zion
tended to be supernatural and miraculous. This tendency grew
stronger after the exile, when the existing order of things seemed so
dominated by evil that it was beyond reform. In some quarters
people began to expect God not to contrive an ideal situation in the
known world but to make a new world altogether. 'For behold, I
create new heavens and a new earth . . . I create a Jerusalem rejoicing,
and her people a joy.' (The same word is used for 'create' as in the

first verse of the Bible, in Genesis.) There will be no sorrow, weeping or disappointment in this new Jerusalem. Everyone will live to be a hundred. Cold and darkness will be abolished. There will be no sun or moon, 'for the Lord will be your everlasting light'.[21]

The future Zion was given the characteristics of Eden, and the new creation would reproduce the golden age of the past. Streams would water the wilderness and the desert was to blossom like the rose. 'For the Lord will comfort Zion; he will comfort all her waste places, and will make her wilderness like Eden, her desert like the garden of the Lord.' The hills will flow with milk and the mountains drip with wine (the vineyards were on mountain-sides). Life will once more know the peaceful innocence of paradise when the world was young. 'The wolf and the lamb shall feed together, the lion shall eat straw like the ox; and dust shall be the serpent's food. They shall not hurt or destroy in all my holy mountain, says the Lord.'[22]

Jesus aroused great excitement by announcing that 'the kingdom of God is at hand', and when he took his disciples up to Jerusalem, they expected him to set up the new order at once. So did the crowds which welcomed him into the city as the Messiah who would deliver Israel from oppression. But they were mistaken. Jesus told Pilate, 'My kingship is not of this world'. He died without fulfilling the ambitions of his disciples. His followers found themselves rejected by most Jews and the new religion quickly spread to Gentiles. Christians therefore rejected the hope of a Jewish national state (which was, however, finally achieved in the twentieth century) and put their trust in the otherworldly Zion. In St Matthew it is 'the kingdom of heaven' which Jesus proclaims, and St Paul drew a contrast between the earthly Jerusalem 'in slavery with her children' and 'the Jerusalem above' which 'is free, and she is our mother'.[23]

For Christians the new era, or kingdom, had begun with Christ's appearance on earth, but it would not be fully established until his

reappearance at the end of the world. Meanwhile the perfect society, the golden age, the exile's eternal home, was in heaven. The epistle to the Hebrews, probably written after the Roman attack on Jerusalem and the final destruction of the Temple, says: 'For here we have no lasting city, but we seek the city that is to come.' This city is prepared in heaven and faithful Christians enter it. 'But you have come to Mount Zion and to the city of the living God, the heavenly Jerusalem.'[24]

In the last superb vision in Revelation, the new heaven and the new earth are created and the holy city, New Jerusalem, comes down out of heaven from God, 'its radiance like a most rare jewel, like a jasper, clear as crystal'. A great voice is heard announcing that 'the dwelling of God is with men'. The word translated as 'dwelling' is related to the Hebrew term for the glory of God's presence, *Shekinah*. The distinction between heaven as God's home and earth as the home of mankind is now obliterated, and the city is the fulfilment of the Almighty's promises to his people in the Old Testament. The city is a perfect cube, like the Holy of Holies, the dwelling-place of the *Shekinah* in Solomon's Temple. It has a great wall of jasper, the jewel associated with the divine radiance, and twelve gates of pearl. Twelve is used repeatedly in the description as a number of completeness, standing for the twelve tribes of Israel and the twelve apostles of Christ, and thus for the whole people and Church of God. The city is of such fine gold that it is transparent, and is richly adorned with gems. There is no evil of any kind in it, no night and no sun or moon, 'for the glory of God is its light'.

A city symbolizes the security, warmth and harmony of a close-knit community, in heaven the 'communion of the saints'. It also suggests high achievements of civilization: magnificent architecture, impressive planning, beautiful and costly objects, treasures of craftsmanship. Though Zion was the blueprint for the Christian celestial city, the idea of the sacred city is not confined to the Judaeo-Christian tradition. In ancient Mesopotamia each city was the home of its own god, who owned all the land and had his temple there. Cities in Egypt and Greece had their own presiding deities, the Greeks regarded the city state as the supremely civilized form of society, and Greek philosophers liked to plan perfect, utopian cities. Plato says in the *Republic* that the pattern of the ideal city is laid up in heaven, 'which he who desires may behold, and beholding, may set his own house in order'.[25] Later philosophers spoke of the universe itself as a great city, the cosmopolis, of which gods and men were citizens. The Roman Emperor Marcus Aurelius called the world the City of God.

Rome was the 'eternal city' and it was the sack of Rome by the Goths in A.D. 410 which impelled St Augustine to write his immensely influential book, *The City of God*. People believed that the humiliation

Right: *The themes of the paradise garden and the celestial city are combined in this detail from Fra Angelico's* Last Judgment, *fifteenth century. Souls are dancing and strolling in the fertile paradise outside the city walls. The pool in the foreground is the spring of life. (San Marco, Florence)*

of Rome was directly attributable to the adoption of Christianity as the official religion of the Empire and the prohibition of pagan cults. St Augustine set out to refute this opinion and he contrasted the imperfect 'city of this world' with the perfect heavenly 'city of God'. 'Two loves therefore have given origin to these two cities, self-love in contempt of God unto the earthly, love of God in contempt of one's self to the heavenly.'[26]

Like Zion in the Old Testament, the celestial city in Revelation has the characteristics of Eden. Through the middle of the city runs 'the river of the water of life, clear as crystal'. Beside the river is the tree of life, which has twelve kinds of fruit and bears its fruit each month. Similarly in an early version of the Vision of Paul, an angel escorts the saint across the lake of Acherusa (a lake in the Greek underworld, mentioned in Plato's *Phaedo*) in a golden ship to the celestial city. It is all of gold, with twelve gates. Round it flow four rivers, which are the rivers of Eden, running with milk, honey, wine and oil. Inside the city are the righteous, arranged in ranks according to their degree of excellence. A high altar stands in the middle of the city and by it King David, his face shining like the sun, plays a harp

and sings Alleluia. And all the towers and gates thunder back Alleluia, until the city trembles to its foundations.

The imagery of the city and of Eden continued to influence Christian concepts of the afterlife. A walled city and a garden are both protected enclosures, separated from the outside world. Both represent the achievement of order and harmony, both imply wholeness and completeness and both are frequently treated as feminine. Zion in the Old Testament and in Revelation is the bride of God. An enclosed garden is one of the principal attributes of the Virgin Mary as God's bride and queen of heaven, but the Virgin also has titles which link her with Zion: the City of God, the Tower of David, the Temple of Solomon. Both the city and the garden can therefore suggest the marriage of the soul with the divine.

Very often the fertile, idyllic landscape of Eden or the Elysian Fields becomes the area immediately outside the city's walls—referred to in Isaiah and *Pilgrim's Progress* as the land of Beulah (which means 'Married'). In the fourteenth-century fresco of the Church Triumphant in Santa Maria Novella, Florence, a garden with a hedge of roses stands beside the gates of heaven and the blessed are crowned with roses on entering. In Fra Angelico's fifteenth-century painting of the

Below: Another treatment of the Virgin's enclosed garden, with St Catherine of Alexandria again in the foreground. Mary, Queen of Heaven by the Master of Flémalle. (National Gallery of Art, Washington)

Overleaf: Allegory of Purgatory *by Giovanni Bellini, sixteenth century, an enigmatic painting which has been interpreted in many different ways. Purgatory in Roman Catholic belief is the afterworld to which the majority of Christians go to be purged of their sins. The foreground apparently represents a formal paradise-garden with the tree of knowledge in the centre. An apple has fallen from it and tempts a child. Justice and punishment in purgatory are suggested by the figure with the sword.*

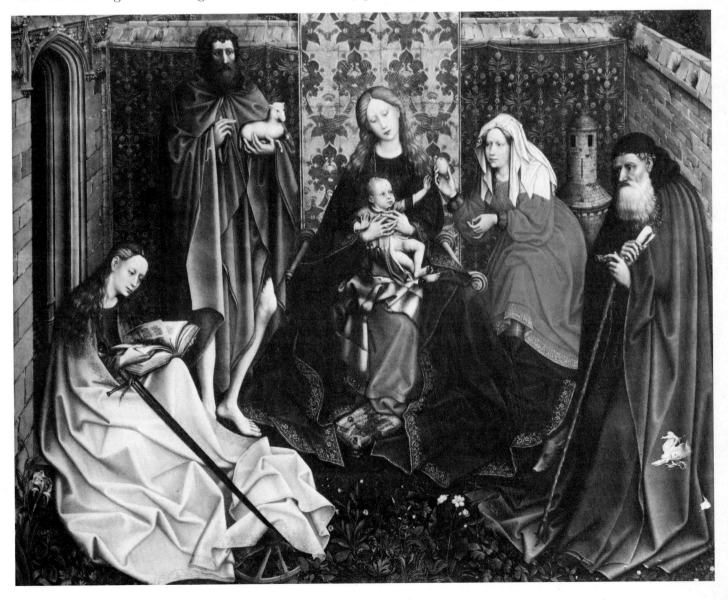

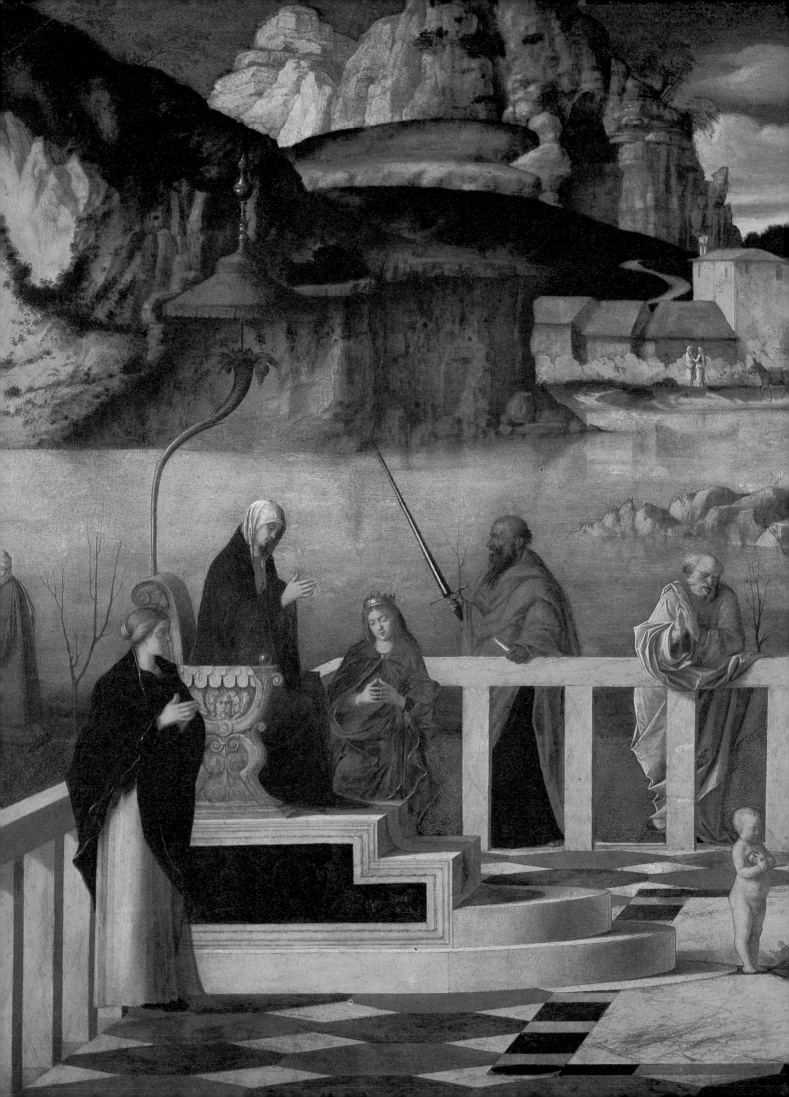

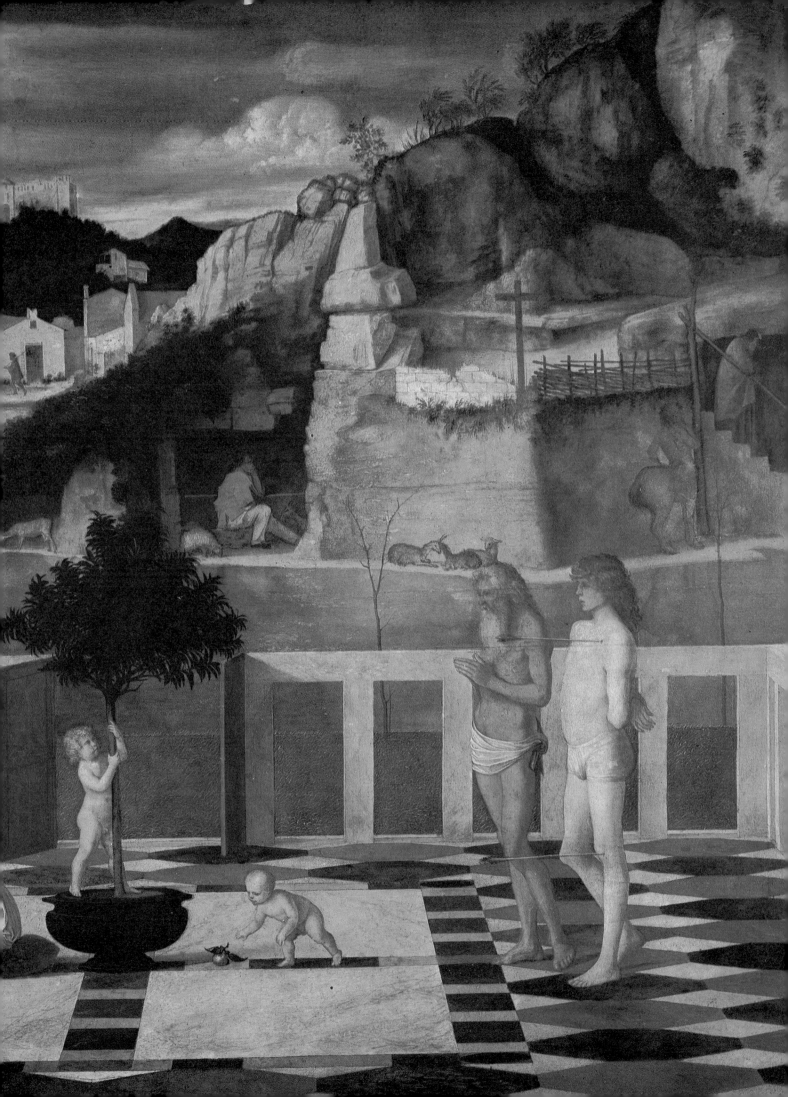

Right: *In both eastern and western religions the pleasures of the happy afterlife have been interpreted spiritually by theologians, but taken literally at popular levels. Paradises are often staffed by delectable girls, like the dark-eyed, high-breasted* houris *of popular Muslim tradition or the* apsaras *of oriental belief. This figure is believed to be an* apsara *from the Chinese Buddhist cave-temples of Lung Men, early sixth century. (Victoria & Albert Museum, London)*

Last Judgment, saints and angels are shown outside the city, from which golden light is streaming. They are depicted strolling and dancing hand-in-hand in a beautiful landscape of trees, flowers and lush grasses, with the well of life appearing as a diminutive pool. In Jan van Eyck's painting *The Mystic Adoration of the Lamb*, the blessed and the angels worship the Lamb of Revelation in a flowery tree-lined meadow with the fountain of life in the foreground and the spires of the city in the background. Giovanni Bellini's *Sacred Allegory* shows a formal paradise-garden in the foreground, complete with the tree of life and the well of life, and, again, the city in the background.

The trees and flowers, the burgeoning fertility and the beauty of paradise all influenced the decoration of churches. Flowers and foliage were carved on capitals and bosses, rood-screens and pew-ends. A church, as the house of God, was a miniature earthly image and foretaste of heaven, where the faithful are gathered together in brotherly love to worship God eternally. The columns and arches soared up into the heights, the ceiling might be painted blue for the sky or spangled with stars, and high up in the roof winged angels were to be seen, often sounding trumpets and playing musical instruments.

In their rich and complex roles in Christian symbolism, the tree of life and the water of life—river or well or fountain—stand for immortality. The tree with its roots in the ground and its crown in the sky is the axis or centre of the world, linking earth and heaven and like the ladder implies spiritual ascent. It is also the cross on which Christ died to bring men the possibility of eternal life, and in legend the tree of the cross grew from a seed of the tree of life in Eden. The tree may also be the family tree of Christ's descent from David, in

which case it is often a vine. A vineyard is another protected enclosure where the faithful flourish under God's care. 'My beloved had a vineyard on a very fertile hill'[27]: this vineyard in Isaiah is Israel, the watchtower at its centre is the Temple in Jerusalem, and the 'beloved' is David (or in Christian exegesis, Christ). In the Song of Solomon, which was interpreted as an allegory of the soul's union with the divine, the royal bridegroom is a keeper of vineyards.[28] Jesus said: 'I am the true vine, and my Father is the vinedresser . . . I am the vine, you are the branches.'[29] The fruit of the vine is the wine of the Eucharist, the blood of the Saviour.

Jesus compared the Kingdom of God to a great tree in which all the birds of the air make their nests.[30] This image was again connected with the tree of life in paradise and became a symbol of the Church. One of the most popular medieval descriptions of the afterworld was the Vision of Tundale, written by an Irish monk in Germany in the twelfth century. Tundale was an irreligious knight who fell into a trance in which he went through a magic door that opened by itself into the meadow of the fountain of youth, filled with flowers and fragrance. He came to a wall of silver, with beyond it a host of souls in white robes giving thanks to God, and then to a golden wall and an immense tree, covered with blossoms and fruit. Birds of every species perched on it and in its shade were saints and martyrs, praising God. The tree is the tree of life from Eden, the tree of eternal life, and the tree of the Church, in whose branches every soul may nest, under whose outspread arms all may shelter.

Both God and Christ in the Bible are sources of 'living water', and the well or fountain of life in the Christian paradise is a symbol of immortality and the life-giving presence of the divine. The four rivers which flowed out of Eden to water the earth could be interpreted as the four gospels, the saving streams of the message of Christ. Baptism in water is the rite through which the Christian enters the ranks of the faithful in the hope of eternal life, and in some paintings of Eden the fountain or well in the garden is an ornate baptismal font.

The tree which gives fruit and shade, the vine and the grape, flowers and birds, the spring and the fountain, are connected with immortality and blessedness all over the world. According to a Muslim tradition, there is a tree in paradise which is so large that a man could ride beneath its shade for a year and not come to the end of it. A colossal rose-apple tree grows on Mount Meru in Hindu legend, and gives shade to the whole earth. The juice of its fruits, which are as big as elephants, forms the river of immortality. In the book of Enoch, an apocryphal Jewish work of the later centuries B.C., a high mountain is seen, which is the throne of God. It is encircled by sweet-smelling trees and one of them, a palm, is the tree of life. Its leaves and blooms never fade and it has 'a fragrance beyond all fragrance'.[31] Sacred rivers, springs and wells abound in Celtic traditions, and so do sacred trees and groves, in which the Druids held their rites.

Revelation says that the souls in heaven will not hunger or thirst any more. The tree of life yields its fruit every month to give them food and the river of life gives them drink. The Old Testament predicted a sumptuous feast in Zion, 'a feast of fat things, a feast of wine on the lees, of fat things full of marrow', and in the time of Jesus it was believed that the blessed would banquet at golden tables in paradise. The 'bread of heaven' or 'food of angels' in the Old Testa-

Below: *One of the* apsaras *who provide sexual delights in Hindu paradises. Apparently, they were originally personifications of clouds and mists as beautiful girls in the sky. Also known as 'daughters of pleasure', they are skilled in all erotic arts and are said to be fond of gambling and dancing. They are the counterparts in paradise of temple prostitutes on earth, and they sometimes come down to earth to tempt holy men.*

ment is the mysterious manna, which God dropped from the sky to save the Israelites from starvation in the wilderness after their escape from Egypt. Jesus identified himself with the manna 'which comes down from heaven and gives life to the world', and said: 'he who eats my flesh and drinks my blood has eternal life'. The Christian's spiritual sustenance in this life is the bread and wine of the Eucharist, transformed into the divine body and blood. The food and drink of the banquet in heaven are similarly interpreted as spiritual refreshment (though some theologians have allowed for the blessed to have physical food and drink if they wish). Cardinal Newman called Christ 'the food for eternity' and referred to 'tasting' the torrents of delight of the divine presence: echoing St Anselm, the eleventh-century philosopher, who in the same sense spoke of drinking the torrents of God's pleasures.[32]

Some Christian authors suggested that the blessed are sustained on the delicious fragrance of heaven. The promised land of milk and honey, however, was originally a country of physical as well as spiritual fertility, and Eden was an oasis of fruitful trees in the barren desert. Judging from the rebukes of preachers, from early Christian descriptions of supernaturally abundant corn, palm-trees and vines in the afterworld, and from talk of rivers of milk, honey and wine, many ordinary believers hoped to enjoy plenty to eat and drink in a straightforward physical sense. 'I should like to have a great pool of ale for the King of Kings', wrote a cheerful Irish Christian author, no doubt in humorous exaggeration. 'I should like the Heavenly Host to be drinking it for all eternity.'[33]

Feasting was one of the principal pleasures of pagan paradises, presumably because it was a special but rare delight in this life. The banquet of the dead was a theme of Etruscan and Roman funeral art. In Valhalla the warriors feasted on inexhaustible supplies of pork and mead, and in Celtic otherworlds and fairylands magic pigs, cauldrons and vats or magic fruit-trees (often apple-trees) produced unfailing quantities of delicious food and drink. We eat to stay alive in this world, so it was natural to think that we will do so in the next, and the prospect of plenty of food appealed to people all too familiar with hunger. But the afterworld feast is not only a matter of gluttonous gorging. It is part of the general theme of the ideal society, in which there is good company and sociable enjoyment. Hospitality was a sacred duty in early societies and the afterworld banquet is the hospitality of the gods.

In Muslim tradition the blessed in paradise are invited to feast with Allah in the garden of Eden, which is a great valley, entered through an emerald gate and glittering with precious stones. 'Its soil is of finest musk and saffron and ambergris, its stones of jacinths and jewels, its little pebbles and rubble are of gold, while on its banks are trees whose limbs hang down, whose branches are low, whose fruits are within easy reach, whose birds sing sweetly, whose colours shine brightly, whose flowers blossom in splendour . . .'[34] Seated in jewelled chairs beneath the trees, and ranked in order of spiritual merit, the blessed are served a banquet of unparalleled savour and magnificence. At the climax of the feast, Allah reveals himself to them, 'and no joy can equal their joy in that, nor can any happiness or delight stand beside their happiness in that.'[35]

In Islam, as in Judaism and Christianity, the pleasures, beauties

Right: *An eternity of sexual pleasure is one of the metaphors which have been used to express the concept of everlasting bliss in the afterlife. This detail from a nineteenth-century painting in a Tibetan Buddhist temple shows the Boddhisattva Samantabhadra in union with his Shakti, or consort. The circles are symbols of completeness and eternity. (Fosco Maraini Collection, Florence)*

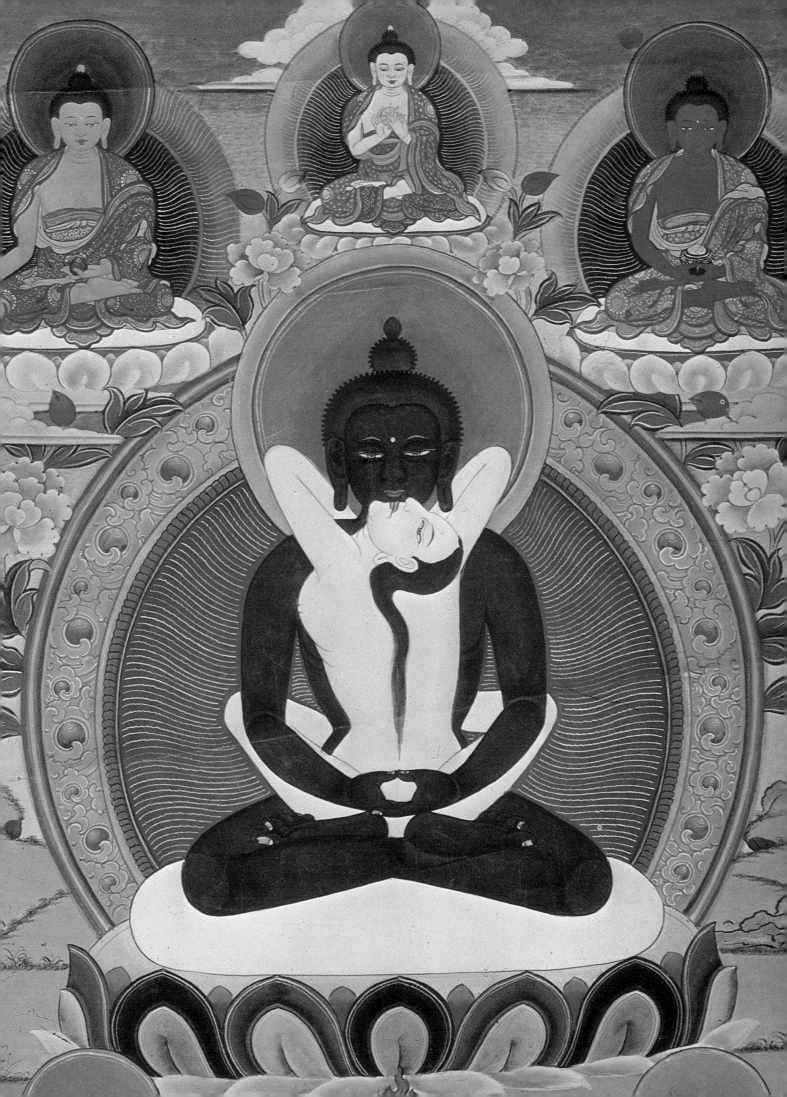

and riches of the afterworld were interpreted spiritually by theologians but were taken literally at popular levels. In the Koran and in Muslim traditions the blessed in the gardens of paradise wear silken robes and recline on soft couches or rich carpets and green cushions. Shaded by trees hung with ripe fruit, never feeling too cold or too hot, hearing the splashing of streams and cool fountains, they engage in amicable conversation and eat and drink from vessels of silver. Paradise is a haven of peace, rest and luxury, where everyone is beautiful and everyone is satisfied with his station and envies no one else. The blessed are attended by graceful boys, spilled about the scene like sprinkled pearls, and by the dark-eyed high-breasted *houris*, girls as lovely as corals and rubies. To increase the erotic pleasures of paradise, each man is specially endowed with the sexual vigour of a hundred men.

Hindu paradises are similarly staffed by delectable nymphs, the *apsaras*, skilled in all sensual arts. The Christian heaven, on the other hand, is devoid of sex. Jesus said that there is no marrying in heaven because there is no death there and so, by implication, no birth. Christian theologians regarded sexual passion as a profoundly dangerous and evil force, and could find no place for it in the Kingdom of God. Some Christians doubted whether a woman could be resurrected in heaven as a woman, and thought she would have to be

Below: Le Concert Champêtre, by Giorgione, fifteenth century. There is no sex in the Christian heaven, but eroticism sidled into Renaissance concepts by way of rediscovered classical mythology. Giorgione used the pagan Greek theme of the Elysian Fields to portray a paradise of innocent sensual pleasure in love, music and communion with nature. (Louvre, Paris)

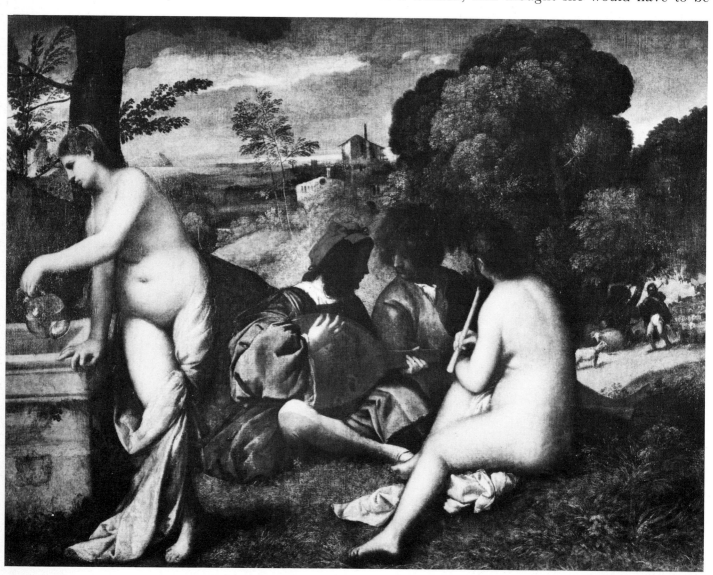

transformed into a man. In support of this opinion they cited a text from St Paul about the Christian goal of attaining 'mature manhood'. If only one pole of each pair of opposites exists in heaven, then perhaps it contains the male but not the female. St Augustine, however, said that women would probably remain female in heaven: there would be no danger in their presence, 'for all lust will then be extinguished'.[35]

All the same, eroticism sidled into Christian concepts by way of the Song of Solomon, the imagery of the garden and the rose, and the connection between the Virgin Mary and Venus, the Roman goddess of love. The Virgin Mary is *hortus conclusus*, 'the enclosed garden' (or literally 'paradise') of the Song of Solomon: 'A garden enclosed is my sister, my spouse; a spring shut up, a fountain sealed.' The garden suggested Eden and in Christian symbolism Mary is the second Eve. As Eve disobeyed God in Eden and persuaded Adam to commit the sin which alienated man from God, so the Virgin submitted to God's will and bore Christ who reconciled man with God. Mary's garden—the second Eden, as it were—is a paradise of roses. She is the Mystic Rose, the rose without a thorn, the rose of love. She is shown in paintings in her walled or trellised rose-garden with the infant Jesus, angels and songbirds. Sometimes a picnic is set out, representing the Eucharist, and sometimes the garden contains the 'spring shut up' or 'fountain sealed', which is the counterpart of the well or fountain of life in Eden. There may be white and red roses in the garden, the white for chastity and the red for consummation. There may be lilies of the valley, again taken from the Song of Solomon: 'I am a rose of Sharon, a lily of the valley.'[37]

Venus also owned a garden, and was originally a goddess of gardens. Her pleasure-ground was rapturously described by classical poets as a paradise of natural beauty and carnal delight. The rose of love, Venus's flower, was worn as a badge by Roman prostitutes, and was a symbol of life after death. In the Middle Ages the garden of Venus was interpreted spiritually, like the Song of Solomon, in terms of God's union with Mary and the mystical marriage of Christ and the soul or the Church. But the pagan and erotic content of the imagery was unmistakable, and there were complaints that Mary's bower of spiritual love and Venus's garden of desire were being unsuitably confused.

Eventually writers and painters linked the garden of Venus with the classical myth of the golden age, which was itself connected with the Elysian Fields. By the time of the Renaissance, in Cranach's painting of *The Golden Age*, the enclosed garden had become a paradise of sexual pleasure and the dancers hand-in-hand are not saints and angels but naked men and women. The Virgin Mary is no longer present, but there are references to Eden in Adam and Eve and the peaceable animals, and there is a city on a hill in the background. The naked picnic in Giorgione's *Concert champêtre* (painted in the Venetian Renaissance) has an entirely pagan Elysian setting, which reappears in paintings by Watteau, such as *L'Embarquement pour l'Île de Cythère* painted in 1717—Cythera was the island of Venus. Watteau's quest, Robert Hughes has said, was for 'an image of a society of the elect, living in harmony with an idealized nature—feathery green trees, golden light sifting down on a lake—and united *as a society* by love.'[38] As with the otherworld feast, the erotic paradise is part of the theme of the perfect society, the kingdom of flawless harmony and love.

Above: *In striking contrast to Giorgione's idyll is this Indian stone carving of the second or third century, showing the dead Buddha surrounded by his disciples. Buddha attained Nirvana, but it was impossible for artists to depict it, since it is a state of liberation from all earthly and human conditions. Buddhists have called Nirvana the perfect peace, the harbour of refuge, the cool cave, the further shore.*

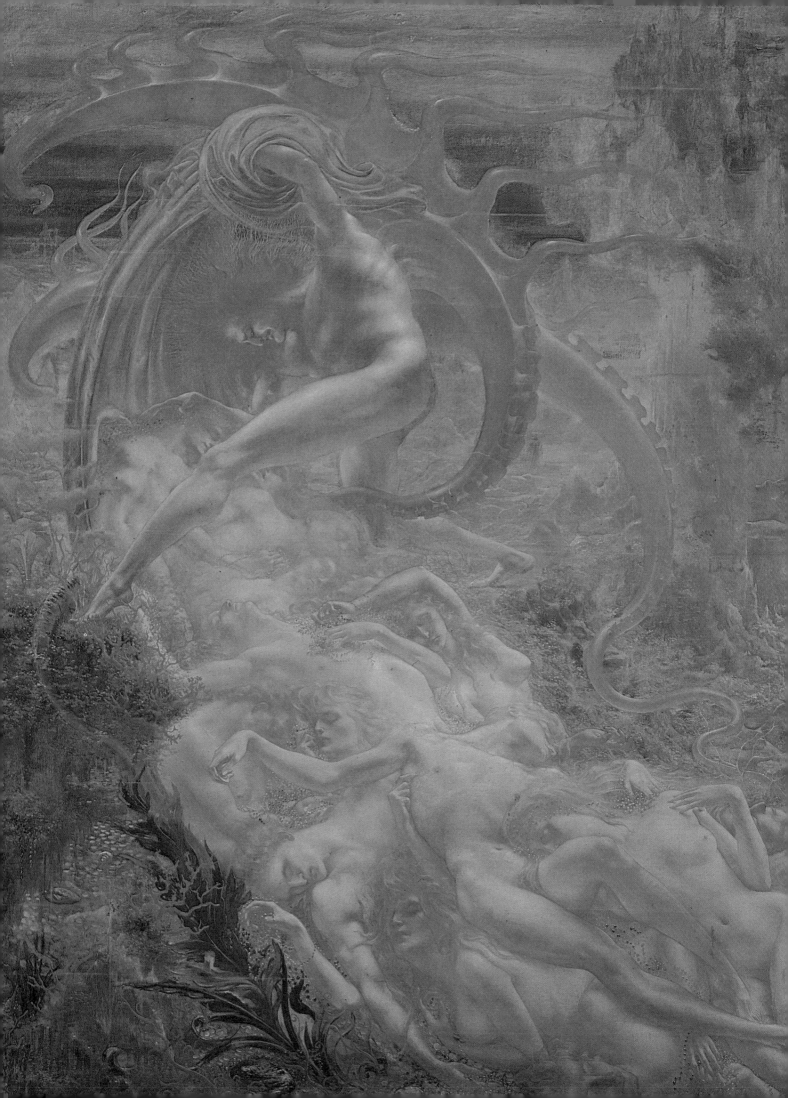

Chapter four
The Underworld

Man that is born of woman is of few days, and full of trouble. He comes forth like a flower, and withers; he flees like a shadow, and continues not . . . For there is hope for a tree, if it be cut down, that it will sprout again, and that its shoots will not cease. Though its roots grow old in the earth, and its stump die in the ground, yet at the scent of water it will bud and put forth branches like a young plant. But man dies, and is laid low; man breathes his last, and where is he? As water fails from a lake, and a river wastes away and dries up, so man lies down and rises not again.

Job 14. 1–12

Left: The underworld of desire in The Treasures of Satan *by the symbolist painter Jean Delville, who died in 1951. Satan is lord of the flesh. His hair is flaming red for desire and destruction. Instead of the angelic wings of a bird, his wings are like snakes, which are earth-bound creatures and are symbols of sex and death. Sunk in oblivion in a submerged landscape, the tumbled human bodies are Satan's treasure-hoard, victims of their own sensuality. (Musées Royaux des Beaux-Arts, Brussels)*

In Irish stories the entrance to paradise, or even paradise itself, is sometimes located in the *side*, the burial mounds of the dead. The prehistoric tomb called Newgrange, in the Boyne Valley, was believed to contain a magic otherworld and some said that the Land of Promise was inside the burial mound of Bri Leith, near Ardagh, County Longford. This type of tradition is the background to medieval tales of people seeing fairies feasting inside hills, and to legends of King Arthur and other great heroes held in an enchanted sleep in deep caverns under hills.

Hills and caves are frequently associated with an underground land of the dead, but it is not always a paradise of pleasure. The dead buried in the ground arouse fear and the darkness of the grave casts its shadow before it. The cave of Cruachan in Connaught, which in Christian times was rumoured to be an entrance to hell, was in earlier pagan tradition a gateway through which sinister armies of the dead emerged to attack the living. The way to the oracle of Trophonius in Greece, of which it was said that whoever visited it never laughed again, was through a deep fissure in the ground. Volcanoes were associated with the fire of punishment in the afterlife. It was said that hell or purgatory was inside Mount Etna, and the same idea was applied to Vesuvius and Stromboli.

In Scandinavian belief the dead lived on in their burial mounds or in hills. Helgafell (Holy Hill) in Iceland was revered as the home of dead ancestors, and the idea of the dead living in hills survived until recently in Lapland. Alternatively, the dead might go to the grim, icy underworld ruled by the goddess Hel, with its massive walls and

great gates. The name Hel probably comes from a word meaning 'to cover' and is connected with the grave. Snorri Sturluson described the goddess as half black and half flesh-coloured, which suggests a decaying corpse. 'The dark underworld ruled by Hel as pictured by Snorri is very much a literary abstraction. But behind this there is a series of glimpses of the grave as the dark dwelling of corpses and serpents, a place of horror and bitter cold and stench and rotting treasures . . .'[1]

In Babylonian texts the underworld is called 'the land of no return'. It is described briefly in a famous passage in the ancient Babylonian Epic of Gilgamesh as the place which no one who has entered it ever leaves—reached by a road on which there is no going back. The dead, winged and flying like birds, exist there in darkness with only clay and dust to eat. Everyone, good or bad, rich or poor, goes to the same bleak, dust-shrouded prison. Gilgamesh is told that when the gods made man, they made him mortal, and immortality they kept for themselves. The moral is that it is life on earth which matters and we had better enjoy it while we can.

The pessimism of the texts contrasts with Mesopotamian burial customs. The 'royal' tombs at Ur, for instance, imply a belief in a life after death which is substantially a continuation of life before it. The rich and powerful in this world were supplied with servants and equipment appropriate to a rich and powerful position in the after-world. Humbler people were buried with food, drink and equipment, and their relatives continued to bring fresh supplies of food and drink to their graves long after death. If they failed to do this, the belief was that the dead man would become ravenously hungry. He might return to the land of the living, stalking the streets and rooting in garbage heaps; and he might also attack his negligent family. Diseases and misfortunes of all sorts were attributed to the unwelcome attentions of angry ghosts. The texts, which represent a very different attitude, may have been intended to discourage the cult and the fear of the dead.

Above: The great Babylonian fertility goddess Ishtar descended into the underworld, where she was killed and her corpse was hung on a stake. The earth became barren until the gods released her and brought her back to life. (Musées Nationaux, Paris)

The darkness and dustiness of the land of no return are both characteristics of the grave. The border of the underworld was only a little way below the surface of the ground, so that when the Babylonians dug deep foundations for a building they could boast that it was built 'on the breast of the underworld'. They believed that there was an entrance to the underworld in the far west where the sun set, and that each grave was also an entrance. The dead had to cross a river, ferried over by a boatman who had four hands and the face of a bird. Then they went to the great city of the dead with its seven walls and seven gates. Inside it was the palace of lapis lazuli where the queen of the underworld, Ereshkigal, 'lady of the place below', lived with her consort Nergal, the god of war and plague.

The underworld had its own bureaucracy of record-keepers and officials, who were imagined as monsters, made of bits and pieces of human and animal forms jumbled together. A text of about 650 B.C. describes a nightmare in which an Assyrian prince saw the underworld and its civil servants. One had the head and wings of a bird but human hands and feet, one had the head of an ox and another the head of a goat, and there was one with two heads and one with three feet. The prince also saw Nergal himself, wearing his royal tiara and sitting on his throne, shrieking and roaring like a howling storm. It is made clear that the dream was intensely frightening.

Terrifying monsters were associated in Mesopotamian mythology with the evil forces of chaos, which had been defeated and subdued long ago when the gods established order in the world but which remained a permanent menace. Other underworlds and hells frequently contain monsters in animal and semi-animal forms. They are often believed to devour the dead and they suggest a deep and persistent fear of the animal world from which the earliest human beings emerged, which preyed on them and on which they preyed.

In the Old Testament, again, all the dead go down into darkness and dust in the land of no return. 'Are not the days of my life few? Let me alone, that I may find a little comfort before I go whence I shall not return, to the land of gloom and deep darkness, the land of gloom and chaos, where light is as darkness.'[2] This land of gloom is called Sheol or 'the pit' or Abaddon, 'destruction'. The dead there are powerless: in G. B. Caird's phrase, they are 'mere carbon-copies of living beings in the eternal filing system of the underworld'.[3] Better to be a dog and alive, says Ecclesiastes, than a lion and dead. The living at least are conscious, but the dead know nothing. 'Their love and their hate and their envy have already perished, and they have no more for ever any share in all that is done under the sun.' And he draws the same conclusion as the Epic of Gilgamesh long before. 'Go, eat your bread with enjoyment, and drink your wine with a merry heart . . . Enjoy life with the wife whom you love, all the days of your vain life . . .'[4]

Old Testament writers, in the main, were concerned with Israel's destiny as a nation, not with individuals. They fixed their hopes on the Day of the Lord, when God would bring the chosen people a new era of holiness, happiness and peace. But they also insisted repeatedly that the dead were forgotten and helpless in Sheol and this was probably because many Jews had not forgotten them, and indeed offerings were made to the dead. The religion of Yahweh as the one God discouraged the cult of the dead as a danger to monotheism.

Above: 'O death, where is thy sting? O grave, where is thy victory?' (I Corinthians 1.55). The hope of new life after the barren darkness of the grave was one of the great bastions of the Christian faith until it began to fade away in the seventeenth century with the rise of modern science, which undermined confidence in the possibility of life after death. The dead rise from their graves at the last trump, from an eleventh-century manuscript. (Klement Gottwald Museum, Prague)

Right: Orpheus in the Underworld
by Pieter Brueghel the Younger,
sixteenth century. The classical Hades
has been turned into the Christian hell,
dark and fiery, seething with torments
and nightmare monsters. Orpheus is
playing the harp before Hades and
Persephone. In the Greek myth his
music so charmed them that they allowed
him to rescue his wife, Eurydice, from
their kingdom of death: but he lost her
again, when he looked back at her as
she followed him out of the underworld.
(Pitti, Florence)

Above: Allegory of Satan, *from a*
fifteenth-century manuscript. The ruler
of the Christian underworld is the
Devil, shown here with a regal crown of
horns, the talons of a bird of prey and
the wings of a bat, a creature of night
and evil. His robe is red for sin and
fire. (National Museum, Prague)

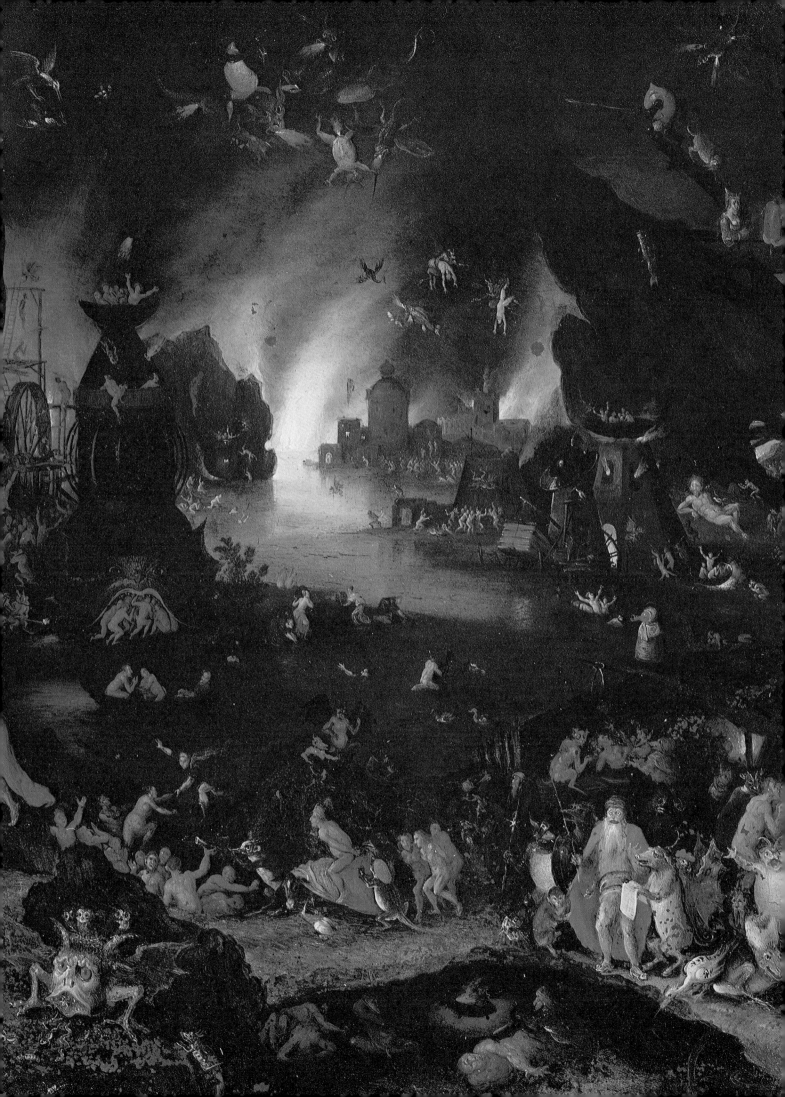

Top: *Detail from a sixteenth-century Flemish painting of the Last Judgment, showing demons carrying damned souls off to be tortured in hell.*

Above: *Hades and Persephone, from a Greek vase. Homer's underworld was a grim, pallid realm beneath the ground. It was not a place of torture, but at popular levels of belief there was a persistent fear of afterworld punishments. (British Museum)*

For the same reason Sheol, unlike the Mesopotamian underworld, had no gods and no bureaucracy, for there was no place for them in a monotheistic system.

In the end it was not possible to maintain the belief in a featureless afterlife, which was opposed to a natural interest in the fate of individuals. It also encountered the problem of God's justice in relation to the notorious unfairness of life. The advice to eat, drink and be merry may be all very well if you can afford it, but what if you cannot? The common human experience is that the good, the pious and the unselfish tend to get the worst of life and the wicked, worldly and selfish the best. The problem of explaining how this can happen in a world made and ruled by a good God is inherent in monotheism, and the long oppression of Israel by foreign powers raised the question on a national scale. Rather as modern writers have suggested that God must be dead, people in Israel began to say that the Almighty, if not actually dead, seemed not to bother about his people on earth. Otherwise, why did his people suffer while their enemies triumphed and prospered?

In the late centuries B.C. there was a tendency to look for a solution to this world's problems in another world altogether, and the belief emerged that the wrongs of this life would be righted in the next. The dead would not all remain forgotten in Sheol. The deserving among them would be resurrected to enjoy a new and happy life. This might not happen until the Day of the Lord, or perhaps the good might go immediately to the bliss of paradise in Gan Eden.

The new belief led to heaven in one direction but to hell in the other. Righting this world's wrongs in the next meant not only that the righteous would be rewarded as they deserved, but also that the wicked would be punished, as they deserved. And although 'the wicked' might initially mean the foreign nations which oppressed Israel, a more humane concern for individuals paradoxically led to the belief in the rigorous punishment of wicked individuals in the world to come.

The punishment was principally by fire. The God of the Old Testament was a god of thunder and lightning, and fire was one of his principal weapons. 'For the Lord your God is a devouring fire',[5] says Deuteronomy, and there are several passages in the Old Testament which describe God's punishment of Israel's enemies on the Day of the Lord as the burning up of rubbish. A prophecy in Isaiah became part of the common currency of Christian beliefs about hell. 'And they shall go forth and look on the dead bodies of the men that have rebelled against me; for their worm shall not die, their fire shall not be quenched, and they shall be an abhorrence to all flesh.'[6]

The place of fiery punishment was called Gehinnom or Gehenna, after the valley of Hinnom to the south of Jerusalem, where the city's rubbish was burned. It was usually thought to be deep underground, but sometimes in the sky. Some said it had seven divisions, apparently the counterpart of the seven heavens above. Although it was fiery and contained rivers of fire, it was also pitch-dark. It was a place of 'dark fire' or 'fire causing darkness'. Hanging, roasting and suffocating in smoke were among its tortures. Some said that the damned would be taken from the fire and plunged into freezing snow, and then back into the fire again. Some thought that the wicked would be punished

in Gehenna for a year and then annihilated, while others believed that they would go on being punished forever. Some declined to believe in it at all.

Some thought that paradise and Gehenna were next to each other, so that the wicked who suffered in Gehenna could experience the additional torment of seeing the happiness which they had forfeited. The conclusion could also be drawn that the blessed in paradise would enjoy watching the agonies of the damned, and this became Christian doctrine. The population of Gehenna was not limited to evil human beings. In the book of Enoch 'angels of punishment' are seen preparing 'the instruments of Satan' for the torture of the wicked, which means that underworld officials have crept back into a monotheistic system. In Christian belief they became the Devil and his subordinate demons who stoked the fires of hell.

The Jewish Gehenna and the Christian hell were both influenced by Ancient Greek beliefs. In Homer, death destroys the body and the conscious self, and with them everything that makes life worth living. All that survives is the *eidolon*, or 'shade', a phantom which goes down underground to the grim kingdom of Hades, the god of the dead, and his queen, Persephone. There the dead flutter about as chirping shadows and helpless caricatures of their former selves, remote from sunlight, love and laughter and all the warmth and sweetness of life.

Odysseus visited the underworld, which he reached by sailing far to the west, into a region of perpetual darkness and mist. He came to a grove of poplars and willows, sacred to Persephone, and went on to

Below: Scene from Dante's Inferno, *by Gustave Doré, nineteenth century. Dante was heavily influenced by Virgil's description of the underworld in the* Aeneid. *The monster is the three-headed Cerberus, the watch-dog of the classical Hades. Originally, the monster may have been believed to devour the bodies of the dead.*

Overleaf: The river of death in classical belief was the Styx and the dead were ferried across it by an old, truculent boatman named Charon. To pay his toll, a coin was placed in the corpse's mouth before burial. This painting by Joachim Patinir, sixteenth century, blends classical and Christian motifs. Charon is rowing a soul across the Styx from purgatory to paradise, in the foreground. Ominously close to paradise is an archway which is the mouth of hell, with the murky, flame-streaked landscape of hell in the background. (Prado, Madrid)

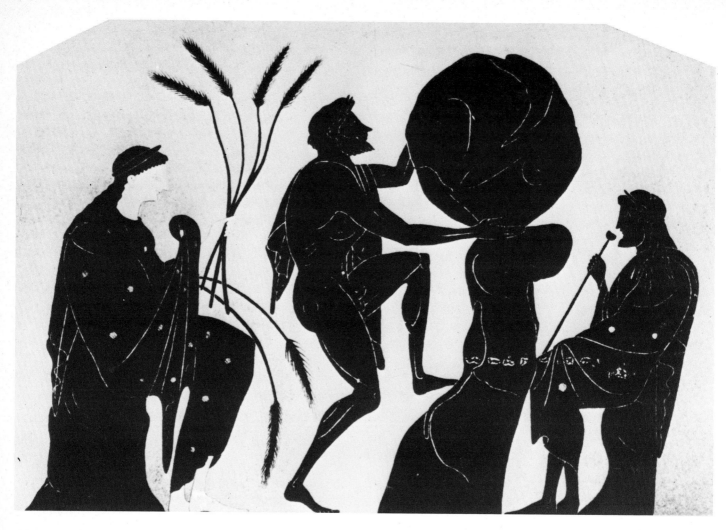

Above: *The torment of Sisyphus, from a Greek vase. In Homer's underworld only a few exceptional sinners were subjected to physical torture. Sisyphus was condemned to push a huge rock up a steep hill. When he reached the top, the rock rolled down to the foot of the hill and he had to begin all over again. The theme of endless repetition of a punishment reappears in accounts of the Christian hell.*

the place where the river of fire and the river of lamentation, a branch of the Styx, joined and poured their waters into Acheron. (Acheron was a river in the north-west of Greece, which at several points in its course disappeared underground, and so was believed to be one of the rivers of the underworld, leading to the Acherusian lake.) Digging a trench, he poured into it libations to the dead, including the blood of two sheep. 'And now the souls of the dead who had gone below came swarming up . . . From this multitude of souls, as they fluttered to and fro by the trench came a moaning that was horrible to hear.' The ghosts were moaning for the blood, which would give them back a temporary lease on the life they longed for. Odysseus saw the under-world meadow of asphodel, a type of lily whose greyish leaves were evidently considered appropriate to the pallid life of ghosts. Perhaps they were believed to eat its roots, which were a staple item of the poor man's diet in Greece. Eventually, Odysseus became afraid that Persephone might send some ghastly monster up from the halls of Hades against him, and he hurried back to his ship.[7]

One monster associated with Hades (the place acquired the name of its god) was Cerberus, the watch-dog who guarded the gate. He was usually shown in art with three heads and a mane or tail of snakes. Perhaps he originally devoured the bodies of the dead. Dogs have an old and uneasy reputation in folk belief as corpse-eaters. Lucian, the Greek satirist of the second century A.D., described Cerberus gnawing human bones. Another underworld monster was Eurynomus,

96

who was certainly believed to eat the dead. He was shown in a painting at Delphi by Polygnotus in the fifth century B.C., blue-black like a blow-fly, showing his teeth and sitting on a vulture's skin. The painting also showed the underworld river, with Charon the ferryman in his boat, as well as criminals being punished for what they had done in life.[8]

Homer's Hades is not a place of punishment for the great majority of mankind, whose actions in life do not affect their lot in the afterworld. But Odysseus does see three cases of punishment there, apparently inflicted for crimes against Zeus. Tityus is savaged by vultures which tear at his liver, Tantalus is tormented by hunger and thirst, and Sisyphus has to heave a huge boulder up a hill over and over again. This contradicts the logic of Homer's description of the rest of the dead, who have no bodies and cannot experience physical enjoyment or physical suffering. The tortures of Tityus, Tantalus and Sisyphus may have been so well known in popular belief that it was impossible to leave them out of a description of the underworld.

Homer's picture of the afterlife was immensely influential, but it was not the only one. One of its rivals was the old belief that the dead lived on in their tombs, from which they could help and protect their descendants. Offerings were made to them and some graves were equipped with feeding-tubes, through which liquid was poured into the corpse's mouth, or in cases of cremation into the ashes. Spending money on the dead irritated legislators and philosophers, including Plato, but people obstinately went on doing it. The practice of feeding the dead through tubes survived in the Balkans into the nineteenth century.

Belief in rewards and punishments after death also flourished. Initiates of the mystery-cults hoped to achieve the Elysian Fields or the Isles of the Blessed. At the other extreme, there are references in the *Eumenides* of Aeschylus, a contemporary of Polygnotus, to punishments in Tartarus. Tartarus is a pit, deep down in the underworld, where victims are tortured and mutilated, beheaded, flayed, castrated, impaled, their eyes gouged out, their throats cut. As in Israel, an important factor was the feeling that wrongs not redressed in this life deserved to be punished in the next.

One of the characters in Plato's *Republic* is an old man who says that it is easy to laugh at the tales of horrors in the afterworld as long as death seems far away, but when it draws nearer a man begins to fear that they may be true. He starts to count up the wrongs he has done to others and when he finds that the total is substantial, he wakes up suddenly at night in terror of what may happen to him. At the end of the *Republic*, Plato describes the fate of murderers, criminals, and the impious. They are beaten and flayed by savage, fiery beings, who card them on thorns like wool and then hurl them into Tartarus. A character in Plautus' play *Captivi* says that he has seen many paintings of the agonies of Acheron. As time went by, descriptions of the torments to come became increasingly detailed and horrific, and reached their peak in Christian accounts of hell.

Some philosophers completely disapproved of the idea of hell. In the first century B.C. Lucretius tried unsuccessfully to dispel the popular 'dread of Acheron' by arguing that human beings are annihilated by death and that therefore nothing survives to be tormented. In the same century Seneca and Juvenal both dismissed the common

people's fear of punishment in the afterworld as childish. But the Greek historian Polybius approved of it because he thought it a useful deterrent to immoral behaviour: 'as the masses are always fickle, full of lawless desires, unreasoning passion, and violent anger, they must be held in check by invisible terrors . . .'[9]

Different beliefs flourished side by side in the Roman world. Some inscriptions on tombs announce that the dead person no longer exists, as in the formula NF F NS NC, standing for *non fui fui non sum non curo*: 'I was not, I was, I am not, I care not.' Sometimes death is 'eternal sleep', but most people seem to have hoped for a conscious afterlife of some kind. The tomb was often called 'the eternal house' and there are other inscriptions which indicate that the dead live on in their graves—for example, 'Lollius has been placed at the side of the road so that passers-by may say to him, "Hullo, Lollius".' The interior of an elaborate sarcophagus of the third century A.D., found at Simpelveld in Holland, was made to resemble a house, with a comfortable living-room, a bathroom and a heating system.

Elaborate Roman tombs often had a dining-room and a kitchen attached to them, and the dead man's family and friends would meet there for a meal on his birthday and during the annual festivals of the dead. (The same custom has survived into this century in Egypt.) A share of the food would be put aside for the deceased host and in some tombs wine could be poured into him down a pipe—wine which cheers and invigorates was naturally a suitable thing to give to the dead. Poorer people were buried in graves with the top of a jar sticking up so that drink could be ladled into it.

Those who could afford it might plant a walled garden, orchard or vineyard around the tomb, with wells and pools for watering the plants. The produce of the gardens could be sold to pay for the banquets and offerings to the dead, but they were also intended to provide pleasant surroundings. The garden might be the earthly

counterpart of the idyllic landscape of the Elysian Fields, which it was hoped that the dead were enjoying; or it might give them an environment bursting with renewed life, for one way in which people were believed to survive after death was through contact with the vigorous life of nature. Inscriptions survive in which the dead man prays for his remains to become roses and violets or for the earth above him to be fertile. This concept of immortality through union with nature did not necessarily deny the survival of the individual personality.[10]

The funeral gardens and vineyards, like the Elysian Fields themselves, contributed to the Christian imagery of paradise. The custom of putting flowers on graves, which has survived to this day, was part of the same concept. Roses were considered especially suitable as talismans of immortality. Rose-gardens were sometimes painted on the walls of tombs and one of the annual festivals of the dead was the Rosalia, when roses were scattered on graves. Garlands, clusters of grapes, horns of plenty and evergreen wreaths and sprays were also symbols of immortal life in Roman and, later, in Christian art. Bees were welcome at tombs, some of which were constructed with crannies to attract them, because honey was used as a preservative and so connoted immortality.

Scenes of the triumph of Bacchus or of Bacchus rescuing Ariadne represented survival of death through the loving embrace of a deity. A similar scene on Roman sarcophagi illustrates the myth of Endymion, who was loved by the moon goddess, Selene. She is shown being led by Eros, the god of desire, to waken the sleeping Endymion, who represents the soul which is to wake from the sleep of death. Hercules is frequently depicted on sarcophagi because he had triumphed over death to become a god. There are also scenes of battle, with Greeks fighting Amazons or gods fighting giants, which may have been meant to suggest a victory over death.

The Romans' most important single legacy to Christian beliefs about the afterlife was Virgil's epic poem, the *Aeneid*, which the great poet had not completed when he died in 19 B.C. The famous tag from the work, *facilis descensus Averno*, 'easy is the descent to Avernus', was constantly quoted as evidence of the ease with which men can fall into hell's clutches; so was another tag about the torments in Tartarus: 'If I had a hundred tongues and a hundred mouths and a voice of iron, I could not describe all the crimes and all the varieties of punishment.'

In the poem Aeneas's descent to the underworld starts at Lake Avernus near Naples, a grim tree-shrouded lake with fumes rising from its black waters, which was popularly believed to be an entrance to Hades. After making propitiatory sacrifices to the underworld powers, Aeneas enters a yawning cave and goes on in eerie darkness, like a man traversing a forest by fitful moonlight, until he comes to the doorway of the land of the dead. At the threshold are the ugly shapes of disease, old age, fear, hunger, poverty, death, pain and war, with all sorts of phantom monsters of human imagination— centaurs, the hydra, the chimera, gorgons and harpies. A great elm-tree stands there with false dreams nesting in its branches. Aeneas passes a whirlpool of seething mud and comes to the marshes of the Styx and the coiling river where crowds of souls, fluttering like birds or the fallen leaves of autumn, wait to be ferried over by Charon.

Above: *Music and singing are pleasures of pagan afterworlds as well as the Christian heaven. This cymbal-player is part of the revel of Bacchus on a Roman sarcophagus.*

Crossing the river, Aeneas succeeds in passing the three-headed Cerberus and comes to a territory equivalent to the Christian limbo, where the souls of dead babies are wailing. At this point the road forks: the path to the right leads to the paradise of Elysium, the one to the left to Tartarus. Looking over to the left, Aeneas sees the outer battlements of a city, encircled by three walls and a river of boiling flames, Phlegethon. The great gate of the city has columns of unforgiving adamant and a tower of iron. From inside he hears moans, the sound of the lash and the clanking of chains. The gates creak slowly open and inside he sees a huge hydra, with fifty black and gaping snake-heads. Further inside is the yawning drop into Tartarus itself, where the wicked are tortured.

Aeneas hurries along the right-hand path to Elysium, the land of green pastures where the blessed live in meadows flooded with roseate

light, among sweet-scented trees and clear streams. Garlanded with snow-white ribbons, they feast, sing, dance, and play games. Aeneas finds his father, Anchises, in a green valley, and he tells him that after death souls are punished to purge them of the taint of their crimes in life. Some are hung up for the winds to blow on, some are washed in a deep gulf, some are purged by fire. Then they are allowed to live happily in Elysium. After a time, some of them begin to long for earthly life again, and they are reincarnated.[11]

The theme of being swallowed by a devouring mouth is repeated several times in Virgil's description—the jaws of the lake, the gaping cave, the jaws of the doorway, the fifty-throated hydra, the yawning gulf of Tartarus itself. The purging of the soul by punishment, though not the belief in reincarnation, reappears in the Christian purgatory. Other elements from the *Aeneid* are also found in Christian accounts of paradise and hell. In Dante's *Divine Comedy* of the fourteenth century, the guide through hell and purgatory is Virgil himself.

Above: The Waters of Lethe *by R. Spencer Stanhope, nineteenth century. Lethe or 'Forgetfulness' was one of the rivers of the classical underworld. In Virgil's* Aeneid *souls which were destined to live a second time on the earth drank the waters of Lethe and lost all memory of their previous lives. In the background is the delightful landscape of the Elysian Fields, the paradise where souls lived happily, playing games and dancing, feasting and singing. (City Art Gallery, Manchester)*

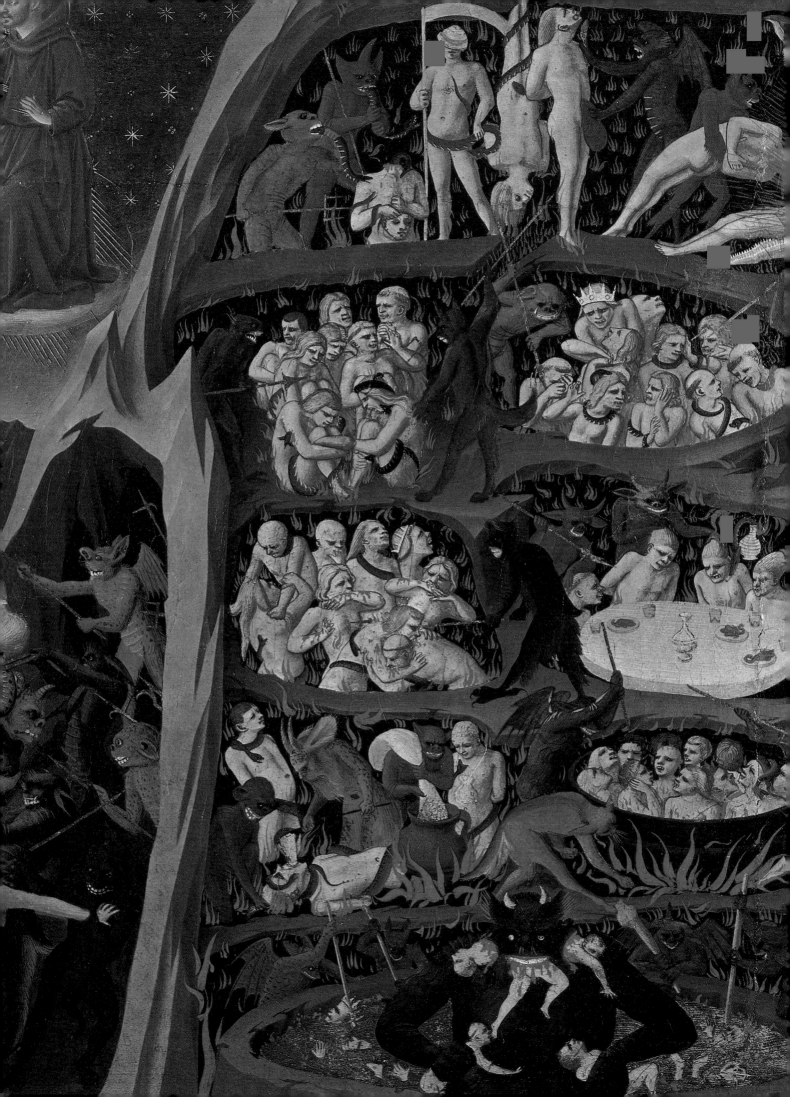

Chapter five
The Abyss of Hell

There are only two kinds of people in the end: those who say to God 'Thy will be done', and those to whom God says, in the end, '*Thy* will be done'. All that are in Hell choose it. Without that self-choice there could be no Hell. No soul that seriously and constantly desires joy will ever miss it. Those who seek find. To those who knock it is opened.

C. S. Lewis, *The Great Divorce*

Left: *Hell, from Fra Angelico's* Last Judgment. *This is the companion piece to his lovely vision of heaven (see page 75), and heaven and hell are treated as opposites in Christian art and literature. The early Church inherited the concept of hell from both Judaism and the classical world. Many Christians were reluctant to believe in it, and doubts about how hell could be reconciled with God's infinite mercy and goodness are expressed in some of the earliest accounts of it: though they are stated only to be overruled. Many of the details of this picture are stock features of the Christian hell, including the carnivorous hell-mouth at the top right, the cauldron in which the damned are boiled, and the monstrous figure of the Devil chewing sinners' bodies at the bottom. (San Marco, Florence)*

In the Apocalypse of Peter, after St Peter has seen the paradise of the righteous dead, Christ shows him another place, opposite paradise, where the air is dark and where sinners are tortured by angels in dark robes. Blasphemers are hung up by their offending tongues over fire. Those who turned their backs on righteousness are sunk in a lake of flaming mire. Adulterous women are dangled by their hair above boiling filth, and adulterous men hang upside down with their heads in the filth. Murderers are confined in a narrow place where they are covered with worms and attacked by evil creeping things. They are watched by the souls of their murdered victims, who applaud God's justice. The dung of the tormented runs down and forms a lake in which women who aborted their babies are immersed to the neck. The babies stand opposite and rays of fire shoot out from them and burn their mothers' eyes.

Those who persecuted Christians are having their lower parts burned while evil spirits flog them and insatiable worms devour their entrails. The wicked rich who exploited widows and orphans are dressed in foul rags and rolled to and fro on sharp, heated stones. Usurers stand in a swamp of pus, blood and seething muck. Homosexuals and lesbians are thrown off precipices over and over again. Children who disobeyed their parents are pecked by flesh-eating birds. Girls who lost their virginity before marriage are beaten until the blood runs. Sorcerers are hung on whirling wheels of fire. The tormented cry to God for mercy, but all that happens is that the angel Tartaruchus ('keeper of Tartarus') comes and heightens their agonies, telling them that it is too late to repent now as the time for repentance

is past. Meanwhile the righteous watch this spectacle with enjoyment.

The Apocalypse of Peter was written early in the second century and its gallery of horrors was popular with Christians. It appealed to a persecuted sect, whose members thirsted for revenge on those who oppressed, mocked or ignored them. But descriptions of hell did not go out of fashion when Christianity had triumphed over hostility and indifference, far from it. The attraction of hell, in Christianity and other religions, is clearly its profound appeal to sado-masochism.

Christianity inherited the concept of hell from Judaism and the mythology of the Ancient World, although judgment and punishment of some sort were in any case necessary consequences of Christian doctrine. God had sent his Son into the world to save all who believed in him. The corollary was that those who did not accept him and his teaching would not be saved. It did not necessarily follow that they must be physically tortured after death, but they must at least suffer the 'pain of loss'. The meaning of 'hell' for many modern Christians is this agony of exclusion from the divine presence. 'He who believes in the Son has eternal life, he who does not obey the Son shall not see life, but the wrath of God rests upon him.'[1]

The result is the tension between Christ as Saviour and Christ as Judge. In the New Testament there is the Jesus who teaches love and forgiveness, and the Jesus who condemns the wicked to 'eternal

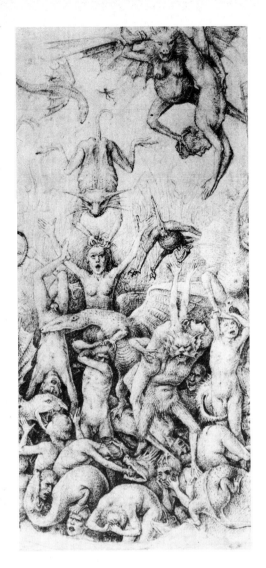

Above left: *Just as heaven means being with God, so the essence of hell is being with the Devil. The damned are literally 'in' the Devil, being eaten by him and then excreted. In medieval art Satan is a semi-human monster, towering over his kingdom of carnage. (Louvre, Paris)*

Left: *The Harrowing of Hell, from the Winchester Bible, twelfth century. Between the Crucifixion and the Resurrection, Christ descended into hell and set free the righteous men of the Old Testament.*

Above: *The demons who infest hell are monsters, mingling human and animal anatomies, to show that they are linked with the animal impulses of man. From* The Fall of the Rebel Angels *by Dierick Bouts. (Louvre, Paris)*

punishment' in 'the eternal fire'.[2] St Anselm said of Christ at the Last Judgment: 'He who is now most patient will then be most severe; now most kind, then he will be most just.'[3] In the twelfth-century mosaic of the Last Judgment at Torcello in Italy, the fire of hell issues straight from the mandorla of light surrounding the figure of Christ. In this and many other pictures of the scene, Christ is shown with the wounds of the Crucifixion, and one medieval writer explained that: 'His scars show his mercy, for they recall his willing sacrifice, and they justify his anger by reminding us that all men are not willing to profit by that sacrifice.'[4]

It was not easy to reconcile the two aspects of Christ and it was as difficult to reconcile hell with God's goodness as the old concept of a featureless afterlife had been to reconcile with his justice. Doubts about the morality of hell are evident in some of the earliest accounts of it, though they are stated only to be overruled. In the Apocalypse of Peter, the apostle says that it would have been better if the sinners had never existed, but Christ reproves him for questioning the will of God and tells him that the damned deserve their punishment. (The same objection is raised and the same answer given in a slightly earlier Jewish book, 2 Esdras.) In the Vision of Paul, the saint bursts into tears when an angel shows him the pains of the wicked, but the angel reminds him that God has given man free will to choose between good or evil. (In later versions, at Paul's pleading, Christ agrees to give the damned a respite from torment every weekend, from three o'clock on Saturday afternoon until first light on Monday, at least until the Day of Judgment.)

The angel's reply to Paul is the justification advanced by modern Christians for hell in the sense of the 'pain of loss', the separation from God. Human beings have free will. They can choose God or reject God. In the end, those who insist on rejecting God must suffer the consequence of that rejection. 'The responsibility is the chooser's,' as Plato said in a similar connection, 'God is not to blame.'[5] If man does not have free will, including the freedom to choose the hell of rejection, then life is pointless. Nicolai Berdyaev, the Russian philosopher, wrote earlier in this century: 'Hell is necessary, not to ensure the triumph of justice and retribution to the wicked, but to save man from being forced to be good and compulsorily installed in heaven.'[6]

In the past, however, the Christian concept of hell was based squarely on the principle of retributive justice. Most of the New Testament references to the fate of the wicked can be construed as annihilation, not torture, but this was not how the Church interpreted them. If people committed crimes, they deserved to be punished in proportion to their offences. If they committed crimes against God, they deserved the severest possible punishment. Extermination was too good for them. In this world, the epistle to the Hebrews says, a murderer is taken and mercilessly executed. 'How much worse punishment do you think will be deserved by the man who has spurned God?' And it goes on to quote, 'Vengeance is mine says the Lord, I will repay.'[7]

The principle that justice demands retribution, an eye for an eye and a tooth for a tooth, lies behind the different torments in hell and the ingenious efforts to make the punishment fit the crime. Just as criminals were tortured and executed in public for the edification of crowds of spectators, so it was believed that one of the pleasures of

the saved in heaven would be to watch the damned writhing in agony, even when the damned were the parents, children or friends of the saved. They would enjoy the sight as a demonstration of God's justice and would realize all the more keenly the happiness of their own condition. This notion eventually went out of fashion with a change in the attitude to retributive justice. In its time it was approved by St Augustine, by Thomas Aquinas, Hugh of St Victor and other medieval theologians, by St Robert Bellarmine in the sixteenth century, and in the eighteenth by Jonathan Edwards, the formidable hell-fire preacher and revivalist of Northampton, Massachusetts.

Another supporting bastion of hell, even among many Christians who privately doubted its existence, was the belief that it was needed as a deterrent. Without the fear of hell people would do whatever they liked and society would collapse in anarchy and crime. An anonymous writer in 1878 echoed Polybius centuries earlier. 'Once remove the restraints of religion, teach the poor that future punishment is a fable, and what will be left to hinder the bursting forth with savage yells of millions of ravening wolves, before whom the salt of the earth will be trodden underfoot, Church establishments dis-

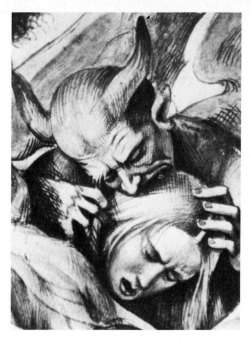

Left: *The torments of hell, from a fourteenth-century frieze at Orvieto Cathedral, Italy. The damned are roped together to be dragged to hell by demons which resemble the lustful, goatish satyrs of Greek and Roman mythology. Below, sinners are being devoured by a monster with two heads. The old dread of being eaten by animals and birds was frequently exploited by writers and artists in descriptions of hell.*

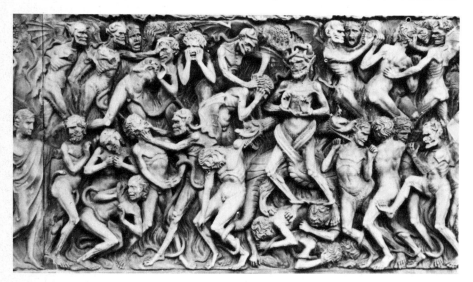

solved and baronial halls become piles of blackened ruin?' R. F. Clarke, a Jesuit who became Master of Campion Hall, Oxford, wrote more moderately in 1893: 'The fear of hell is a powerful deterrent to many educated as well as uneducated, and many a sin would be committed were it not for the wholesome dread of eternal misery before the sinner's eyes.'[8]

Nineteenth-century authors of childrens' books used hell as a deterrent to bad behaviour. A Roman Catholic priest with the appropriate name of Furniss described the horrors of hell for his youthful readers. One child is trapped forever in a flaming oven, screaming to be let out and beating her head against the roof. A 16 year old girl who preferred going to the park on Sunday to going to church is condemned to stand eternally barefooted on a red-hot floor. A boy who drank and kept bad company is permanently immersed in a boiling kettle. The blood of a girl who went to the theatre seethes in her veins and her brain is audibly boiling and bubbling in her head.

Some Christians always obstinately wondered whether God in his mercy would condemn any soul to eternal torture, and had to be

Above: *Detail from a fresco at Orvieto by Signorelli, sixteenth century. Again, one of the damned is being gnawed by a demon.*

Right: *The afterworld punishments of Christian and oriental belief are very similar. The attempt to devise gruesome and agonizing tortures has produced the same motifs independently from the cruellest depths of the human mind. This detail from a Chinese Buddhist painting shows Yama, the king and judge of the dead, enthroned in his hall of judgment in the seventh hell. In the foreground demons and dogs drive sinners into a river. (Horniman Museum, London)*

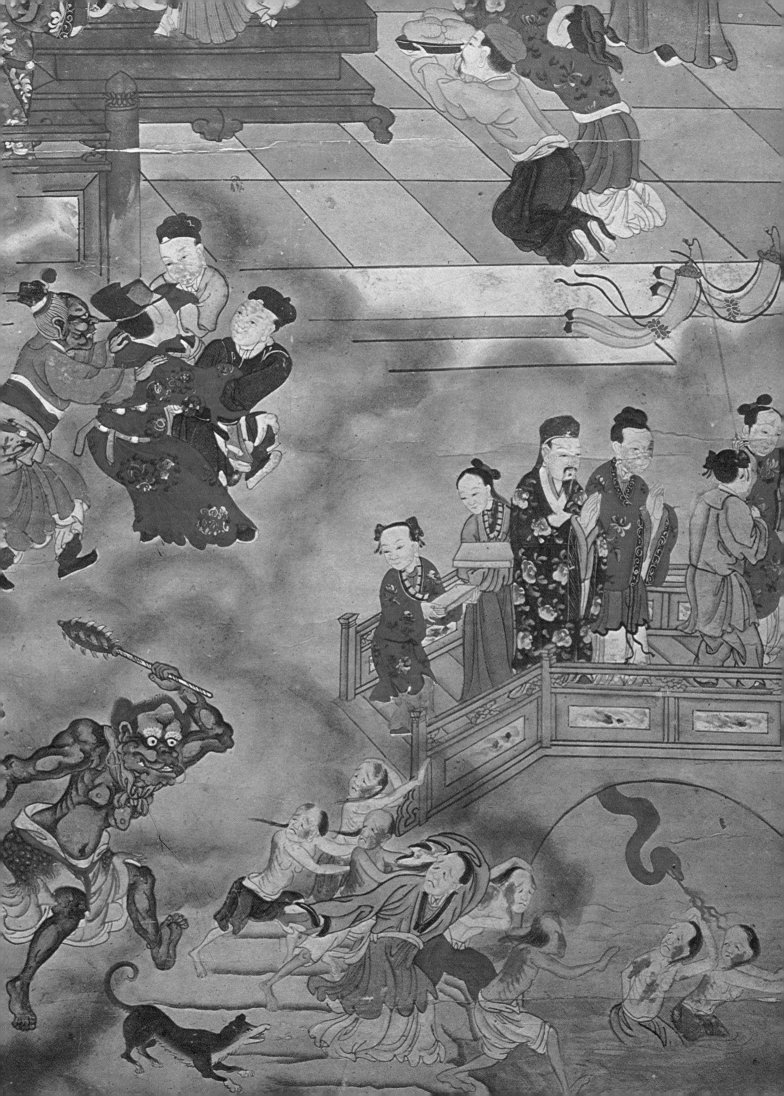

corrected by those determined to preserve hell in all its rigour as a deterrent. St Augustine contradicted Christians of his time who thought that the saints might successfully intercede for the damned. An English preacher of the fourteenth century said disapprovingly that 'many men think that there is no hell of everlasting pains, but that God doth but threaten us and not do it indeed'. A famous preacher of the thirteenth century, Berthold von Regensburg, reported some people saying that Christ would protect sinners from torment in hell, and others that no doubt a man could become used to hell in time and be more at his ease there than anywhere else: both of which abominable opinions he vigorously denounced.[9]

Heaven and hell were not only a spur to good behaviour and a deterrent to bad, but social and political tranquillizers. They helped to reconcile people to undeserved suffering and the unfairness of life, which rewards and punishments in the afterlife had originally been needed to justify. The poor were encouraged not to rebel but to keep their humble station in this life and wait for the ample revenge which would be granted them in the next: the opposite of the old belief in a happy afterlife reserved for the aristocracy. This note is clearly struck in a sermon by John Bromyard, an English Dominican of the fourteenth century, preaching on the fate of the rich and powerful after death: 'Their soul shall have, instead of palace and hall and chamber, the deep lake of hell, with those that go down into the depth thereof. In place of scented baths, their body shall have a narrow pit in the earth; and there they shall have a bath more black and foul than any bath of pitch and sulphur. In place of a soft couch, they shall have a bed more grievous and hard than all the nails and spikes in the world; in places of inordinate embraces, they will be able to have there the embraces of the fiery brands of hell . . . and in place of the torment which for a time they inflicted on others, they shall have eternal torment.'[10]

Preachers and writers harped constantly on the reversal of this life's fortunes in the afterlife. Jesus himself had said that it was easier for a camel to go through the eye of a needle than for a rich man to enter the kingdom of heaven. There was vengeance in store for privilege, power, wealth, beauty or any worldly attainment. 'This the kings, earls, princes and emperors well demonstrate, that once had the joy of the world and now they lie in hell and cry out and wail and curse and say, "Alas, what help us now our lands, our great power on earth, honours, nobility, joy and boast? All is passed, yes, sooner than a shadow or a bird flying or the quarrel of a crossbow."'[11]

For all the oceans of ink and ingenuity expended on it, hell, like heaven, is ultimately unimaginable. The negative formula, often used to give an impression of heaven, has its counterpart in descriptions of hell. If a man had a thousand tongues of steel, he could not describe all the horrors of it, or if a hundred men with four iron tongues apiece spoke from the first day of creation to the Day of Doom, they could not exhaust the list of tortures. One hour of the agony of hell is worse than a century of the severest pain known on earth, and the suffering of a woman in childbirth has the same relation to the suffering of purgatory as a cold bath has to a burning oven. Hell is not fully conceivable, in the end, because it is chaos. It is the opposite of the perfect order of heaven. Attempts to picture hell, however, necessarily import order into it, because total chaos is not describable.

Above: *This detail shows the colossal figure of Satan in the lowest depths of hell of Dante's* Inferno. *He has three heads, because he is the infernal parody of the Trinity. In his central mouth he chews the body of Judas Iscariot, the betrayer of Christ. In the other two he mangles Brutus and Cassius, assassins of Caesar. Drawing by Botticelli, fifteenth century. (British Museum)*

The most powerful and effective attempt to give a detailed description of the Christian hell is Dante's *Inferno*, part of his *Divine Comedy*. It was so vivid that people believed that Dante had explored the afterworld not only in the spirit but in the flesh. The great poet died in exile from his native city of Florence, in 1321 at Ravenna, where he was buried. The Florentines made several attempts to recover his remains, but in 1519, when his sarcophagus was opened, there was nothing inside but some withered laurel leaves and a few fragments of bone. The Florentines reported to Pope Leo X that 'it is supposed that, as in his lifetime he journeyed in soul and body through Hell, Purgatory and Paradise, so in death he must have been received, body and soul, into one of those realms.' Dante's remains had been hidden, however, and his skeleton was discovered in a different coffin in 1865. It was put on display in a glass case and thousands of people came from all over Italy to see it.[12]

Dante's hell is an inverted cone which has nine circles or layers, corresponding to the nine spheres of the heavens above. The deeper down into the pit, the greater is the degree of wickedness and the more terrible the punishment. The *Inferno* begins with Dante in a dark wood at night, uncertain of how he has come there. He meets the shade of Virgil, who takes him to the gate of hell, with its chilling inscription: 'Abandon hope, all ye who enter here.' They pass through to the river Acheron, where Charon ferries the dead across in his boat. Beyond the river, they enter the first circle, the limbo where the souls

Below: The principle of retributive justice, that the wicked must be punished because they deserve it, lies behind ingenious attempts to make the punishment fit the crime in hell. In this illustration to Dante's Inferno, *by Gustave Doré, the souls of blasphemers are tormented by fiery flakes, falling softly like snow, the hellish equivalent of the manna, the miraculous food with which God saved the Israelites from starvation after their escape from Egypt.*

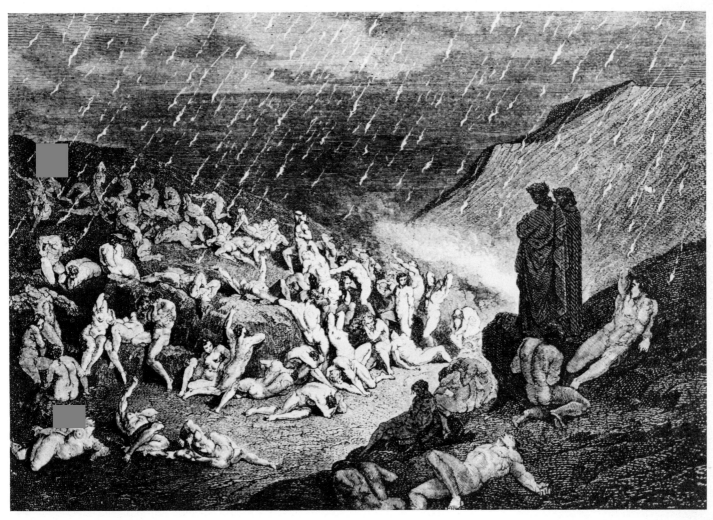

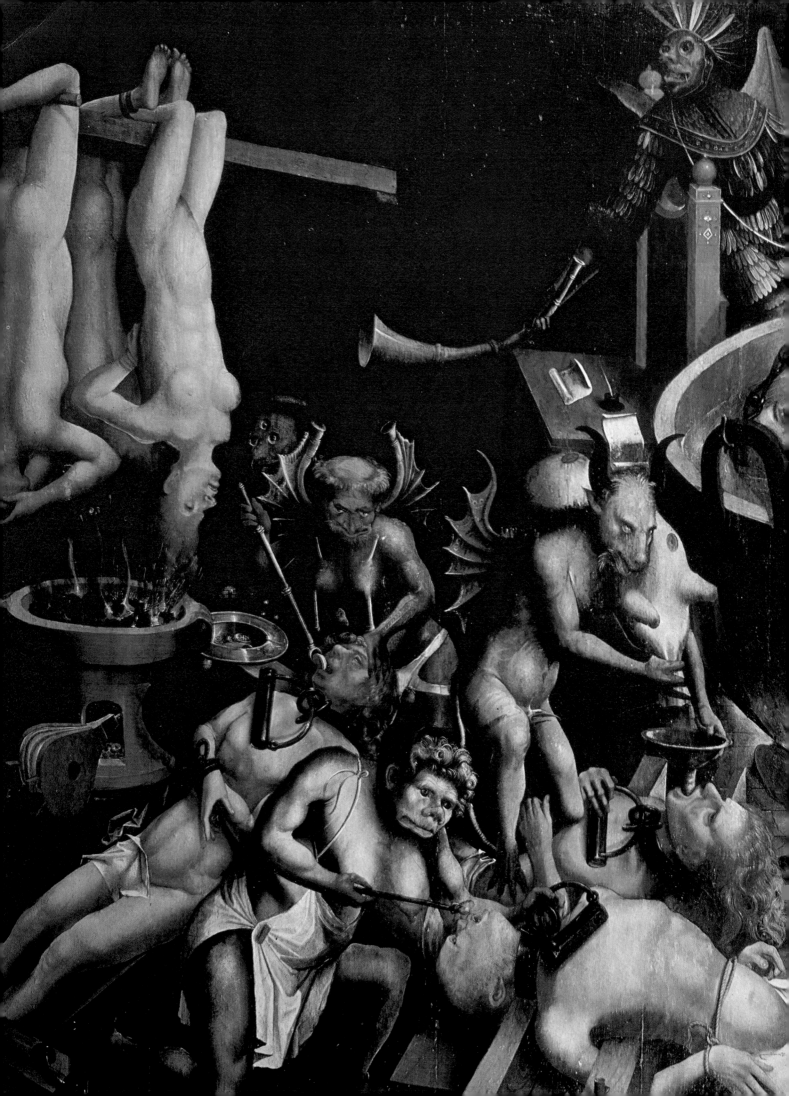

of virtuous pagans bewail their lot for having lived too soon, before the coming of Christ, but pass the time not altogether unpleasantly in the green meadow of the Elysian Fields. Dante and Virgil descend into the second circle, where those who in life fell prey to tempestuous sexual passion are forever whirled about and buffeted in a raging storm. The third circle is a place of perpetual rain, snow and hail, where the souls of gluttons are clawed and flayed by the three-headed, red-eyed Cerberus. In the fourth circle sinners guilty of the two opposite crimes of miserliness and prodigality push heavy weights round and round in opposite directions, crashing into each other and snarling abuse.

The fifth circle is reached by a path through a deep gully beside a black stream. In the festering ooze of the marshes of Styx the wrathful, naked and smeared with slime, are furiously striking and tearing each other with their hands and teeth. The sullen are gloomily sunk in the mud. Across the Styx is a great moated city with iron walls, guarded by monsters from Greek mythology, the Furies who drove their victims mad and the Gorgon whose gaze turned all things to stone. In the sixth circle heretics are crammed together and roasted in fiery tombs. In the seventh, the violent are punished. Murderers and armed robbers are submerged in a river of boiling blood, suicides are turned into trees whose leaves are torn and eaten by harpies, the loathsome bird-women of classical legend. Blasphemers are penned in a dismal, sandy plain under a snowfall of fiery flakes.

The eighth circle, called Malebolge (Evil Pit), has ten divisions in which various types of sin are punished. Pimps are flogged by horned demons, flatterers are immersed in human excrement, swindlers are sunk in boiling pitch and prodded by demons with sharp pitchforks. Hypocrites are dressed in cloaks and hoods of gilded lead which are so heavy that they can only just drag themselves along. Thieves are

Wherever else hell may be, it is in the human mind. The concept of hell, in Christianity and other religions, appeals to sado-masochistic impulses, and artists have given these feelings free rein.
Left: *Detail of Portuguese painting of hell, seventeenth century. (National Museum of Ancient Art, Lisbon)*
Above: *A sinner devoured by a snake: illustration to Dante, by Doré (detail).*

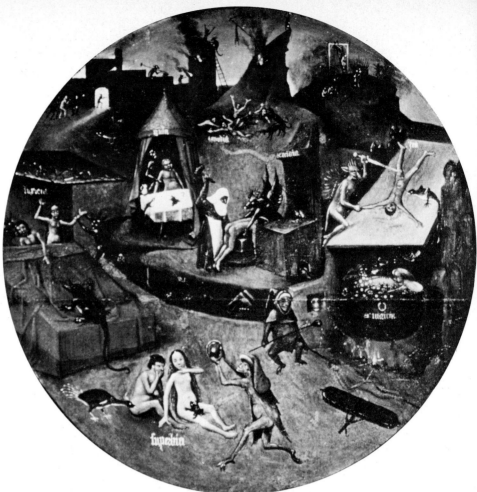

Right: *Fire and heat are the principal torments of hell and hell-fire is the infernal counterpart of the beautiful radiance of heaven. It emits blinding and smothering smoke. The imagery of furnaces, ovens, fumes and smoke inspired painters like Hieronymus Bosch in the fifteenth century and John Martin in the nineteenth to portray hell in terms of industrial scenery. Detail from* The Seven Deadly Sins *by Bosch. (Prado, Madrid)*

Below: *Besides variations on the theme of fire and heat, many other tortures were imagined, as suitable forms of retribution and as deterrents to crime and sin in earthly life. Some of the torments were punishments inflicted on criminals in real life, others were the products of the artist's own ingenuity. Detail from Giotto's* Last Judgment, *in Padua, fourteenth century.*

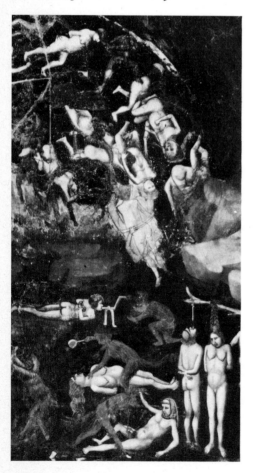

confined in a snake-pit. Those who caused division and schism are lopped, cloven and mutilated by a demon. Their wounds heal swiftly and then they are mutilated again. Liars are stricken with leprosy, dropsy and other repulsive diseases and covered with sores and itching scabs.

The ninth and lowest circle of all, furthest from the light and warmth of life, is the hell of ice where treachery is punished. Those who betrayed their families, friends or country are encased in the frozen lake of Cocytus, the water of lamentation, another of the rivers of the classical underworld. Their tears of pain congeal on their cheeks like crystal masks and one of them in his desperate hunger is gnawing the head of another, who cannot move. Here in the utmost depth, in the lowest abyss of infamy at the centre of the world, is the colossal figure of the Devil, the arch-traitor, the rebel against God. Covered with matted hair, he is sunk in ice to his chest and his gigantic bat's wings soar up towards the roof of the cavern. Because he is the infernal parody of the Trinity, he has three heads. In one mouth he mangles the body of Judas Iscariot, whose back he flays with his claws. In the other two he is gobbling Brutus and Cassius, the assassins of Julius Caesar. He is weeping and tears and bloody froth trickle down over his chins.

Most accounts of hell's geography are much simpler, and the principal physical tortures are those of fire and heat. The damned burn forever in the kingdom of the Devil, their master, and in this life Satan's followers on earth, heretics and witches, were put to death by burning. Hell is described as an abyss of flame, a huge furnace or

oven. The souls there live in fire as fish live in water, but it is inside them as well as outside. They breathe it and their blood boils in their veins, and their hearts, brains and entrails seethe and simmer. The fire is the blaze of God's wrath which in the Old Testament consumes sinners like rubbish. 'For behold, the day comes, burning like an oven, when all the arrogant and all evildoers will be stubble; the day that comes shall burn them up.'[13] In the New Testament Jesus is quoted talking about the flames of Gehenna, 'where their worm does not die and the fire is not quenched'.[14] A particularly important influence on the Christian picture of hell was the passage in St Matthew, predicting Christ's return in glory to judge the nations, to separate the good sheep from the wicked goats and banish the latter to the eternal fire prepared for the Devil and his angels.[15]

There are seas, rivers and torrents of fire in hell and often a lake of flame, descended from the lake of fire and brimstone in the book of Revelation, into which the Devil is hurled alive to be tortured forever. There were said to be four rivers in hell, corresponding to the four rivers of paradise. In one description the rivers are of fire, snow, toads and snakes, in another of fire, snow, poison and black water. It was occasionally suggested that hell might be in the blazing ball of the sun or the glowing tail of a comet, but its generally accepted location was deep down below ground. In the mid-nineteenth century it was still being argued that hell is at the centre of the earth and is the source of the fiery eruptions of volcanoes.

Hell is the opposite and counterpart of heaven and its fire is the infernal equivalent of the beautiful radiance of heaven, the light of the godhead. But although hell is a maelstrom of flame, it is also the opposite of heaven in being pitch-dark. Hell-fire is black or dark fire, burning without giving light and emitting blinding and smothering smoke. In this way the fiery Gehenna was reconciled with the 'outer darkness' to which the wicked are also consigned in the Bible, where there is weeping and wailing and gnashing of teeth.[16] Fire was also the principal punishing and cleansing agent of purgatory, and sinners in either place were not only seared and roasted but scalded and stewed in pots, vats or wells, or in Furniss's kettle.

All sorts of ingenious variations were played on the theme of agonizing heat. Sinners are pronged on hooks which protrude from flaming wheels, or hung up in blazing trees, or boiled and strained through cloths. Women are forced down onto saddles studded with red-hot spikes. An afterworld ladder appears in the Vision of Alberic, an Italian monk of the twelfth century. Made of red-hot iron, its rungs are sharp teeth which spit out sparks, and at its foot it has a huge tub of boiling oil and pitch. Sinners have to climb the ladder, licked by tongues of flame from the tub. Some of them lose their footing and fall into it. Alberic, who is shown hell by St Peter, also sees babies being broiled in hot vapours and fed with lighted coals. When he expresses some surprise at this, St Peter explains that even a baby may commit sin, for example by hitting his mother with his childish fist.

In the Vision of Adamnan, Abbot of Iona, which was written down in the tenth century, sinners in hell are fastened to burning pillars, with fiery chains of snakes round their waists and a sea of fire lapping them to the chin. Others are beaten by demons with burning clubs and pelted by showers of fiery rain, or pierced through the tongue or

Above: *More tortures in hell, from a church in Cyprus, fourteenth century. Christians sometimes interpreted torments of this kind as symbols of psychological agonies which the damned would suffer, especially 'the pain of loss', the agony of being forever cut off from God. For some modern Christians, this is the true meaning of hell.*

Right: *The motif of weighing the soul appears again in this Japanese Buddhist painting. This detail shows one of the condemned being hammered flat with a mallet. The full painting shows Emma-O, the ruler and judge of the dead who keeps a book in which all human actions are recorded, presiding over the scene. (Horniman Museum, London)*

Above: *Artists have let their powers of imagination and fantasy loose not only on the pains of hell but in the creation of monstrous demonic figures which torture the damned: this is a Tibetan demon. (Victoria & Albert Museum, London)*

the head with red-hot nails, or dressed in blazing cloaks and collars. Still others struggle across blistering flagstones under a hail of fiery arrows. In the Vision of Tundale the Devil is chained on a grill over a brazier in hell. Each time he breathes out he expels a thousand scorched souls from his lungs, while with a thousand hands he clutches others and drops them onto the glowing coals beneath him.

The imagery of furnaces, ovens, fumes and smoke inspired John Martin in the nineteenth century to paint hell in terms of the scenery of the Industrial Revolution. The Black Country of the English Midlands seemed to him the pattern of the infernal regions. Earlier, there is a hellish workshop in *The Seven Deadly Sins* painted by Hieronymous Bosch. Earlier still, in the story of St Brendan's voyage, the saint and his companions come to an island which is barren, stony and dotted with forges and slag-heaps. They hear the clang of hammer on anvil and the blowing of bellows, and realize that they have come to the gates of hell.

Torments of fire and heat also have a leading place in the hells of other religions. In the Koran an inferno which is again descended from the Jewish Gehenna awaits the faithless and the wicked. 'For the unbelievers we have prepared fetters and chains, and a blazing Fire.' 'Garments of fire have been prepared for the unbelievers. Scalding water shall be poured upon their heads, melting their skins and that which is in their bellies. They shall be lashed with rods of iron. Whenever, in their anguish, they try to escape from Hell, the angels will bring them back, saying, "Taste the torment of Hell-fire!"' When their skin is cooked, Allah will substitute new skin, so that they can go on suffering. 'They shall dwell amidst scorching winds and seething water: in the shade of pitch-black smoke, neither cool nor refreshing.'[17]

Hell is described less vividly in the Koran than paradise, with which it is frequently contrasted. At the end of the world on the Day of Reckoning wicked Muslims and the unbelievers will be judged and sent to hell (there was no such thing as a good unbeliever, any more than there was in Christianity). The Prophet may have thought that meanwhile they lay unconscious in their graves, but it was later believed that they either went to hell immediately after death or were given a foretaste of punishment in their tombs, where they were beaten by angels and poisoned by monstrous snakes.

In Buddhist and Hindu hells fiery agonies are prominent among sufferings which, for the majority of victims, are temporary. Sooner or later, most of the sinners will be released and sent back to lead fresh lives on earth. The exceptionally wicked, however, may be condemned to eternal punishment. There are hells of burning, roasting, frying, boiling in oil or blood, dismemberment with burning saws, grinding between blazing rocks, shredding with fiery pincers, swallowing lumps of red-hot iron. Some unfortunates are ground between millstones and turned into lamp-wicks, which are lighted and slowly consumed. Others are scorched in burning sand or made to lie on beds of glowing coals or boiled in blood and filth.

Besides fire of unimaginable intensity, the Christian afterworld contains ice, snow and frost. Sometimes the damned are made to suffer each in turn, as in the Jewish Gehenna and in some oriental hells. In paradise it is never too hot or too cold, but in hell or purgatory it can be both. Scriptural authority for the alternation of cold and heat

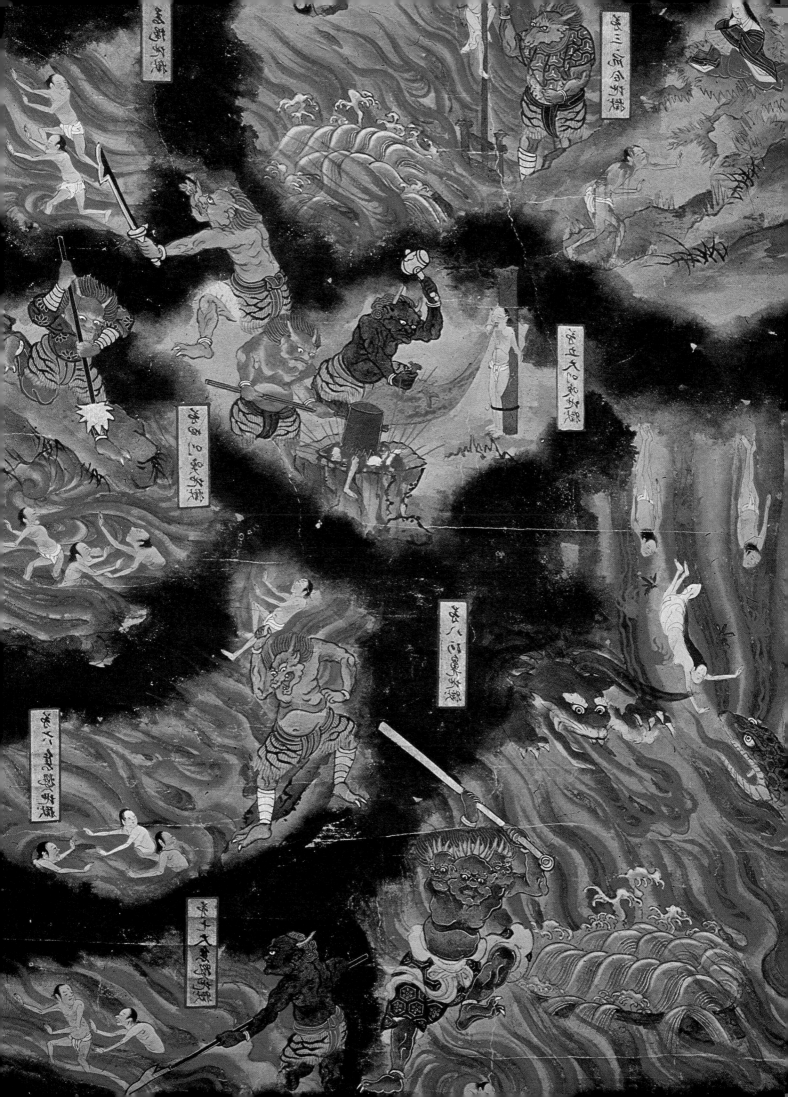

was found in a verse from the book of Job which in the Vulgate says, 'They shall pass from the snow waters to excessive heat.'[18] In the seventh century in Northumbria a man named Drycthelm fell ill and died, but suddenly came back to life the next morning, to the alarm of those weeping round his bed. He said that a man in a shining robe had guided him in a north-easterly direction until they came to purgatory in a deep, broad valley. 'The side to our left was dreadful, with burning flames, while the opposite side was equally horrible with raging hail and bitter snow blowing and driving in all directions. Both sides were filled with men's souls, which seemed to be hurled from one side to the other by the fury of the tempest. For when the wretches could no longer endure the blast of the terrible heat, they leaped into the heart of the terrible cold, and finding no refuge there, they leaped back again to be burned in the middle of the unquenchable flames.'[19]

The human imagination has inflicted almost every conceivable variety of excruciating torture on the wicked in hell: as a fitting retribution, as a deterrent, and sometimes with an unmistakable relish in the contemplation of pain. Some of the torments were punishments inflicted on criminals in real life, others are the products of ingenious invention. The damned are flogged, flayed, racked, dismembered, disembowelled, hacked, pierced, torn, impaled. They are blinded, throttled, suffocated, cramped, crushed. They are hanged by the neck, the feet, the arms or hands, the tongue, ears, genitals, hair or heart. Maggots, toads and venomous snakes penetrate their bodies. Their agonies go on and on, endlessly repeated. They long for death but they are condemned never to die.

No Christian author may have thought of the Chinese expedient of replacing the brains of sufferers in hell with hedgehogs, but generally there is little variation between the afterworld punishments of Christian and oriental belief. This is partly the result of Christian influence on the East, but more often it seems that the attempt to devise gruesome torments has produced similar motifs independently. People are devoured by animals or plunged head downwards in mud, beaten with rods and hammers, sliced with razors, roasted and boiled. Those serving their sentences in one Burmese Buddhist hell are immersed in excrement and gnawed by worms the size of elephants. In another they are made to climb up and down a thorny tree which tears their flesh.

East or West, there are different punishments for different crimes. In a Tibetan description of hell, one of the condemned is quartered and fixed on spikes and another is locked in the 'Doorless Iron House'. Monks who hurried through the sacred texts too quickly are pressed painfully under the weight of a gigantic book. A sorcerer is cramped inside a triangle and spoonfuls of molten metal are poured into a prostitute. A murderess is sawn in half and other offenders are boiled in a cauldron.

The scenery of the Christian hell is at the opposite pole from that of heaven. In place of the glorious city, the flowery meadow, the ripe and sheltered garden, hell has a black and barren landscape of gloomy valleys, jagged cliffs, stony plains, whirlwinds of fire, rivers of flame and pitch, fuming pits, putrid swamps, yawning chasms and frowning battlements, overhung with smoke and reek. And where the blessed enjoy delicious feasts, the damned are tortured by hunger and insati-

Above: *Some of the damned are seethed in a cauldron, in this detail from a carving in Bourges Cathedral. The cauldron was originally the 'boiling pot', associated in the old Testament with Leviathan, the great dragon of the sea, an adversary of God who was later identified with the Devil. A bishop and a king are here included among the damned. One of hell's social functions was to act as a political tranquillizer. The poor were encouraged not to rebel, but to wait for the revenge which would be theirs in the next world, when the rich and powerful were consigned to damnation.*

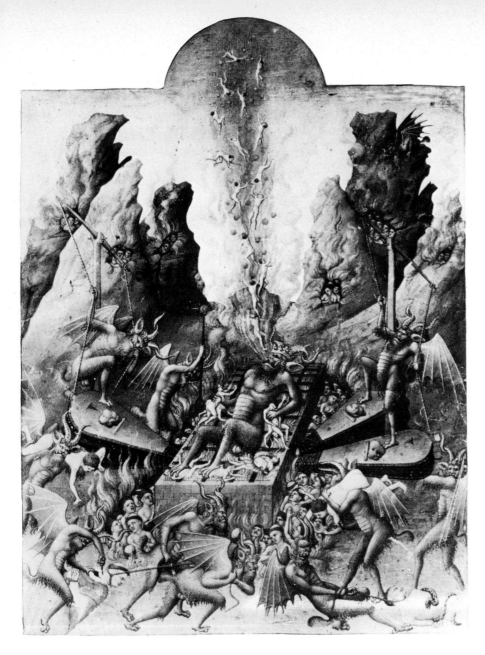

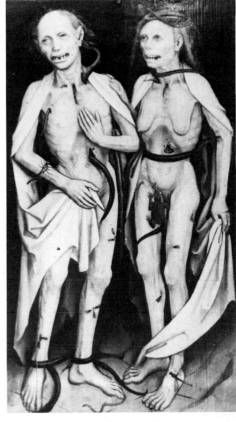

able thirst. If they are given anything to eat, it is painful and foul. In the Koran they are supplied with boiling water to drink and disgusting filth to eat, and also with bitter fruits shaped like demons' heads produced by a tree which grows in the depths of hell. In some Christian descriptions, the souls in hell are driven to eat bits of their own bodies and they drink the poison of vipers.

Instead of the sweet music of heaven, the songs of praise and thanks to God, hell resounds to a cacophony of screams of agony, wailing and gnashing of teeth, and desperate pleas to God for mercy, which he ignores. In their torments the damned bite their tongues to shreds and their tears of pain turn into live coals which scorch their faces. Heaven is filled with a delightful, sustaining fragrance, while hell is thick with an intolerable stench compounded of the stink of sulphur (brimstone), the grave-odour of rotting corpses, the fumes of burning rubbish and the smell of every kind of filth, dung, offal, scum and slime. St Bonaventure, an Italian theologian of the thirteenth century, made the often quoted remark that the pestilential odour of the body of a single damned sinner would infect the whole earth. Jeremy Taylor, an Anglican bishop of the seventeenth century, said that each damned soul's body was more unsavoury than a million dead dogs.

Above left: *An illustration of the Vision of Tundale, with the Devil chained on a brazier in hell. Each time he breathes out he expels scorched souls from his lungs, and with his hands he clutches others and drops them onto the glowing coals beneath him. From* Les Très Riches Heures du Duc de Berry. *(Musée Condé, Chantilly)*

Above right: The Guilty Lovers *by Mathias Grunewald, sixteenth century. The flesh, whose pleasures the lovers have enjoyed, is pierced by snakes, toads, scorpions and flies. The body-hating strain in human psychology comes out clearly in many depictions of hells, Christian and others. (Musée de l'Oeuvre Notre Dame, Strasbourg)*

The theme of hell as the world's ultimate cesspit was sometimes connected with the old fear of being devoured, which reappears in many descriptions. Monsters seize sinners, swallow them and then vomit or excrete them again, or they tear them to pieces and chew them up. In the Vision of Adamnan some of the damned are eaten by mangy dogs. Dante condemned Judas Iscariot to be eternally mangled in the Devil's mouth. St Frances of Rome, an ascetic and mystic who died in 1440, saw a vision of hell occupied by a colossal dragon which breathed out black and foetid fire. Sinners were thrown into its maw and it eventually excreted them into the depths of the pit. The dragon was the Devil. John Fisher, Bishop of Rochester in the time of Henry VIII, drew the same lesson from the story of Jonah and the whale. If God had not rescued Jonah, the whale would have digested him and voided his remains into the sea, which shows how the sinner can be 'incorporate to the substance of the devil' and 'so shall be conveyed through his belly and fall down into the depths of hell'.[20]

In the Old Testament Sheol has a mouth and in Christian art the entrance to hell is through the jaws of a whale, dragon, lion or predatory monster. The gaping hell-mouth had a long career in Christian imagery. It gulps down sinners in thousands, roaring for its prey and grunting like millions of hogs. It is the maw of Leviathan, the great sea-monster of Jewish legend, identified with the Devil and connected with the whale which swallowed Jonah. Leviathan is described in the book of Job in a way which was easy to link with hell. 'Out of his mouth go flaming torches; sparks of fire leap forth. Out of his nostrils comes forth smoke as from a boiling pot and burning rushes. His breath kindles coals and a flame comes forth from his mouth.'[21] Medieval artists showed the 'boiling pot' as a cauldron inside the mouth of hell in which the damned are seethed.

As well as its 'pain of sense' hell has psychological agonies which are even worse. In the perfect society of heaven the saved enjoy the communion of the saints and the company of angels. In hell the wicked have the company of demons and monsters, and the burden of each other's hated presence. This is aggravated in some accounts by the fact that they are packed as closely together as herrings in a barrel. A text of the late twelfth century, *Sawles Warde* ('Soul's Protection'), says that each of the damned in hell loathes himself and all the others, especially any that he loved in this world, whom he there hates even more bitterly than the rest.[22]

'The worm that never dies' or 'the worm that sleeps not' was often taken to represent the torments of conscience which gnaw at the damned, their belated repentant self-loathing, their regret for what they have lost, their envy of the saved. The fire of hell and the other physical tortures were sometimes understood figuratively, as images

Left: *Accounts of hell and its demonic monsters sometimes resemble experiences reported by people under the influence of drugs or suffering from insanity. This is a variation on an old theme.* The Temptation of St Anthony, *by Max Ernst. Many of the images are inspired by Bosch and Brueghel.*

of mental and spiritual anguish, though this was not the impression of the majority. Origen, an unorthodox theologian of the early third century, said that each sinner kindles his own fire in hell and his own vices form its fuel, meaning that what torments him is remorse. He also thought that the suffering of the damned would have an end one day, when God restored the primeval order and blessedness of his original creation, but the Church condemned this view as incorrect.

The psychological horrors of hell culminate in the pain of loss, the realization of being forever cut off from God in a state of utter hopelessness and despair. 'The keenest and fiercest of bodily pains is nothing to the fire of hell; the most dire horror or anxiety is nothing to the never-dying worm of conscience; the greatest bereavement, loss of substance, desertion of friends, and forlorn desolation is nothing compared to the loss of God's countenance.'[23]

Hell's substitute for the presence of God is the presence of Satan. Though sometimes portrayed as a human figure with a certain dignity, the Devil of medieval art is more often a bloated semi-human monster of supreme evil and corruption, a giant who towers over his kingdom of carnage and ruin. His armies of subordinate demons, who staff the torture-chambers of hell, are also monsters, made of human and animal forms weirdly mingled together. They have grotesque bodies, the heads of carnivorous animals and birds, horns, fur or scales, the shells of insects, the wings of bats. They are equipped with protruding fangs and tusks, beaks, goggling eyes, snaky tails, hooves, elongated noses or piggish snouts, scalloped ears, faces in their bellies or buttocks, and too many or too few limbs.

Medieval artists inherited the monsters of the Ancient World and the tradition of depicting the supernatural in a literally super-natural way by joining pieces of different creatures together. The demonic was represented in animal or mixed animal and human shape because of its bestial nature and its links with the animal impulses of man. But these nightmarish anatomies are also creatures of the chaotic underworld of the mind, in which they swarm just as the demons were believed to infest the depths of hell. Hell is inhabited by monsters, or is itself a monster, because it is the realm of chaos and sin, the disorderly, the unnatural, the deformed and perverted.

Oriental hells similarly have their grim rulers and monsters. The lord of the dead in Hinduism and Buddhism is Yama, who judges the dead and sends them to the appropriate paradise or hell. His afterworld is guarded by four-eyed dogs and surrounded by a coiling river, across which the dead are ferried by a boatman. He is described as green or black and yellow in colour, dressed in red robes. He has curly hair, red eyes, large teeth and a defective leg, which is covered with sores and accounts for his title of 'rotten foot'.

The Tibetan Book of the Dead, which is a guide to the experience of dying, describes the judgment in Yama's court, and a painting of the scene shows him wearing a human skin as a cloak, a girdle of human heads and a head-dress of skulls. He holds a sword and a mirror, in which every human action is reflected. The good and evil actions of the dead are weighed in his presence and the wicked are led off to punishment in the eight hot hells and the eight cold hells.

The hell of the Jodo-shu or Pure Land sect in Japan has eight hot divisions and eight cold, presided over by Emma-O, the Japanese equivalent of Yama. He is shown dressed as a judge with a book in

Above: *In Christian art hell is frequently entered through the gaping mouth of a dragon, a whale, a lion or a carnivorous monster. This is another expression of the ancient horror of being devoured, which was believed to rob a human being of any chance of a happy afterlife. The scroll held by the demon says, 'There is no redemption from hell'. (Musée des Beaux-Arts, Strasbourg)*

Right: *Demonic beings of Muslim belief, from a Persian manuscript. (British Museum)*

which all human actions are recorded and with two severed heads beside him. One sees all crimes, however secret, while the other smells out all offences. The sinner is dragged by a demon to a mirror in which he sees all his bad actions reflected, then his guilt is weighed on scales and he is sent for punishment to a suitable section of hell. In popular Chinese belief the dead were judged, and those condemned were tormented by grotesque demons and animals which devoured them, burned them, cut them to pieces, fried them in oil, impaled them on stakes, mashed them, picked out their eyes, buried them in ice and subjected them to other vicious tortures.

The Tibetan Book of the Dead says that the judgment and the punishments, though intensely frightening and painful, are temporary, hallucinatory and self-inflicted. 'The mirror in which Yama seems to read your past is your own memory, and also his judgment is your own. It is you yourself who pronounce your own judgment, which in its turn determines your next rebirth. No terrible God pushes you into it; you go there quite on your own. The shapes of frightening monsters . . . are just an illusion which you create from the forces within you.'[24]

Heaven and hell have their roots in theology and in the social need to encourage good behaviour and discourage bad, but they are also founded on spontaneous human experience. There are those

who encounter hell's pain of loss in this life, in a sense of utter rejection, of being already lost and damned, which occurs in states of profound unhappiness and depression. In his essay on *Heaven and Hell*, Aldous Huxley pointed out the similarities between some of the elements of traditional pictures of heaven, paradise and hell, and experiences reported by visionaries, schizophrenics and people under the influence of drugs. Hells, for example, frequently include punishments of constriction and pressure. 'Dante's sinners are buried in mud, shut up in the trunks of trees, frozen solid in blocks of ice, crushed beneath stones. The *Inferno* is psychologically true. Many of its pains are experienced by schizophrenics, and by those who have taken mescalin or lysergic acid under unfavourable conditions.'[25] Hell-mouth has its counterpart in Carlyle's feeling, in a state of deep depression, that the jaws of a great monster waited to devour him. On the other hand, the Irish poet and painter George Russell, who wrote under the pseudonym A.E., had visionary impressions of 'an intolerable lustre of light' and of looking at 'landscapes as lovely as a lost Eden'.

Ideas of the world after death have been affected by, and have themselves in turn affected, the experiences of visionaries, ascetics and people in extra-ordinary states of mind. Many of the visits to the afterworld supposedly made in trances or dreams or during meditation are conscious and deliberate creations, but they draw on genuine visions. The use of drugs to induce visions by shamans, holy men and mystery initiates has a long history all over the world. Fasting, asceticism and meditation can also induce altered states of consciousness in which a person may not only 'see' a different world or plane of reality, but have sensations of hearing, touch, smell and taste as well. These journeys into inner space may be positive, joyful and uplifting, or negative, hideous and terrifying.

Heaven and hell are inside the mind. Whether they are also outside it is an open question, but it is not only modern authors who have recommended visionary experience as a way of penetrating a reality which has more meaning than the accustomed scenery of everyday life. *The Art of Dying* was translated into English in about 1375 from a book by Lorens d'Orléans, a Dominican who was confessor to Philip the Bold of France in the previous century. It tells its readers to escape from the body 'by thinking and by desire' and so 'go out of this world' in the spirit. 'If you would learn good and evil go from home, go out of yourself, that is go out of this world and learn to die; send your soul from your body by thinking; send your heart into that other world, into heaven or hell or purgatory, and there you shall see what is good and what is evil. For in hell you shall see more sorrow than any man can describe, and in purgatory more torments than any man could endure, in Paradise more joy than any man could desire.'[26]

Right: The Fall of the Rebel Angels *by Brueghel (detail). Hell is the realm of the chaotic, the unnatural, the deformed and perverted. Michael and the good angels are driving the evil angels into the abyss. As they fall, they turn into pullulating monsters. (Museum of Ancient Art, Brussels)*

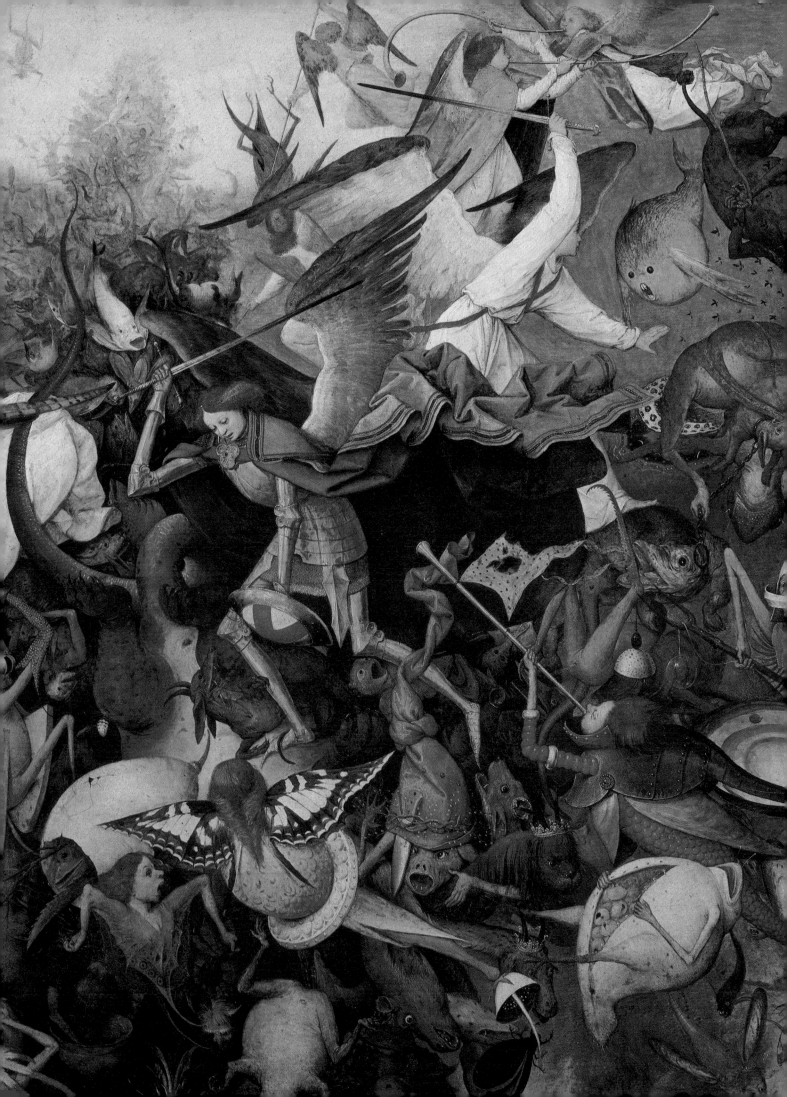

Notes

Chapter One: Life After Death

1 Sir Arthur Barker *Encyclopaedia Britannica*, 14th edn (1929), vi. 772
2 Ross *Pagan Celtic Britain*, 356–7
3 *ibid.*
4 *ibid.*
5 Cicero *Republic* 6. 13, quoted by Grant, *Ancient Roman Religion*, 149
6 Lucian *Satirical Sketches*, 11
7 Walker *Hindu World*, ii. 462
8 Brandon *Judgement of the Dead*, 42
9 Eliade *From Primitives to Zen*, 302
10 Philippians 3. 20–21
11 Brandon *Man and his Destiny*, 346
12 Toynbee A. J. *Man's Concern with Death*, 96–7

Chapter Two: Paradise and Heaven

1 Psalm 8. 3–4
2 1 Kings 8. 27
3 Genesis 2. 8–17
4 Isaiah 51. 3; Ezekiel 31. 8, 36. 35; Joel 2. 3
5 Luke 23. 43
6 2 Corinthians 12. 1–4
7 Revelation 2. 7
8 Eliade *From Primitives to Zen*, 383
9 Dillon and Chadwick *Celtic Realms*, 191
10 Ross *Pagan Celtic Britain*, 328
11 See *Lives of the Saints*—trans. J. F. Webb
12 Genesis 5. 24, *cf.* Hebrews 11. 5
13 2 Kings 2. 11–12: Acts 1. 9

Chapter Three: The Perfect Existence

1 1 Corinthians 2. 9
2 *Life of St Mary of Oignies* in *Later Medieval English Prose*, W. Matthews (Ed)
3 Newman *Meditations and Devotions*, 26–7
4 Blench *Preaching in England*, 262
5 Romans 14. 17
6 *Encyclopaedia Judaica* xii. 1357
7 1 Corinthians 13. 12, *cf.* 1 John 3. 2
8 *New Catholic Encyclopedia* ii. 191
9 John 14. 2
10 Rowell *Hell and the Victorians*, 50
11 2 Peter 3. 8
12 Blench *Preaching in England*, 207–8
13 Coulton *Life in the Middle Ages*, i. 48
14 Anselm *Proslogion*, chapter 25
15 *Later Medieval English Prose*, 207
16 Revelation, chapters 4, 5 and 7
17 Hebrews 4. 9, *cf.* Revelation 14. 13
18 Isaiah 2. 3–4
19 See Psalm 48. 12
20 Isaiah, chapters 54 and 60
21 Isaiah 65. 17–18: Zachariah 14. 6–7: Isaiah 60. 19
22 Isaiah 51. 3: Joel 3. 17–18: Isaiah 65. 25
23 Mark 1, 15: Luke 19. 11: John 18. 36: Matthew 4. 17: Galatians 4. 24–6
24 Hebrews 12. 22, 13. 14

Chapter Four: The Underworld

1 Davidson *Gods and Myths*, 162
2 Job 10. 20–22
3 Caird *Revelation*, 253
4 Ecclesiastes 9. 4–9
5 Deuteronomy 4. 24
6 Isaiah 66. 24
7 Homer *Odyssey*, book 11
8 Pausanias 10. 28. 1
9 Polybius, *Histories* 6. 56, quoted by Grant, *Ancient Roman Religion*, 158
10 See Toynbee, J. M. C. *Death and Burial*, 37
11 Virgil *Aeneid*, book 6

Chapter Five: The Abyss of Hell

1 John 3. 36
2 Matthew 25. 41, 46
3 Anselm *Meditations* 1. 85
4 Mâle *Gothic Image*, 369
5 Plato *Republic*, 10. 617C
6 Berdyaev quoted by Rowell, *Hell and the Victorians*, 217
7 Hebrews 10. 29–30
8 Rowell *Hell and the Victorians*, 83n, 177
9 Coulton *Life in the Middle Ages*, i. 193–4
10 Owst *Literature and Pulpit*, 293–4
11 *The Art of Dying*, in *Middle English Religious Prose*, 132f. Blake N. F.
12 Toynbee, P. *Dante*, 113
13 Malachi 4. 1
14 Mark 9. 48
15 Matthew 25. 31
16 Matthew 8. 12
17 Koran, suras 22, 56, 76
18 Job 24. 19
19 Bede *History*, 5. 12
20 Blench *Preaching in England*, 12
21 Job 41. 19–21
22 *Sawles Warde*, lines 94f, in *Early Middle English Verse and Prose*, Bennett, J. A. W. and Smithers, G. V. (Eds)
23 Newman *Meditations and Devotions*, 34
24 See Brandon *Judgement of the Dead*, 175
25 Huxley, Aldous *Heaven and Hell*, 79, 109
26 *Art of Dying*, lines 65f, in *Middle English Religious Prose*, Blake, N. F.

Bibliography

Anselm *Prayers and Meditations*—trans. B. Ward (Penguin, Harmondsworth 1973)

Augustine *The City of God*—2 vols. (Everyman's Library, London 1945)

Bede *A History of the English Church and People*—trans. L. Sherley-Price (Penguin, Harmondsworth 1968)

Bennett, J. A. W. and Smithers, G. V. (Eds) *Early Middle English Verse and Prose* (Clarendon Press, Oxford 1966 and New York 1968)

Berry, Thomas *Religions of India* (Collier-Macmillan, London 1971; Bruce Publishing, New York 1971)

Blake, N. Z. *Middle English Religious Prose* (Arnold, London 1972; Northwestern University Press, Illinois 1972)

Blench, J. W. *Preaching in England in the Late Fifteenth and Sixteenth Centuries* (Blackwell, Oxford 1964)

Brandon, S. G. F. *The Judgement of the Dead* (Weidenfeld & Nicolson, London 1967)

Brandon, S. G. F. *Man and His Destiny in the Great Religions* (Manchester University Press, 1962)

Breasted, J. H. *The Development of Religion and Thought in Ancient Egypt* (Harper Torchbooks, New York 1966)

Budge, E. A. W. (Ed) *The Book of the Dead* (Routledge & Kegan Paul, London 1960; Dover Press, New York 1967)

Caird, G. B. *The Revelation of St John the Divine* (A. & C. Black, London 1966; Harper Row, New York 1966)

Cavendish, Richard *The Powers of Evil* (Routledge & Kegan Paul, London 1975; Putnam, New York 1975)

Charles, R. H. (Ed) *The Book of Enoch* (Society for the Propagation of Christian Knowledge, London 1966)

Coulton, G. G. *Life in the Middle Ages*—4 vols. (Cambridge University Press, 1967)

Cumont, Franz *After Life in Roman Paganism* (Dover Press, New York 1959)

Dante *The Divine Comedy*—trans. L. Grant White (Pantheon Books, New York 1948)

Davidson, H. R. Ellis *Gods and Myths of Northern Europe* (Penguin, Harmondsworth 1964)

Dawood, M. J. *The Koran* (Penguin, Harmondsworth 1966)

Dillon, Myles and Chadwick, Nora *The Celtic Realms* (Sphere, London 1967)

Edwards, I. E. S. *The Pyramids of Egypt* (Penguin, Harmondsworth 1961)

Eliade, Mircea *From Primitives to Zen* (Collins, London 1967)

Evans-Wentz, W. Y. (Ed) *The Tibetan Book of the Dead* (Oxford University Press, 1960)

Grant, F. C. (Ed) *Ancient Roman Religion* (Liberal Arts Press, New York 1957)

Heidel, Alexander *The Gilgamesh Epic and Old Testament Parallels* (University of Chicago Press, 1949)

Hesiod *Works* (Loeb Classic Library, Heinemann, London 1936)

Homer *The Odyssey*—trans. E. V. Rieu (Penguin, Harmondsworth 1946)

Hughes, Robert *Heaven and Hell in Western Art* (Weidenfeld & Nicolson, London 1968)

Huxley, Aldous *Heaven and Hell* (Penguin, Harmondsworth 1959)

Jackson, K. H. *A Celtic Miscellany* (Routledge & Kegan Paul, London 1951)

James, M. R. (Ed) *The Apocryphal New Testament* (Clarendon Press, Oxford 1953)

Lewis, C. S. *The Great Divorce* (Geoffrey Bles, London 1963)

Lives of the Saints—trans. J. Z. Webb (Penguin, Harmondsworth 1965)

Lucian *Satirical Sketches*—trans. P. Turner (Penguin, Harmondsworth 1961)

Mâle, Émile *The Gothic Image: Religious Art in France in the Thirteenth Century* (Fontana, London 1961; Harper Row, New York 1973)

Matthews, W. (Ed) *Later Medieval English Prose* (Peter Owen, London 1962; Meredith, New York 1963)

Mew, James *Traditional Aspects of Hell* (Gryphon Books, Ann Arbor, Michigan 1971)

Newman, J. H. *Meditations and Devotions* (Burns & Oates, London 1964)

Owst, G. R. *Literature and Pulpit in Medieval England* (Blackwell, Oxford 1961)

Patch, H. R. *The Other World According to Descriptions in Medieval Literature* (Harvard University Press, 1950)

Pausanias *Description of Greece*—5 vols. (Loeb Classic Library, Heinemann, London 1918–35)

Plato *Works*—trans. B. Jowett (Bigelow Brown, New York, third edition)

The Prose Edda—trans. J. I. Young (California University Press, 1966)

Richmond, I. A. *Archaeology and the After-Life in Pagan and Christian Imagery* (Oxford University Press, 1950)

Ross, Anne *Pagan Celtic Britain* (Routledge & Kegan Paul, London 1967; Columbia University Press, New York 1967)

Rowell, Geoffrey *Hell and the Victorians: Study of the Nineteenth-Century Theological Controversies Concerning Eternal Punishment and the Future* (Clarendon Press, Oxford 1974)

Schumann, H. W. *Buddhism* (Rider, London 1973)

Simon, Ulrich *Heaven in the Christian Tradition* (Rockcliff, London 1958)

Toynbee, Arnold J. *Man's Concern with Death* (Hodder & Stoughton, London 1968)

Toynbee, Jocelyn M. C. *Death and Burial in the Roman World* (Thames & Hudson, London 1971)

Toynbee, Paget *Dante Alighieri, His Life and Works* (Harper Torchbooks, New York 1965)

Index

Acknowledgments

The quotation on page 7 is from 'Death' published in *Collected Poems* of William Butler Yeats and is reproduced by kind permission of Macmillan Publishing Co., Inc. © 1933, renewed 1961 by Bertha Georgie Yeats. We are grateful to M. B. Yeats, Miss Anne Yeats and The Macmillan Co. of London and Basingstoke.

The quotation on page 13 is from 'Crusades' in *Encyclopaedia Britannica*, 14th edition (1929), 6: 772.

We are grateful to Collins Publishers for permission to quote from *From Primitives to Zen* by Mircea Eliade on pages 24, 44, 82, and from *The Great Divorce* by C. S. Lewis on page 103.

We are grateful to the Trustees of the Tate Gallery for their kind permission to reproduce *The Plains of Heaven* by John Martin as it appears in the frontispiece.

We are grateful to the following for the illustrations on pages: 6 Musées Nationaux, Paris; 8 Michael Holford; 9 Musées Nationaux, Paris; 10 British Museum/Michael Holford; 11 Museo Nazionale, Athens; 12 Scala; 13 Manx Museum, Isle of Man; 14 Michael Holford; 15 Pinacoteca, Bologna/Scala; 16 University Museum of Anthropology, Jallapa/Werner Forman; 17 Prähistorische Staatssammlung, Munich/Claus Hansmann; 18–19 British Museum/Michael Holford; 19 (top) Roger Viollet; 20 British Museum/Michael Holford; 21 British Museum/Michael Holford; 22–3 Prado, Madrid/Mas; 24 Mary Evans; 25 (left) Orbis Publishing; 25 (right) Museum of Fine Arts, Budapest/M. Pucciarelli; 26 Imperial War Museum, London/Cooper-Bridgeman; 28 Bulloz; 29 (left) Rijksmuseum; 29 (right) Mansell Collection; 30 Novosti; 30–31 Museum of Oriental Art, Venice/M. Pucciarelli; 32 Werner Forman/ Philip Goldman Collection; 33 India Office Library and Records; 34 Prado, Madrid/Cooper-Bridgeman; 36 (top) Mary Evans; 36 (bottom) Sonia Halliday; 37 Mary Evans; 38–9 Doria Gallery, Pamphili/M. Pucciarelli; 40 (left) Sonia Halliday; 40 (right) Victoria and Albert Museum/Michael Holford; 41 (left) Mary Evans; 41 (right) Museum of Fine Arts Rennes/Giraudon; 42–3 Victoria and Albert Museum/M. Pucciarelli; 44 (left) Bulloz; 44 (right) Mansell Collection; 45 (top) Bodleian Library – manuscript douce no. 134 F. 165; 45 (bottom) Mary Evans; 46 (left) Victoria and Albert Museum; 46–7 IGDA; 48 Victoria and Albert Museum, 49 Danish National Museum/Werner Forman; 51 Gustave Moreau Museum, Paris/Cooper-Bridgeman; 52 Scala; 53 Scala; 54 F. & N. Schwitter; 55 Bodleian Library/M.S. New College 65.F. 12V; 56 (left) Sonia Halliday; 56 (right) British Museum/ Michael Holford; 57 Sonia Halliday; 58 Scala; 60 Roger Viollet; 61 (left) British Museum/ Michael Holford; 61 (right) Roger Viollet; 62 (left) Bulloz; 62 (right) British Museum/ Mansell Collection; 63 Musée Condé, Chantilly/Giraudon; 64 (top) Sonia Halliday; 64 (bottom) Sonia Halliday; 65 (left) Scala; 65 (right) Prado, Madrid/Mas; 66 Bodleian Library/ M.S. Douce No. 134 F. 158E; 67 Musée des Beaux Arts, Dijon/ Giraudon; 68 (left) The Tate Gallery; 68 (right) Novosti; 69 (left) Victoria and Albert Museum; 69 (right) Victoria and Albert Museum/C. M. Dixon; 70 Sonia Halliday; 71 Robert Walker Collection/Cooper-Bridgeman; 72–3 City Art Museum and Galleries, Manchester; 74–5 Scala; 76 National Gallery of Art, Washington; 77 National Gallery of Art, Washington/ Cooper-Bridgeman; 78–9 Giraudon; 80 Victoria and Albert Museum/Photoresources; 81 Werner Forman; 83 Fosco Maraini Collection/Scala; 84 Louvre/Giraudon; 85 Claus Hansmann; 86 Musées Royaux des Beaux-Arts, Brussels; 87 (left) Mansell Collection; 88 (right) Musées Nationaux, Paris; 89 Klement Gottwald Museum, Prague/M. Pucciarelli; 90 National Museum, Prague/M. Pucciarelli; 91 Pitti, Florence/IGDA; 92 (top) Bulloz; 92 (bottom) British Museum/Michael Holford; 93 Mansell Collection; 94–5 Prado, Madrid/Mas; 96 Mansell Collection; 98 M. Pucciarelli; 99 Biblioteca Apostolica, Vatican/M. Pucciarelli; 100 Mansell Collection; 101 City Art Gallery, Manchester; 102 San Marco/Scala; 104 (top) Louvre, Paris/Roger Viollet; 104 (bottom) Sonia Halliday; 105 Louvre/ Bulloz; 106 (left) Mansell Collection; 106 (right) Mansell Collection; 107 Horniman Museum/Michael Holford; 108 British Museum/Orbis Publishing; 109 Orbis Publishing; 110–1 National Museum of Ancient Art, Lisbon/M. Pucciarelli; 111 (right) Orbis Publishing; 112 (left) Scala; 112 (right) Prado Museum, Madrid/Mas; 113 (top) Sonia Halliday; 113 (bottom) Sonia Halliday; 114 Victoria and Albert Museum/Orbis Publishing; 115 Horniman Museum/Michael Holford; 116 Roger Viollet; 117 (left) Roger Viollet; 117 (right) Musée de l'Oeuvre, Notre Dame, Strasbourg; 118 Cooper-Bridgeman; 120 Musée des Beaux-Arts, Strasbourg/Giraudon; 121 British Museum/Michael Holford; 122–3 Museum of Ancient Art/Scala.